BURDETT, Osbert. The Beardsley Period; an Essay in Perspective.
Cooper Square, 1969 (orig. pub. by Lane, 1925). 302p 75-79196.
7.50

Despite its original publication date, no other survey of the 1890's has superseded *The Beardsley Period*. Burdett, unlike Holbrook Jackson (*The Eighteen Nineties*, 1922) confined himself to the "Aesthetic" writers and painters of the period. Both Bernard Muddiman (*The Men of the Nineties*, London, 1920, o.p.) and Gaunt (*The Aesthetic Adventure*, CHOICE, Dec. 1968) cover this decade, but Muddiman's approach is more biographical, while Gaunt traces the Aesthetic Movement from Pre-Raphaelitism through the 1890's. Despite Burdett's pontifical tone and his displacing of Oscar Wilde that Beardsley might appear as the central figure of the decade, *The Beardsley Period* is provocative criticism that would be valuable in a college library.

THE BEARDSLEY PERIOD

THE BEARDSLEY PERIOD

An Essay in Perspective

by

Osbert Burdett

"I belong to the Beardsley period."
MAX BEERBOHM

COOPER SQUARE PUBLISHERS, INC.
NEW YORK
1969

Originally Published 1925
Published by Cooper Square Publishers, Inc.
59 Fourth Avenue, New York, N. Y. 10003
Standard Book Number 8154-0297-X
Library of Congress Catalog Card No. 75-79196

Printed in the United States of America

To
CHARLES GARDNER
in gratitude and affection
for the bread
of his friendship
and the wine
of
his books

CONTENTS

NOTE

MY regretful acknowledgments are due to the many writers for whom I had no room in the following pages. No disrespect is intended, and I trust that no one will take it amiss that a choice had to be made, because the space at my disposal was limited.

A less easily excused matter is the most inadequate mention made of the painters and artists who are nominally included. These really need a volume to themselves, and the proper person to write it is obviously one who is or has been a painter and artist himself. When we recall the prose that painters, living and dead, have written, it seems presumptuous for a man of letters to write about painters at all : an opinion better understood in the studio than in the library. Therefore I have trespassed, in this volume, as little as I could beyond the mention of names.

Through the courtesy of the owners, I have been permitted to inspect many Conders in private possession. To these owners and to others who have variously assisted me, my warmest thanks are due. On the positive side too, Mr. John Lane and Mr. Edmund Gosse have helped me with the loan or inspection of books, and with other information. For the use made of all this generosity the present writer alone is responsible. That this might be no less apparent than real, the mention of authorities throughout, whether books or not, has been made sparingly.

Since the dates have not always been correctly given, it may be well to add that Aubrey Beardsley was born on August 21st, 1872, and died on March 16th, 1898.

OCTOBER, 1924

THE BEARDSLEY PERIOD

INTRODUCTION

A LREADY a body of literature has begun to grow around the personalities and the work of the little group of men who with their followers have become known to us collectively as the nineties. Admittedly they had their due share of talent, wit, originality. Admittedly they were the joint or collective expression of a common tendency or mood which, partly by an accident to be considered at our leisure, has inveigled the attention of foreigners, so that there is perhaps no country in Europe which is now unfamiliar with their best work or unimpressed by the achievement of their leaders. For this interest and curiosity, it may be observed, it is difficult to find a parallel. Since the days of Byron, and the German interest in Carlyle, English literature has somehow failed to arrest the excited attention of French, German, Italian and Russian readers to the same extent as some of the work of the nineties has arrested it. The effect is the more puzzling to ourselves because, however much at one period of our individual lives we may have felt their fascination, a maturer judgment has grown impatient at the manner, the tone, the extravagance in which the movement of set

choice presented itself. A further complication is
this. The movement chose to startle ; it was not
sparing to annoy received opinion ; its appeal was
addressed haughtily over the heads of the multi-
tude to " the twelve superior persons " of the
universe, and now, when the dust of dismay has
subsided and Mrs. Grundy has once more com-
posed her ruffled petticoats, superior persons them-
selves regard the movement with ill-concealed
dislike, profess its achievement to have been much
exaggerated, though all this while edition succeeds
edition of the once disturbing volumes, and some
among the young of each generation of readers
catch the infection almost as readily as, a decade
or two earlier, those did who now profess that
their admiration was no more than the green-
sickness of taste. If this attraction and repulsion
were local to our shores, it would still be worth
while to inquire why the movement retains its
hold upon successive generations of younger readers,
but the same condition is found in European
countries and America. Is there an historical
cause to explain this ?

We are well accustomed to hear our great writers
recommend us to study foreign authors. A hun-
dred years ago we listened with charming patience
to Carlyle's eulogium of Goethe and of German
literature. Sixty years ago we bore with Matthew
Arnold's criticism of English provinciality, and
admitted that we would do well to study Sainte-
Beuve, though no one except Mr. Edmund Gosse
has been recognizably influenced by him. Now

we find that foreigners do not betray any remarkable interest in Matthew Arnold or Tennyson, in Ruskin or Browning, and are not greatly comforted to know that Aubrey Beardsley and Oscar Wilde have won an international reputation. It seems, does it not, an anticlimax, an inconvenient and inexplicable fact, made the more irritating from the continued popularity of these among our more youthful and less responsible readers ? [1]

Nearly a quarter of a century has passed since Wilde died in Paris in 1900. The War, with all its changes in our preoccupations, has intervened. But for those susceptible to it the interest in the nineties is unabated. On the potency of their odd elixir the War has produced no visible effect, and this invites us to inquire how far they may have stood for something more enduring than we thought, and if their chosen triviality may not have a more vital principle than the seriousness against which it was directed.

Some such feeling as this has doubtless prompted the cluster of books that the decade continues to provoke, but, so far as I have been able to discover,

[1] An assertion of this kind is sometimes denied ; but so recently as September 6, after these pages had gone to the printers, the *Spectator* contained an article on " The Books and Men of the Nineties," by Mr. A. J. A. Symons, the bibliographer, in the course of which he said : " Collected by many, they are difficult to find and not cheap when found. . . . An attempt is now being made by some members of the First Edition Club to consolidate into one vast volume all that can be ascertained, before it is too late and the knowledge be lost, concerning the books and men of the nineties."
We may grumble at the fact, but the fact is there.

no critical attempt has yet been made to analyse the question. The writers of these volumes have confessed a fascination that, it seems to me, they have not explained to themselves, and have therefore been content to record rather than to investigate. But the expression of ardent feeling, pleasant enough in conversation, is irritating to critical readers in the absence of any attempt to define its cause, and an absence of definition, I think it will be admitted, is the staple of most books about the nineties. Among these one or two volumes stand apart. Mr. Arthur Ransome's *Oscar Wilde* deserved to be called "a critical study," and Mr. Frank Harris's life of the dramatist is likely to be final. There have been essays on Aubrey Beardsley by such authorities as Robert Ross and Mr. Arthur Symons, but the moment when we pass beyond isolated members of the group—which is really a narrow one—a fog descends upon the writers' imaginations, and the effect upon the reader is like an attack of jaundice. Mr. Holbrook Jackson's formidable volume is a monument of industrious research. He has swept the activities of the whole ten years into his pages. But the nineties is not a period but a point of view, and many of those who figure largely in the decade itself, since they did not share this point of view, must be excluded. The title of this essay is intended to mark the limit that Mr. Jackson's comprehensive survey overleapt. In *The Trembling of the Veil* we are nearer to the definition that we need, but, unless I mistake Mr. Yeats's intention, this beautiful tapes-

try ot prose is concerned only in part with the
1890 movement, and still more with the prepara-
tion of the soil that was to bear its fruit afterwards,
far away, in Dublin. Several members of the
group with which we shall be concerned emerge
into Mr. Yeats's pages, and the subtlest criticism
is often expended on them, but to him they were
the fringes of the curtain which Synge and himself
were to raise later, in the Abbey Theatre.

The scene of the nineties was set in London,
and its tone was not local or patriotic but cosmo-
politan. Not Synge but Wilde was its dramatist ;
not Mr. Yeats but Mr. Symons and Ernest Dowson
were its critic and its poet. The author of *The
Land of Heart's Desire* was in London only on his
way, and as it had been on a secret errand there.
Apart from his insight into all the personalities
with whom he deals, and the suffusion of his prose
with imagination, the subject of Mr. Yeats's volume
consists of two strands that cross and recross each
other as they run backwards and forwards between
Dublin and London. Mr. George Moore's de-
lightful trilogy had covered some of the same
ground, as it was trod by one whose original centre
of attraction had been neither London nor Dublin
but Paris. The revelations of his temperament
provoked a flutter of controversy, but Mr. Yeats's
pages reveal an interior preoccupation with which
the ninety attitude had little to do. A charac-
teristic distinction is his indifference to the recep-
tion that his work might receive, whereas the
typical attitude of the leaders of the ninety group,

in which Whistler must be included, was one of preoccupation with the public, a public no less courted than despised. The rank and file of the group turned their backs upon it contemptuously. The Irish poet was not attracted by the landscape of London, by the crowded restaurants, the garish lights, painted scenery and painted faces. He did not rejoice at notoriety, love to figure in the newspapers, or to be regarded as a man of fashion no less than a man of letters. He was not preoccupied with sin. The French writers that influenced him most were those that seemed to be working in his own direction ; he was content to trouble the rhythms of his prose and to heighten the imagination by the use of symbols, where others were experimenting with drugs or pursuing finally disastrous courses of conduct. The one atmosphere alien to his work is that of the metropolitan city.

Whistler had painted its river-banks by night. Wilde delighted in the contrast of its luxury and wretchedness. Beardsley translated the contrast into masses of black and white, and, stripping the inhabitants of their masks, showed that to men without convictions the passions become identified with sin, and, in an age when the degradation of beauty had been pushed to its extreme, he took this degradation for his subject and proved how beautifully degradation itself could be depicted. The ugliest century in history laid, in the course of its decades, a deposit on the human imagination from which the poets and the artists had tried in their several ways to escape. Whistler found a

natural aspect in which all could be beautifully seen. Beardsley took the reality itself and, without any concession to idealism but the beauty of his line, wove the incongruous element into a pattern that became satire in its fidelity to the soul out of which this curious world was made. He pierced beyond the accidents to the essence, and the essence, translated into form, became the satire of itself. We must not shrink from this indictment, or imagine, because we are growing accustomed to a world deprived of beauty, that this deprivation is in the nature of things, and not a sinister event in history. In their intense consciousness of it lies the cosmopolitan appeal of the nineties, and this helps to explain their influence. Their imagination was haunted with this aspect of the modern world, and it is because Englishmen are not constitutionally so troubled, having an instinctive respect for material things, to which our poetry has been, as it were, but a private protest, that the greatness of Beardsley seems uncanny. If he be a great artist, then many of the things that we respect must be the reverse of great, and we cannot accommodate the contradiction. Nine people out of ten would agree that, if we had to offer a representative modern artist or playwright to Europe or America, the one name that we should not ourselves choose in either category would be that of Wilde or Beardsley, which are both respected abroad. Men are so constituted that it is the truth that irritates them, and that we feel more or less irritation at this situation is undeniable.

To us Beardsley does not seem a representative
English artist ; to us there seems something un-
English about the criticism of Arthur Symons ;
to us the levity of Wilde has an alien quality for
which his Irish blood is felt to be an imperfect
excuse. There must be a misunderstanding that
we would fain remove in the persistence that makes
these men the European favourites of their genera-
tion of English artists. No English critic has a
more balanced sense of historical perspective than
Mr. Edmund Gosse, no critic steers more surely
between fluctuations of taste whether critical or
vulgar ; and it is noteworthy therefore that not
long ago he criticized the compiler of an anthology
of late Victorian poetry for omitting to include any
of Oscar Wilde's verses, not, Mr. Gosse explained,
because he admired them himself, but because
their surviving popularity entitled them to be
represented. This judgment is an excellent minor
example of his eye for the current of taste, and it
illustrates my contention that in regard to the art
of the nineties, in the limited aspect of the decade
in which this term has come to be used, criticism
and the general verdict have somehow lost track
of each other.

An examination of the evidence suggests that
the artistic product of the period, of the point of
view, that is, denominated by it, continues to be
interesting because it gave expression in literature
and art to an eternal mood of the human mind, a
mood only the facetings of which had previously
been found, and these in unrelated writers. In

such exemplars therefore we have been able to
regard the attitude as a personal idiosyncrasy,
without much reference to the general body of
work to which each writer contributed. The
1890's, however, present us with a group of
writers, for Beardsley's poems and prose entitle
him to be included among them, simultaneously
animated by the same protesting mood, each of
whom contributed his own morsel to its monument.
Like every movement in art, it was a movement
of young men, and, like almost every movement,
it produced its Bible. Had *The Yellow Book* never
appeared, not only might the genius of Beardsley
have missed its widest opportunity, but the move-
ment itself might have escaped detection for what
it was. Byron had been an isolated figure. The
short-lived *Germ* reminds us that a faith without
a canon bears small fruit ; but in the nineties the
dispersed ingredients were combined, and the
centrifugal tendencies collected, to express a point
of view in a body of verse, prose, and illustration
that gave coherence to a movement. By this
common publication the attitude was defined, both
to disciples and opponents, and, unexpectedly in
England where movements neither in art nor politics
much flourish, certain active imaginations of the
time cohered, thereby to produce an effect that
they never could have created individually.

They were all young men, and the mood, the
attitude of mind, that they represented is the mood
of excess natural to youthful imagination, especially
in an age when everything is made to the measure

of a crowd. This phase, through one or other aspect of which every vital spirit passes or ought to pass, was suddenly flashed upon the public view through the egoism of a dozen talents. It was in its very surface insincerity sincere, and because the more impressionable of succeeding generations find in these predecessors a mirror of their own desires and discontent, the 1890's continue to attract succeeding waves of readers. "A critic is any undergraduate of Oxford or Cambridge," wrote Mr. Richard Le Gallienne in *Retrospective Reviews*, and in the phrase we overhear the eternal undergraduate speaking to himself. But, in a world of change, we grow to blush for these confessions, and thus it comes that the persistent attraction of the period to youth surprises those who, once similarly fascinated, have outlived its influence. We grow more critical of the accidents of the form of the books that once we loved. The earlier of these, likely enough, we know that it would be rash to reopen, and it is indeed unusual that young men have sufficient maturity of talent to make others share the youthful point of view. By the time when an artist can interest us in the romance of first love, in the excitement of the latest artistic theory, in first-night receptions, a visit to a tailor's, or the fun of dining out, he can interest us in many other things. He will touch upon the things that attract the young on his way to graver issues. Meredith was past thirty when he played the diversion upon a penny whistle. Hardy was middle-aged when he presented Sue

Bridehead to a recalcitrant world. But the pecu-
liarity of the youthful imagination is an unashamed
precocity. Mr. George Moore could never give
us the confessions of a young man to-day ; and,
though we are entitled to prefer his autumn volumes,
it cannot be denied that without the acidity of the
Confessions the young man would not be fairly
represented there. In spring-apples the greenness
is a quality, and to be raw upon the palate is a
virtue of their age.

All imaginative young men who are sincere
with themselves, and not echoes of impersonal
opinion, whatever be the colour of their politics,
are Tory in their tastes. They delight in distin-
guished surroundings, leisure, love, pedigrees,
adventure, money and good wine. They are bored
by middle-class standards and recoil from com-
mercial activity. To them a house without tradi-
tions on its walls and in its cellar is not the house
that they most desire to visit or to own. Their
imaginations are most responsive to the extremes
of society, and oscillate between the garret and
Grosvenor Square. The house of their desires
has been described in the words of Statius :

> " Hic premitur fecunda quies, virtusque serena,
> Fronte gravis, sanusque nitor, luxuque carentes
> Deliciæ,"

if I may steal the motto that a humanist has taken
for his own home. Balzac understood these young
men, and gave to their representative but two
desires ; *d'être célèbre et d'être aimé.* In these

words, Mr. Moore remarked, with early enthu-
siasm, the eternal young man reveals himself. The
Beardsley period expressed this attitude, and con-
sequently has captured the ears of young men for
an indeterminate season. But, as I have said, it
is unusual for a young man or a group to have the
artistic power to communicate this ardour to others.
Being inarticulate, the young man is despised ;
when he has acquired later the power of artistic
creation the mood is mainly a memory. Only
the point of view of middle age is perennially repre-
sented in art, because only when youth has gone
do men become accomplished artists. The excep-
tion of the poets does not alter this balance, for
young poets are more interested in beauty or
abstract thought than in accidents of life and char-
acter.

Manners, finest of the fine arts, is the province
of prose, and to practise it the privilege of aris-
tocracy. To have been born some one is the
foundation of an aristocratic creed, and its axiom
is that no acquirement, or skill, or reputation, can
add anything to a man's personal title to distinc-
tion ; and indeed it is generally admitted that,
however we choose to define the terms, the best
endowment that anyone can have is to be born
of the best stock or ancestry. No event in any
man's life is so important as his parentage. The
developed personality, independent though it be,
demands a society of its similars, a life of cultivated
ease. The fine arts, from architecture to sculpture,
painting and music, provide a background for this

art of living, in which people are worthy of their surroundings and humanity fulfils itself. This dream, never abandoned, never achieved, is instinctively divined by young men, and the extravagance of their assertion in the nineties was the protest against a commercial society, in which the pressure of numbers had become so great that the needs and standard of the multitude necessarily dominated everything. Confronted with such a teeming population, egoism tends to become assertive, for the individual without property can only escape from being sacrificed to the ubiquitous machinery that such a population engenders by dominating it with more of his own devising. The pressure of population is the material root of all against which we rebel in modern life. There are too many people ; and against the drab uniformity that the satisfaction of their needs necessitates human imagination becomes either starved or restive.

The reputation of the group depends upon the natural endowments of its members ; the moment at which they appeared, the historical accident that decided the pitch on which their work was done, and the story attached to some of them. The pitch was falsetto, for the crowd was answered in its own key. The colour was yellow ; the sunflower a favourite emblem, and both pitch and colour had been out of favour since the time of the Prince Regent and the days of the dandies. In order therefore to appraise their achievement, we must see the movement in better perspective

than can be given by confining ourselves to a few
preceding decades, for the point of view of the
Beardsley period is best seen when related to the
deeper springs of modern thought. To return to
these is not to exaggerate the importance of the
period, but to trace a symptom to its cause. Land's
End is a small place, but it takes all day to get
there. The point of view was called *fin de siècle*,
and that nothing might be wanting to its effect,
it gave rise to an immortal scandal, but the cycle
that it seemed to close was longer than a hundred
years.

CHAPTER I

The Historic Background

OF loose phrases now in use probably " modern thought " is the most vague. It is susceptible of definition, however, and can even be referred to a date. For its development we shall turn to the historians, but before we traverse the familiar ground we will define the term as it will be used in the following chapter. Modern thought is the attitude that succeeded the disruption of the mediæval mould when the Council of Trent in 1555 failed to stem the Reformation. It had been the pride and happiness of the mediæval mind to repose upon a general theory of man and nature. In Dante (1265–1321) both conceptions are woven into a single imaginative structure ; and when one strand after another yielded to inconvenient facts not only was the vesture rent but the repose vanished. The ensuing mood was one of gathering disillusion, for the new principle of private judgment often led to no conclusions, until at the end of three hundred years—for the year 1859 is the second date that we shall notice—the cycle traversed seemed complete, and a new hypothesis gave an

unexpected sanction to the modern attitude. Of this the nineties may, I think, be regarded as the culmination, and the object of the following excursion is to see the decade in the stream of change. To do this it must first be foreshortened for the sake of historical perspective.

The discovery of America is a piece of news from from which we have not yet recovered. It upset traditional notions of geography, and in the same epoch a good European's conceptions of astronomy were similarly modified. It was in 1543 that the Pole, Copernicus, published his theory *De Revolutionibus Orbium Cœlestium*, wherein he rejected the prevailing Ptolemaic explanation of planetary motion. For his support of this and his attacks upon the theological conceptions that grouped themselves around the Ptolemaic astronomy, Bruno was burnt on the Campo dei Fiori at Rome in February 1600. The *Cena de le Ceneri*, his dialogue upon the later system, had been printed in 1584, and the mental atmosphere into which his comet burst is condensed in the statute that Bruno found when he visited Oxford. This ordained that all "masters and bachelors who did not follow Aristotle faithfully were liable to a fine of five shillings for each divergence," and Bruno's arguments were not limited to movements so remote as those of the planets. Indeed in another dialogue, the *Spaccio della Bestia Trionfante*, he deliberately assailed the assumption that man was the centre of the universe, and handled the Hebrew divinities and the Greek myths with the same contemptuous

freedom. It is true that Copernicus died in his bed of apoplexy in 1543, but, though Pope Clement VII approved his work, the epistle in which Copernicus had dedicated his labours was preceded, upon its publication, by an anonymous preface that insisted the theory to be hypothetical only. As late as 1633 Galileo was summoned before the Inquisition, and though the popes and the Holy Office were ultimately lenient, it is on record that the theologians consulted by the latter in 1616 had declared the thesis, that the sun is the immovable centre of a universe, to be " absurd in philosophy and formally heretical, because expressly contrary to Holy Scripture." Galileo promised not to hold, to teach, or to defend, the condemned doctrine ; and the Congregation of the Index repeated the censure, though the word heretical was spared. The book was re-published in 1620 with a few verbal changes, and this allowed the hypothesis to exist precariously. The decree was not confirmed by Paul V, and was apparently withdrawn in 1757 in the reign of Benedict XIV.

These discoveries overthrew the general basis of conceptions on which good Europeans had previously been agreed. The earth was not so small as had been thought, and the heavens were differently contrived. The basis of certainty was changed, and a new revelation was being found in science. At the same time the mediæval dream of Church and state in a united Holy Roman Empire was proving impracticable in European affairs. Certain abuses in the Church were troubling men's

consciences, and the trouble, manipulated by kings and statesmen, led to the break in Germany and the defection of England. In knowledge, in politics, in principles, there occurred a revolutionary change, and the immediate effects are grouped together under the name of the Reformation. With the overthrow of authority, private judgment and the ego were emerging into independent existence, and a new loneliness and isolation were soon to make themselves felt. The old synthesis did not give way without a struggle, and the failure of the Council of Trent to stem the current of disobedience to traditional ideas marks the last endeavour to order life upon agreement and a general theory.

If we compare the attitude of Dante with that of Shakespeare the difference becomes personal and plain. In Shakespeare's plays we meet the first of the moderns. To him the supernatural is a convenient stage effect and no more, or he would not have made Hamlet speak of the undiscovered country from which no one returns immediately after his conversation with the ghost of his father. He is interested not in man and a theory of virtue, but in men and women, whose interactions on each other, without ulterior reference, form the simple tissue of the plays. His insight can penetrate weakness ; he has no vision of the great, and among the many motives that actuate his characters the religious is not to be discovered. Even his monks and nuns have the small talk of their craft and nothing more. The mood of Hamlet and Jaques is the mood of disillusion, for they are men without

convictions. It is, I think, the absence of a general theory that explains this, though they do not realize the cause of this disillusion in themselves, and can only say with Antonio : " In truth I know not why I am so sad." The admission confesses the absence of something only dimly remembered or divined. The one philosophy that we can imagine Hamlet to have found convincing is the subjective philosophy of Berkeley, which was the delayed but inevitable intellectual product of this throwing back of the individual upon himself. It was not willingly embraced, but it contributed to the gathering disillusion which may be studied in its more conscious condition in the nineteenth century, in which, moreover, its climax was reached.

The struggle between traditional authority and idiosyncrasy of opinion gradually settled into the compromise or truce of the seventeenth century. The Reformation was stemmed but not defeated. Its own divisions gradually began to define themselves, and the process of subdivision was bound to go on to the present day, until fundamental agreement was banished from society, when the individual, gradually more isolated in his opinions, tended to concentrate upon himself, and society to be held together more by commerce than by ideas. The reflective minds in the eighteenth century began to evolve a new synthesis, of behaviour in the sphere of conduct and scepticism in the sphere of thought. Dr. Johnson's exaggerated fear of death was the comment of his animal nature, which was strong, on his faith which needed supporters.

His sense of solidarity suffered from the prevailing
scepticism, and he needed the support that he did
not find in his contemporaries for the deeper aspects
of his creed. He was temperamentally gregarious,
and intellectually the advocate, rather than the off-
spring, of an interrupted tradition. The Church
of England and the monarchy were his cardinal
tenets, but the monarchy, being less questioned, was
the more stable reflection of his mind. He adopted
that which seemed to him a necessary compromise;
but compromise is never so satisfying to ardent
minds as triumphant assertion, even if the assertion
be an error. More typical figures of the eighteenth
century are men like Gibbon and Lord Chesterfield
in England, the Abbé Galiani in Italy, and Voltaire
in France, who were happier in their surroundings
and transferred their allegiance from theory to
observation, from belief in a system to a standard
of behaviour. They were finely impersonal even
in their confessions, as we discover in the cold
pages of Gibbon's *Autobiography*. Something re-
mained beside the ego, which Rousseau was per-
haps the first to assert with unblushing importance.
 The ideal man sketched in Lord Chesterfield's
Letters is an interesting conception, and his merit
is that he would be at home in any civilized society
from the age of Pericles to the age of Anne. No
apter treatise upon education has been written,
because the object of the *Letters* was not a theory
but a boy, and its advice is never abstract or divorced
from humanity. How could it be when the author
fairly embodied the qualities that he endeavoured

to teach, and knew how to appeal to the imagination of his correspondent by a wit that redeemed the suggestions from prosiness or preaching ? The advice succeeded as far as it deserved, and where it failed is no less stimulating. It reminds us that education cannot be given away, and that much more depends upon the candidate than on his advantages. Popular education has proved, as yet, the craziest of dreams, and the attempt to achieve it has done little more than to place popular standards in the centres of learning, and to incapacitate an ever larger number of persons for leading useful and contented lives. Only by retaining the natural difficulties in the way of its acquirement can people at all be sorted into those capable or incapable for its pursuit, and the acquirement of literateness even, though a public convenience, has no necessary good effect upon the character or mind. The knowledge of the world, which, Lord Chesterfield said so often, could not be acquired from books, is a better training, and really human occupations, like the farmer's and the artist's, cannot be learned in schools at all. Schools devoted to these activities produce only teachers, which is education reduced to an absurdity. These facts that we are desperately trying to ignore were manifest to Lord Chesterfield, whose sense of humanity never allowed his mind to stray. Dr. Johnson's hostility to the book can be explained best by his personal grievance against its author. The *Letters*, moreover, touched Dr. Johnson's own weakness to the quick. He was uncouth, and the criticism of uncouthness left

him defenceless. Quick enough to see that excuse would emphasize his own shortcomings, he tried to make a merit of his defect. Like most Englishmen, he had never been crossed with foreign ideas, and was therefore but a glorified cockney. He was constitutionally unable, for want of more humility than he possessed, to understand Lord Chesterfield's contention that the highest human attainment would unite the virtues of the French and English nations.

Englishmen have taken Dr. Johnson to their hearts partly through the intimacy achieved by the art of Boswell—for a human being is lovable through the degree of our intimacy with him—but chiefly because no author of equal courage and intelligence has flattered English vices half so grossly. Dr. Johnson was insular, rude, intellectually lazy and proud of his laziness as Englishmen are apt to be, and the consequence has been that his clownish epigram on Lord Chesterfield's *Letters* is better known than the *Letters* themselves, and a hundred readers can quote his comment upon Berkeley's philosophy for one that has read the dialogue between Hylas and Philonous. Berkeley's philosophy was directed against the materialism of the time, but the point for us to notice is that it emphasized the individual's isolation in a subjective world, and this was more than Dr. Johnson could bear to contemplate. He was as gregarious in thought as he was gross in his behaviour. He really occupied the position of one who accepted the Ptolemaic philosophy while subscribing to the Copernican

theory of the stars, and his great intelligence was impounded to support the compromise. Disappointed in his higher aspirations, because he found in himself an unacknowledged doubt in place of the certainty that he desired, he is a great failure, whose battle with disillusion won a Pyrrhic victory, a Christian who never emerged from the Slough of Despond and whose burden never tumbled from his back. He is a symbolic figure, marking, as it were, the period of transition from earlier to later times.

To see Dr. Johnson in the perspective that is necessarily denied to his fellow-countrymen, we have to understand how he has impressed the imagination of foreigners. Nathaniel Hawthorne is not too far removed from the English ambit, but he is capable of detachment, and he writes : " Dr. Johnson meddled only with the surface of life and never cared to penetrate to more than ploughshare depth ; his very sense and sagacity were but a one-eyed clear-sightedness. But "—he goes on of Johnson's teaching—" it is wholesome food even now. And then how English ! The great *English* moralist . . . Dr. Johnson's morality was as English as a beef-steak." The following is a French critic's opinion, and I take it simply because it is the nearest to my hand :

" Sermons are liked in England, and these essays are sermons. We discover that men of reflection do not need bold or striking ideas, but palpable and profitable truths. They desire to be furnished with a useful provision of authentic examples on

man and his existence, and demand nothing more.
No matter if the idea is vulgar, meat and bread are
vulgar too, and no less good. They wish to be
taught the kinds and degrees of happiness and un-
happiness, the varieties and results of character and
condition, the advantages and inconveniences of
town and country, knowledge and ignorance, wealth
and moderate circumstances, because they are
moralists and utilitarians ; because they look in a
book for the knowledge to turn them from folly,
and motives to confirm them in uprightness ;
because they cultivate in themselves sense, that is
common, practical reason. A little fiction, a few
portraits, the least amount of amusement, will suf-
fice to adorn it. This substantial food only needs
a very simple seasoning. It is not the novelty of
the dishes, nor dainty cookery, but solidity and
wholesomeness, which they seek. For this reason
Essays are Johnson's national food. It is because
they are insipid and dull for Frenchmen that they
suit the taste of an Englishman. We understand
now why they take for a favourite the respectable,
the tiresome Dr. Samuel Johnson" (Taine).

Dr. Johnson is like virtue in this, that " it would
be difficult to overrate him if he had not been
already overrated." To us the men that he derided
are a healthier influence, because they flattered not
at all our national weaknesses, and were humane
where he was only national. The Puritan survived
in him, and because the Puritan conscience thrives,
like a mushroom, in the dark of disillusion, Dr. John-
son is the link between the seventeenth and the

eighteenth centuries. The Puritan cultivates a
sense of sin as carefully as the artist cultivates a
sense of beauty, and as that which he cultivates is
supposed to be unmentionable an attempt is made
to emasculate the arts, and the more successful it
is the greater will be the ultimate revenge of the
instincts of human nature.

It was Dostoievsky who found a defence for the
Church in the great service that it renders to such
people by delivering them from the burden of deci-
sion, and enabling them to escape from themselves.
But some there are who accept deliverance, as it
were, in their own despite, and who desire even
more certainty than revelation and dogma can give
to them. To these a moiety of disillusion remains,
and we know them for the moderns, born either
too late or too soon, in the transition from which
even now we are far from emerging. Gibbon and
Chesterfield were happier in the hour of their birth,
and in his own way each achieved the synthesis of
the eighteenth century. The pattern, as I have
said, shifted its place from the sphere of belief to
the sphere of behaviour. Before the modern period
began, men behaved as they have always behaved,
but comforted themselves with the assurance that
they knew right from wrong even when they acted
wrongly. The modern period had not this assur-
ance, but preferred to say : whatever be true or
false, you can still live and die a gentleman. Such
a person has since been defined as follows : " A
gentleman is one who makes certain claims for him-
self : that he shall be able to live a handsome and

dignified life, a life that will develop his faculties to the utmost and place him in a respectable and honourable position. In return the gentleman is willing to do the utmost for his country that he is capable, and would scorn to put a money value on his services." Partial as this definition [1] is, and forgetful that it generally takes more than a generation to produce such a complex character, at all events it is distinguished from the dead and colourless image of respectability. Those Palladian houses that still stand in the countryside, their colour and dignity so exactly reflected in the steel engravings of their own and the succeeding period, express the same ambition in their architecture. They do not carry the mind beyond themselves, but they are fit habitations for civilized men, and remind us how delightful life can be when human beings are worthy of the backgrounds provided by good architects. The distinction of a great age is upon them, but an age's distinction does not last, and Palladian houses languished with the passing of the eighteenth century. The sense of form contracted into formalism, and the couplet which Waller had been using at the very date when the First Folio was published [2] received the last polish from Dryden and Pope, who left nothing more to be said in the idiom that they had perfected. The eighteenth century was an age of beautiful prose, but it cramped poetic sensibility,

[1] Cf. Mr. Frank Harris's aphorism : " A gentleman, to me, is a thing of some parts, but no magnitude : one should be a gentleman, and much more."

[2] Cf. *From Shakespeare to Pope*, by Edmund Gosse.

and this, asserting the instinct that the synthesis
had overlooked, created the Romantic movement
and the cult of egoism. Man's desires are more
complex than any pattern that he can invent to lend
them form and dignity. The pattern represses or
omits some inconvenient element, and this in time
will take its revenge by attracting all emphasis to
itself. So at the end of the eighteenth century the
other-world asserted its prerogative of fascination
to capture the pulpit of Wesley, and Nature escaped
from the churchyard in which Gray had confined
her to wander on the mountains as the holiday
companion of the poets.

The writers who slipped over the border of the
eighteenth century in part escaped the disillusion
that is confessed by their successors. We hardly
find it in Blake, because he was attempting to re-
create a lost synthesis with a new symbolism of his
own. Wordsworth broods like the spirit of con-
templative ecstasy over nature and mankind, and in
such an utterance as

> " Suffering is permanent, obscure and dark,
> And shares the nature of infinity,"

there is a grave joy, a sense of affirmation and repose,
that rises far above the mood of melancholy. In
the last analysis the absence of a general theory
begets subjectivity not only in philosophy but in
art, and it is only the strongest minds that can
endure such a degree of isolation if they are not
temperamentally endowed with the intelligence of
the Comic spirit. As egoism deepens in intensity,

disillusion tends to deepen too, for those who are free to make up their minds on every question have first to discover whether they have any minds to make up. The poetry of Emily Brontë records her personal conflict with disillusion, and her courage is that of a heroic figure who will not despair because she has never hoped. But when Shelley was eight years old, Macaulay was born, and he, so confident, strident and lacking in subtlety, deserves our notice because his style reflects the surface mood in which the industrial changes were at first regarded. Macaulay was the jubilant cock crowing over the material riches that the industrial revolution was creating side by side with greater misery than civilized man had known before. In him a gross illusion is triumphant and disillusion nowhere felt. His style has been compared to the rejoicings of a shopman over the increase of his business, and the later criticism, that recent advances in applied science are " mainly mighty means for petty ends," would have been beyond the pale of his imagination. This untroubled state was exceptional among considerable writers, for the note of disillusion is struck in different keys and for different reasons by Byron, Keats, Shelley, and waxes with the century till this reaches middle age, when it becomes explicit.

The two noteworthy mid-Victorian writers who most escaped the prevailing tendency were Morris and Dickens, though much of the humour of Dickens was intended, let us remember, to force us to recognize evils that were escaping attention. The

realities over which it plays are depressing enough. Besides this, he set the picaresque novel against the background of a modern London street, and the adventurous imagination which finds this form congenial delights in mere living too much to demand, or feel the loss of, a general theory. As Mr. W. H. Davies exists, like Dickens, to remind us, disillusion is not within the capacity of the grown child. Patmore was in possession of a general theory, but he does not wholly escape, because he felt its loss in his contemporaries. The real exception is William Morris, whose wistfulness is that of a man to whom death can never be a little thing, because life can be so good while it lasts. It is only a shadow cast by a cloud in the prevailing sunlight. To Morris, to point the contrast, the lights and shadows raised no question except that of their own loveliness.

Readers of Borrow, Jane Austen, Thackeray, Landor, the serious George Eliot even, may urge exceptions in their favour, but there must be a debatable border to the subject, and the tendency is unaffected by such claims. If the absence of a general theory is apparent in their work, the negative quality (which Shakespeare exemplifies) will be present. It is an atmosphere charged with disillusion, into which it may, or may not, condense. Carlyle, in the absence of a general theory, falls back despairingly on the panacea of private heroism. It is his one point, but only the germ of a theory ; hence the exasperation that he felt, and the untempered improvisation of his style. In

Tennyson the note, with its accompanying doubts
and hesitations, is intrusive. Ruskin, unlike a
happy, that is, an affirmative or creative writer,
is a moralist in a scold. Yet we are not loud
about deep convictions ; rather we repose on them
in consciousness of strength. The buoyancy of
Browning and of Meredith is self-confessedly an
effort to stem the current that they oppose. There
is only the fragment of a theory in Browning. His
Men and Women is the latest edition of Shake-
speare's *dramatis personæ* over again. Stevenson's
gaiety was the brave reaction of a sick man. It
has not the peace of spontaneity, and supports
itself, therefore, on the prop of a brilliant artificial
style. Such a style differs from finer styles in
that an artificial style is one that calls attention to
its phrases. A true style, ornate or exquisite, is
intertissued with its substance, so that the sub-
stance as much as the style carries us away, and we
cannot easily distinguish the one from the other.
Matthew Arnold's note is negatively affirmative.
His gospel of culture, the study of perfection, is
an emphasis on the need for a general theory that
it does not itself supply, and his appeal for a bal-
ance implies confusion. But he defined the enemy,
and .gave the word " Philistine " to his age, for,
having been influenced by other literatures, he was
alive to the defects prevailing in the temper of his
time, and transcended them mainly in their defi-
nition. The gravity is deeper and more wistful
in the tapestry of Pater, who retrieved prose from
vulgar applications, and reacted to the shadow of

uncertainty by enlarging on the beauty peculiar to all shadows. To him the art of different periods is the beautiful record of the transient moods of man, and the degree of our life lies in the degree of our susceptibility. In the age in which he found himself, he had to wear a mask, and we shall never know all that lay repressed, though there are indications of a hungry soul behind that shy reserve, a reserve that spoke once only in overt tones, namely, in the conclusion to the essays on the Renaissance. In the unreprinted essay on "Æsthetic Poetry" the same spirit is overheard, to retire into the folds of his style beyond the tracking of all but sympathetic observers.

In its comparatively coarse way, the *Omar* of Fitzgerald gives expression to a not dissimilar reaction. There is no more joyless poem in the language. Once this point was reached, we should expect the turn of the tide. Thus in James Thomson the energy of the rhythm defies the gloom that it describes. Complementary to this is the complicated movement of Rossetti's verse, which may be compared to that of a dreamer stirring in a troubled sleep.

If, then, the literature of the period was indeed a haunted literature, with disillusion for its spectre or refrain, we should expect the arrival of an imaginative writer who would carry the tendency which had been implicit a step further, one, in fact, who would make a virtue of necessity, and in viteus to recognize the beauty of a tragic conception of human life. This is that which the art of Thomas

D

Hardy has achieved, and his age must be judged
by the fact that, at the height of his powers, it
discouraged him from writing novels. In return
he has been canonized. There was nothing we
would not give him, if only he would not exercise
his gift ! He had adopted the Greek conception
of Fate in the terms of its modern equivalent,
wherein the intricacy and web of natural laws and
chance circumstances, at work even more within
us than without, replaces the old conception of
an external controlling Destiny, and is heightened
because the new Ananké, in a subtler and more
mysterious sense, has man always in its toils. A
motto for the Wessex Novels might be found in the
following : " Natural laws we shall never modify ;
but there is still something in the nobler or less
noble attitude with which we watch their fatal
combinations." A salt is added to the tragedy
by the author's peculiar irony. To others it has
been sufficient that a reprieve shall not arrive until
too late. To Hardy it must arrive while the man
is falling through the air. His characters, when
they endure to the end, are dignified because they
have been spared nothing, and thereby assume for
us the " nobler attitude " which, to Pater, was
the " something heroic " that still remained pos-
sible for modern man. Under Mr. Hardy's spell
we are driven to accept ourselves as nobler than
the chances which have us at their mercy, and
to see the tragedy of life to consist in the emerg-
ence of creatures more sensitive than the destiny
that has evolved them : a tragic partnership to

which man and destiny are alike immitigably bound.

In the later writers the emphasis is so pronounced, the disillusion, if I may say so, is so confident, that a further and more immediate cause suggests itself. This cause, I think, is to be found in a volume which occupies a small place in literary histories, though a large one in its own field. The book to which this confidence may be related was *The Origin of Species*. The exultation expressed by Macaulay had begun to wane with the creation of its national monument, the Crystal Palace, which was opened in 1851. *The Origin of Species* was published in 1859, the year of Macaulay's death. During these eight years the tide turned, and belief that all was well with modern progress turned to doubt. After 1859 the complacency of the century was definitely smitten, for with the publication of *The Origin of Species*, the revolt against the system became conscious, because the effect of the book (unintended by Darwin) was to make the system understood. There is no need to recall the sensation with which it was received, but when a technical treatise is immediately and widely popular, it is no discredit that an element of luck should have contributed to its success. In regard to Darwin's book, this can be resolved into the reaction which ensued when the Crystal Palace, the symbol of progress and prosperity, was proved to be indeed a palace of glass, and partly to the favourable position of the author, who belonged to the class that does not have to swim against the stream. If we read the book with fresh minds,

as if it had been written yesterday, we cannot but feel a momentary surprise that it should have been a popular success. It has no charm of manner. The style is often slovenly, and the arrangement often confused. The reason for its welcome is to be found, of course, in the two doctrines which quickly became popular catchwords : the struggle for existence, and the survival of the fittest. These were popular because they seemed to give a scientific sanction to the prevailing industrial system. In the midst of that squalor it was some relief to believe that the facts against which the human spirit was rebelling, that the hideous commercialism which had caught men in its toils, was in the nature of things, and that the conditions for which man could find no interior sanction had the sanction of inevitability, notwithstanding some survivals from a different, and seemingly happier, past. So, after eight years of contemplation and comparison with them, the Crystal Palace began to seem less convincing.

At this moment of reaction, the hour was ripe for a rationale of the situation, even if that rationale seemed to justify it. A theory was wanted, and it was found. In *The Origin of Species* the industrial system seemed to find its Bible, and men learnt that the world of nature was also ruled by *laissez faire*. The news came, too, with the infallibility of " science," " fact," and " observation." The claim to certainty still rested on revelation, but revelation was now the perquisite of science. The new prophet was the professor, and the stern

tables of the law that he brought from his laboratory fitted in extremely well with men's everyday experience of life. True, the prophet seemed to deify luck, and to confirm their despair, but at all events he did confirm it. Anarchy was the order of the universe. The suspense was over. The worst was known.

Whether such inferences were fairly drawn from *The Origin of Species* is not here in question. That they were drawn, and that they contributed to the popularity of the book, does not admit of serious doubt. In the result, the traditional code, the first great challenge to which the Council of Trent sought to answer, received its second, and seemingly fatal, blow. The tremors from that blow reverberated through literature. The course travelled by the modern mind was complete, and the alpha and omega of its progress are the Tridentine Council and *The Origin of Species*. It fixed a mood that grew (all but unquestioned) till it reached the climax of disillusion in the War. There the forces of Victorian prosperity were revealed in all their nakedness, and produced an orgy of destruction. The imposing Victorian structure proved to be another Crystal Palace when the dwellers therein had begun to throw stones ; but the mask had been dragged from their faces twenty years before when Mr. Pecksniff had sat to Aubrey Beardsley for his portrait, and all that side of human imagination and human instinct that Respectability had chosen to ignore absorbed the arts in the last decade of the century.

CHAPTER II

The Converging Reaction

AS we saw in the preceding chapter, the eighteenth century had achieved a synthesis of behaviour in the sphere of conduct and scepticism in the sphere of thought. Its ideal product had combined the qualities of a scholar and a man of the world, in which the new humanism justified itself. But the times were not propitious for the continuance of the type or the ideal, which was the fine flower of enlightened individuals in the midst of a social structure already threatened and emerging from certain relics of mediæval barbarism : torture, the criminal system, the weight of a dead authority, against which the spirit of protest was raised in the persons of Bentham and Beccaria, Voltaire, the Cartesians, and the Encyclopædists. In the meantime the economic revolution that Henry VIII had brought about, by the destruction of the monasteries and the creation of a new nobility upon their foundations, was repeated by the industrial revolution of 1780 and succeeding years. The first revolution was the greater, and made the economic effects of the second much more serious

than they would otherwise have been. The French Revolution seemed to guillotine not only the aristocrats but the guiding principle of their order, and the new men had no moral sanctions—which only time can confer—to ennoble their wealth. They wore their aristocracy like a faded flower, the morning after the feast was over. England escaped a political revolution, but aristocracy all but died in the odour of corruption during the Regency.

A picture of the time is familiar in *The Greville Memoirs*, *The Creevey Papers*, and *The Four Georges* of Thackeray. The last of these is instructive for the criticism that the Victorian age, in the person of Thackeray, passed upon its predecessor.

" Shall I not acknowledge [wrote Thackeray in 1860] the change of to-day ? As the mistress of St. James's passes me now, I salute the sovereign, wise, moderate, exemplary of life ; the good mother ; the good wife ; the accomplished lady ; the enlightened friend of art ; the tender sympathizer in her people's glories and sorrows."

It is not necessary to emphasize the one sound clause in this complacent panegyric, which indeed is more valuable for the light it throws on Thackeray's age than for the criticism that it casts upon the time of the Georges. We now discern the complacency that defined too narrowly the exemplary qualities in human beings. Queen Victoria was not an exemplary mother, she was not accomplished, she was not a friend of art ; her patronage of Boehm was not enlightened. She *was* 'moderate', and her insight into practical affairs was not accom-

panied by imagination nor moved by very much beyond them, and the ideal of respectability that she represented to her admirers has proved to be unsatisfying in the retrospect. The arts of her age that survive in undiminished splendour are precisely those that were least responsive to its touch. The limitations of its point of view can be seen in their characteristic light in Thackeray himself when he is criticizing the behaviour of George II at the death-bed of Queen Caroline. He recalls how, when she begged the King to marry again, he cried, "Non, non," adding between his tears, "J'aurai des maîtresses." There never was such a ghastly farce, says Thackeray, who fails to see that the redeeming feature of the situation is the King's self-revealing candour. Thackeray was shocked that the King should speak the truth, because Thackeray shared the prevailing convention of his time that no truth that was not respectable should be mentioned. The results of this convention were that the subject-matters allowed to art were circumscribed, and that the characteristic vice of the age was hypocrisy, since this was the only vice allowed to be respectable. It became indeed impossible to be respectable without it, and men once more made the old mistake of thinking that in changing their vices they were improving their characters. So long as class distinctions had been cherished, nobility and distinction had been the old ideals, but the industrial revolution, at the moment when it was putting a higher standard of comfort within the reach of men, was accompanied

by a monstrous increase of population that con-
verted society into a scramble for wealth that could
best be gained by appealing to the needs or flat-
tering the ignorance of the multitude. The new
rich of the period, who had sprung from the mush-
room cities of the Midlands and the North, cities
that were chiefly congeries of slums, reposed no
longer on the basis of broad acres. They were
slum-bred and slum-minded, and found it better
to be enthroned on one acre of advertisements than
on a hundred acres of land. The slum and the
factory had no traditions on which their owners
could rely, and a new sanction that the multitude
could understand, and to which it could aspire, had
to be found to lend its masters dignity and assur-
ance. Since the dissolution in the sixteenth century,
society came increasingly to be divided into a few
rich and many poor, and a new word had to be
found to commend the new order to public regard.
The word arrived and the ideal with it ; and Mr.
Dombey, now enthroned in place and power, was
able to feel his advantage over the corrupt Carlton
House circle by asserting his superior respecta-
bility.

The history of the word is curious. In its Vic-
torian sense it is only a hundred years old.[1] No
one hitherto had desired to be respectable, because
so amorphous a desire could arise only in a time

[1] The creator of the original Mrs. Grundy died in 1838, the
year after Queen Victoria's accession. He was Thomas Morton,
the playwright, who invented the beldame in *Speed the Plough*,
the most famous of his twenty-five dramas.

when the pressure of population was blurring
class distinctions and making a character to which
every man could aspire a general need. Such a
character must be colourless. The appeal is made
to an imaginary communion, the communion of
respectable people. There are no such people
when the truth is known. The ideal is a sub-
human monstrosity, whose pretence can only be
preserved so long as the truth is scrupulously con-
cealed about them. The larger half of life became
unmentionable, because respectability is a mask
maintained by a conspiracy of silence. The mask
could be worn by anyone above the poverty line
that set apart at most one quarter of the total popu-
lation. It meant that people were esteemed in
proportion to their wealth—industrial democracy
is only the trade-mark of a continually shifting
plutocracy—and with that colourless thing, which
only inherited traditions can ennoble, colourless
virtues are invoked. To be respectable is to have
money, and so to behave that no one, however
ignorant or foolish he may be, can be offended by
your conduct. Such an ideal is beyond the reach
of all but the most complaisant, but, though it may
have little effect upon the conduct of men except
to encourage hypocrisy and concealment, it may
influence their point of view and deform their
imaginations.

Now people had certainly grown tired of the
Prince Regent and his circle. The new middle
classes had neither the culture nor the taste of
George IV, but, if he was allowed to put away one

wife after another, who was secure in a commercial
society which apparently only respectability was
holding together ? So his excesses were made the
excuse for a reaction that covered more ground,
and uniformity of pretension became the desire of
the new society. This happened to become incar-
nate in the young princess who ascended the throne
in 1837, and was as much revolted at the conduct
of her uncles as Mr. Dombey would have been in
her place. The middle classes were in power, and
for the first time the throne was occupied by one
who shared their mental outlook. At first sight
the Victorian convention seems inexplicable till we
see it on its moral side to have been a reaction
from the Regency, and on its intellectual side the
flattery of the triumphant middle classes, whose
money required a mask of virtue. This the new
conception of respectability provided. The cen-
tury was rich in figments. The respectable man,
like the economic man, does not exist. He is
the greatest common measure of all men stripped
of their differences ; in other words, of their vitality.
He needed nothing but to appear colourless to the
crowd, and this appearance could be purchased by
the sacrifice, on the surface, of individual taste,
culture and opinion. The opportunity for develop-
ing these was simultaneously lessening in an over-
populated country necessarily immersed in satisfy-
ing the cruder appetites of its inhabitants. These
could with difficulty be fed by the manufacture
and export of goods for which markets had to be
either invented or conquered. The world was

growing uglier, the struggle for subsistence more acute, for the pressure of population led to the manufacture of goods for sale at a distance rather than for satisfaction on the spot, a condition that establishes an ideal of quantity only.

Early in the century the active spirits had begun to rebel. Byron had set to song the cynicism that he had found in his own circle, and had taken a keen delight in breaking the silence that respectable convention had begun to expect from every author. Shelley, a child of aristocracy and culture, bewildered at the strange world in which he found himself, recognized the disease rather than the remedy. He did not really attack anything except the idol of morality,[1] and his conduct has the value of reminding us that action cannot be judged apart from character, and his character is one that becomes more lovable the more we examine it. But Byron and Shelley were isolated men, and, like Keats, died early. Tennyson was to be the representative Victorian poet, in whom the genius that is above the age and the talent that reflects it were curiously mingled. The challenge was not to come till 1850 from the Pre-Raphaelite Brotherhood. This group was more critical of its time, and appealed from it. Its members tried to recapture the mood in which the art of the Middle Ages had been created, but, sceptics themselves, their art was mainly an escape from the present into a world of beautiful regrets.

[1] Shelley thus remembered Bunyan's warning that the Village of Morality is hard by the City of Destruction, to which it points the road in every age.

Their dreams were troubled by the modern mood of disillusion, but had the memory and desire for a beauty that had perished from the world. The pictures were sometimes like dreams painted between sleeping and waking, sometimes attempts to infuse contemporary subjects with the feeling of an earlier age and to impose the elder pictorial pattern upon them. The characteristic figures were shadows in a land where colour alone was real, and haunted by tragic or imperfectly realized memories. Their æsthetic poetry, as it was called, was thus described by one who was to carry on their influence and to develop their attitude into a philosophy that was to dominate the last two decades of the century :

" Here, under this strange complex of conditions, as in some medicated air, exotic flowers of sentiment expand, among a people of remote and unaccustomed beauty, somnambulistic, frail, androgynous, the light almost shining through them."

In such art there might seem to be little disturbing to the new convention of respectability, but the simplicity with which the Pre-Raphaelite painters sought to reawaken life in religious subjects offended those to whom religion, like all else, must be a mask with no pulse beating beneath its smooth exterior. A chronicler of the period later described a typical congregation as one which " would be equally horrified at hearing Christianity doubted or at seeing it practised." The artists of any period, however, are often foci of the sub-conscious desires or instincts of their time, and the hunger felt by the Pre-Raphaelites, who were the inheritors

of the earlier Romantic movement, for a departed
beauty converted the pursuit of beauty into a
religion, all the more easily because the Christian
tradition had inspired so much of the art that they
most admired. A similar, if less conscious, instinct
was dimly driving the populations of the new indus-
trial towns. In them it took frankly a religious
form, and the Tractarian movement owed some of
its popularity to its appeal to men's sense of beauty
in towns where it was now starved except inside an
old church or at the symbolic service of the altar.

Tractarianism, which radiated from Oxford, was
largely a town movement ; in the country it made
its way more slowly because the need for it was less
visible there. In the antithetical prose of Ruskin,
the threads of art and religion were woven into a
double strand, and he rebuked the age for its neglect
of both of them. His prose also reminded all
susceptible to its influence that "prose" might be
rich in imagination, that words had colour as well
as meaning, that they could suggest as well as
speak, and need not be condemned to the hodman's
work of conveying information. The Romantic
movement, save for the personal exception of De
Quincey, had not cared to trespass beyond poetry
or to revive the possibilities of imaginative prose.
Ruskin, despite his influence upon the imagina-
tion of prose writers, is not in point here, for he
wrote either in wedges of blank verse or in the
complementary cadence derived from the Author-
ized Version. The source of his effects con-
ditioned his attitude, which was self-confessedly

rather that of a prophet than of an artist. Foreign critics of our literature agree that energy and character are the English ideals, that our poetry is the issue of feelings denied expression elsewhere, that utility and morality are our preoccupations, and that, except in poetry, which is itself an exception, we do not care for art unless it be applied to some extraneous purpose. The most English of all poems is an elegy written in a country churchyard, a sermon brimming with sentiment, melodic, serious, moralizing, but enunciating very doubtful truths, truths that we should be quick to scrutinize were it not for the intense emotional appeal of the surroundings, which excite the feelings and put the intelligence, only too willingly, to sleep. The Romantic Movement was didactic also ; its freedom was chiefly confined to form and language. It escaped, indeed, from the churchyard to the hill-top, but was didactic on the heights or in the valleys. Wordsworth, Coleridge, Shelley and Byron were didactic, with magnificent interludes. But the tendency, in its later developments, was gradually to define the relation of art to religion, then to separate them, and finally to pursue beauty without ulterior reference till at last the end should become an art of decoration, in prose not least, and of experiment in criticism, in drawing, in conduct, and even in dress.

That it might so break with the national tendency, an influx of foreign influence was necessary. It has always been so in the past before we have been content disinterestedly to satisfy our imaginations.

Chaucer had been almost as much French as English. The Elizabethans had been steeped in humanistic influence from the Continent, especially from Italy. The age of Dryden owed much, though not all, to the return of the exiles from France. The early Romantics had been inspired by French revolutionaries and German metaphysicians. The Pre-Raphaelites returned to the Middle Ages and recovered exotic forms ; and so it was to be with their successors. For it seems to be a law of English literary development that, left to itself, it will create such native art as that of Bunyan or Gray, and will only desert this narrow ground under the stimulus of foreign influences. These it will first employ to criticize established conventions, institutions or morals, until, weary of uses, it will begin to study forms for their own pleasure, and appeal finally to the imagination alone. If this be true, there is a sense in which the term, the pursuit of art for its own sake, has a definite meaning in England, where literature is so often a means to other satisfactions.

In 1850 the reaction was renewed, for if the complacency of the century had raised its monument in the Great Exhibition, the little magazine of the Pre-Raphaelites, prophetically called *The Germ*, was then published, and this was to forebode an entire criticism of the standard of Victorian times. The Victorian age was the age of romantic materialism, nowhere more romantic than in the sphere of avowed morals and nowhere more material than in its imaginative ideals. In the second half

of the century the protest grew stronger, the complacency less assured, and the scientific spirit on the one hand, and imaginative art on the other, were to attack both and finally refuse them sanction. In the sixties Tennyson was the dominating influence in poetry, but the shadow of his diminished splendour was first seen when Swinburne's *Poems and Ballads* broke like a sudden tidal wave upon the apparent security of the islanders. As Mr. Thomas Hardy wrote in the retrospect :

" It was as though a garland of red roses
 Had fallen about the hood of some smug nun
 When irresponsibly dropped as from the sun
In fulfth of numbers freaked with musical closes
 Upon Victoria's formal middle time
 His leaves of rhythm and rhyme."

In the whole of English poetry there is no volume more sacred to Apollo. There is only one *Poems and Ballads*, and we speak of it without its author's name because we recognize the direct inspiration of the god. In its kind it has no rival. It is insuperable in the revel of its rhymes. Apollo, the god of song, and morning, and youth, is glad because of Swinburne, and renews his gladness in the joy with which youth, in every generation, surrenders to the song of the poet when it falls for the first time upon its ears. All other poetry then is eclipsed and swept away by it. All other beauties retire before comparison with it. They seem no more than sickened sunsets to its dawn. It is the poetry of the morning, the morning of

life in youth, when, to health and high spirits, the hardest and longest of tasks in the world will be conquered easily before the end of the day. The galloping stanzas hitch us to the chariot of the horses of the sun. We cannot live long at their tremendous speed, however, and when we have grown less exultant, and begin to yield to the strain of our fatigue, we peevishly transfer our increasing coldness to the metres, until, one day, long afterward, when the sense of spring momentarily returns to a man in his maturity, we discover that we, and not the book, have aged. In this moment of recovered vitality (and what man has not felt it somewhen in his life?) our ears are open again to the lute of Apollo. This experience, coming with the force of a second or repeated revelation, consecrates *Poems and Ballads* for the rest of our lives. We shall never again be eager to discuss it or defend it. We shall never reply to those who question the inspiration of its author, or weigh in their nice balances the respective amounts of diction, truth and music in his work. His songs have passed into our circulation. Our hearts and his music are beating to the same tune, and we would as soon question the rhythm of life in the one as in the other.

The English language had never been set to such a thunder of music before, and the themes which this sonorous verse bore upon its tide were, in one word, those that had been gradually excommunicated from poetry since the humanistic age, and were supposed no longer to engage the life

and thoughts of men. Like Shelley, Swinburne was a scholar, and an even more accomplished artist in verse than he. Swinburne's blood still beat to the pulses of the classic age, and he was the embodiment of the classical spirit, except where he touched contemporary matters—when he was the most romantic of imaginary republicans. To the Hellenic imagination the human body, at its best, was the most admirable object in nature, and human instincts the forces most worthy to be celebrated in art and song. Greece and Rome remain the supreme subjects for our study, because we need the comparison of a civilization and a thought *unlike* our own if we are to see our own in any critical perspective, and these are the only European civilizations, not Christian, the record of which survives virtually in full. Thereby the irreplaceable standard of comparison is provided for us, and no age has needed it more than the Victorian, because no age has remembered it less. Its want of self-criticism, its complacency, is the failing that estranges us most, and if we recoil too little impressed by its achievements, this is because it made its triumphs their own measure of degree no less than kind.

 " Men of genius and character," said Matthew Arnold in a passage that applies to the Victorian convention, " are born and reared in this medium as in any other. From the faults of the mass such men will always be comparatively free, and they will always excite our interest, yet in this medium they seem to have a special difficulty in breaking

through what bounds them, and in developing their totality." How apt a criticism of himself ! He was the critic of his age, but he was constitutionally incapable of indicting it with any but its own weapons, and therefore only the great adjective of his invention, imported from Germany, really made any impression on his time. He christened the epoch ; he reminded us that criticism less insular could be found, and was worth studying, in France, but, except in his poetry, he failed to realize that, if—as was said later—'Philistinism is simply that side of life unillumined by the imagination,' the imagination and not the reason must transform it. It was the music of Ruskin that gained attention for his ideas. It was the mysterious monotony of Pater's prose rhythm that beguiled the ears of his listeners. Matthew Arnold was ignored in this country because he was so lucid and so reasonable. The mind acquiesced : the imagination was untroubled. Only one word, a definition that quickly blossomed into a term of abuse, lodged itself in the city of Philistia. Matthew Arnold is remembered as a prose writer for having thrown a single stone.

The limited province reserved by Victorian art may be studied at its acknowledged best, to emphasize the degree of departure that will occupy us later, by a glance at its admirable draughtsmen. The sixties, wherein *Poems and Ballads* first appeared, are called to-day the golden age of English illustration. The draughtsmen applied the Pre-Raphaelite convention to contemporary subjects,

popular stories in popular magazines, and gave an
atmosphere of romantic beauty to the most correct
and conventional situations. The lovers are wistful
and sentimental figures, in whom passion is sup-
pressed beneath a chimney-pot hat, and ardour
preserved at an inappropriate distance by the escarp-
ment of the crinoline. The words stopped, but
the drawing went on to suggest all that was being
denied to the characters by the authors. No more
beautiful art has been made out of such insignificant
material, or has touched to more idyllic issues
simple and domestic themes. The designs had a
true pictorial quality. The Victorian interior
became beautiful and romantic, but, however charm-
ing they may be made to be, such interiors are only
one of the imagination's many mansions, and
humanity cannot be confined within their doors.
At the moment when these artists were enduing
with beauty everyday conditions that were not
beautiful in themselves, William Morris was trans-
forming things of daily use, and designing papers,
chairs, dresses and hangings, by picking up the
threads of artistic tradition at the point where they
had been lost.

By these means the imagination had begun to
leave the studio and the library, the poem and the
picture, and to step down into the life of the time.
There were stirrings of an æsthetic movement, as
people, with Morris' chintzes at their call, began
to dress like the women in Pre-Raphaelite pictures,
and to adorn their rooms and houses with blue
china, and anything that they could find in the

East or the West that was not machine-made. It
had come to be realized that the characteristic
improvements of the century could provide nothing
but comfort, and were often so hideous in them-
selves that every beautiful thing made at the time
had an air of challenging the entire period surround-
ing it. Beauty became an obsession, and was
gradually identified, therefore, with the fantastic
and the strange. An unnatural self-consciousness
appeared under the stimulus of Ruskin's teaching,
against which Whistler, whose own nerves seemed
to be morbidly excited whenever he left his studio,
was soon to protest. This preoccupation only
needed a prose Bible, devoted exclusively to the
imaginative attitude, in order to define itself. This
was supplied in 1873 by the publication of Walter
Pater's *Renaissance*, where the famous concluding
chapter raised the new attitude to the level of an
epicurean philosophy.

The pursuit of beauty was now disentangled
from religion, and recommended as sufficient in
itself, in sentences which, while never trespassing
on the confines of metre, had a linked rhythm that
made them appeal to the ear, with a vocabulary
very carefully sifted. There came an air of wonder
and surprise at epithets and collocations somewhat
funereal and strange, but full of colour and sug-
gestion. The prose was like a tapestry in rich and
sombre hues, flecked with gilt and purple threads,
and approaching as far as might be to the quality
of music. There had been nothing like it before,
for rhetoric was almost absent. The style was a

true invention, and made English seem a learned tongue. This was one of its most welcomed qualities, for the recondite becomes precious in a time when the printed word is beginning to lose all distinction in newspapers and books that do no more than reflect the illiteracy of the mass of readers. Pater's criticism was the translation into prose of the emotion aroused in himself by the works that he was criticizing. The quality that he set himself " to disengage " was that peculiar to the picture or the poem ; his analysis is often subtle, if elusive. Sometimes it reflects more truly his own response than the virtue of the art that he is considering. The attitude suggested in this prose could not remain where he discreetly left it, mental, visionary, an escape of the emotions from real life. He himself, as Mr. George Moore has pointed out, wore a mask, the pattern outwardly of the convention that his work was undermining ; and it is tantalizing to conjecture what form his life would have taken in a frankly humanistic age. He cherished his mask because he could never feel at home in contemporary surroundings. As it was, he remained a quickening and incalculable influence, which spread indefinitely farther than the circle of his acknowledged disciples.

These were quickly forthcoming and immediately recognized. As early as 1875 the first volume of J. A. Symonds' *History of the Italian Renaissance* was published, a book in which the writer's debt to Ruskin and to Pater was apparent. The very subject of the two authors was the same,

and the temperament of both was more similar
than appeared upon the surface. In this year, too,
Oscar Wilde was at Oxford, and began to invent
a life in which the æsthetic theory should be put
into practice, so that the protest began, from another
angle also, to escape from pictures, books, furniture,
and to colour conduct, beginning extravagantly
with dress. Here the Victorian ideals of duty and
conformity were more openly challenged, and the
legend of Wilde pushing one of Ruskin's wheel-
barrows, no doubt unskilfully, becomes symbolic
of a movement which was to overthrow the Ruskin
canon altogether. Ruskin himself, who had sought
to unite the two ideals of art and religion, had since
1860 begun to leave theories of art for theories of
political economy, which scandalized respectable
people as much as the eccentricities of the æsthetes
were doing. After the revolution in domestic
interiors that William Morris's decorations had
made possible, a craze for eccentric frocks and
flowers became so noticeable that the time was ripe
for the caricature that Gilbert was to achieve in
Patience, an opera that was produced in 1881, the
same year as that in which Oscar Wilde's *Poems*
made their appearance. These poems met with
immediate success, partly because their author was
already notorious, but probably no less because
they were the echo of so many writers who were
more likely to appeal to the general in the transcript
than in the original. Wilde, as his later dramatic
work was to prove, even if his power of concen-
trating the limelight upon himself needed such

emphasis from his writings, had a great command
of effect, and his verse produced the effect of
æsthetic poetry better than the genuine poetry,
which was not theatrical, could do. His lines
were full of coloured phrasing, the phrasing of an
imagination that can produce its finest effects only
in prose, and all that was factitious was enchanting
to the people whose ears lacked the sensitiveness
to discern the counterfeit. For Wilde's verse will
not bear a moment's critical attention. But he
had exactly the quality that, in a different fashion,
was to make the poetry of Stephen Phillips a success
twenty years later. Once admit that Wilde's verses
are not poetry, that the difference is one of kind
and quality, and we are free to accord to them the
merits of a verse that, however factitious and rheto-
rical, gives the illusion of poetry extremely vividly
to those who do not know what poetry is. Their
success was natural, and crystallized the growing
desire for decorative writing, for vivid and coloured
language, and for subjects either recondite or
strange.

In many directions then, to which we shall have
to add the stimulus of foreign, and especially French
influences, the naturalism of Zola, the decoration
of Flaubert and Baudelaire, the stirrings of indi-
vidualism, the inevitable protest of the human
imagination against the colourless uniform of
industrialism, were being felt. The demand was
for the reflection of personality in literature, of the
unique against the mass, the exception against the
general, the ugly truth, if need be, against the conven-

tional euphemism. Gilbert's songs were the bridge
between the two attitudes, and only the merriment
of their metres disguised the (indeed unconscious)
satire of conventional ideas that they suggested.
There had been already some respectable attacks
upon respectable people. Thackeray had sati-
rized the snobbery, Dickens the hypocrisy, and
Matthew Arnold the Philistinism, of respectable
men. Gilbert led a still lighter assault when he
showed that the logical outcome of such conven-
tions often produced Gilbertian situations. But
Gilbert never developed the suggestions that he
threw out in such profusion. The geniality of
his satire cannot altogether disguise the satire
itself, though it enabled his audiences to flatter
themselves grossly on their forbearance and good
humour.

The extreme individualist's attitude to art was
defined in 1885 by Whistler. In the following
year, the *Confessions of a Young Man* mentioned
many unmentionable facts about the natural selfish-
ness and callousness of youth, and ended signifi-
cantly with a colloquy between the young man
and the " exquisitely hypocritical reader." This
book had first been written in French, and is typical
of the foreign influences that were to bring the
latent seed to harvest in the last decade. Zola
had been translated, and Vizitelly had been re-
warded with imprisonment for the public service
that he had performed. The shadow of Ibsen was
also upon the horizon. The Victorian convention
had become a taboo, which was inevitably to lead

to a cult of the unmentionable. After Zola's translator had been rewarded with imprisonment, our favourite diploma for distinction in the arts, the success of realism in this country was assured. It requires an effort of the imagination to recall the charm excited by the words " a realistic novel " on the covers of many forgotten books. The period still lives in the catalogues of the second-hand booksellers, and perhaps the most amusing entry is this : " Piping Hot, a realistic novel by Emile Zola, with a preface by George Moore." That entry carries us back to the eighties ; as, in their degree, do the popular imitations of these in the yellow-backs of later years. Men were wanting a literature that would tell them not what life was supposed to be, but what it was, and a language that should stir their sense of truth. Taboos die of the weariness that they engender and the curiosity that they excite ; and all the desires, moods, instincts and fantasies that had been excommunicated for two generations necessarily occupied the imaginations of writers who knew that the taboo was insular, and desired a freedom for themselves that was accorded to their colleagues in other countries. The imagination had been surfeited with a decorum that was unnatural and a conventionality that was dull. In the last decade of the century the convention was to be reversed. For almost a century of peace had given to English society the apparent stability of a machine, and the routine of life on which it throve had little for the imagination, so that the convention and the period,

working together, began to identify any protest with sin ; and since the imagination was protesting, and beneath the surface human instincts remained unchanged, art and scandal came to be associated, and the imaginative life began to take vice for its province and to praise forbidden fruits. The removal of the mask was to be completed, and this the Beardsley period achieved.

CHAPTER III

French Influences

THE character of the literature and art of the Beardsley period was largely the product of French influence, and this may be conveniently traced to Swinburne, who was the first to show its saturation. Already at Oxford, in 1858, Swinburne had gained the Taylorian prize for French and Italian, and French no less than Hellenic influence was apparent in *Poems and Ballads* which took the world by storm in 1866. The central figures in the French literature of the period that were to capture the imagination of English writers were Gautier, Baudelaire, Flaubert and Zola, and the book to which *Poems and Ballads* bore an apparent kinship was *Les Fleurs du Mal*, that had been first published in 1857. It is interesting to remember that the poems in this volume to which most objection had been taken were reprinted as *Les Épaves* in the same year as that in which Swinburne's volume had appeared. The influence of French literature on Swinburne is confessed not only in the ode written in honour of Baudelaire, but in other poems, three of which Mr. George

61

Moore has specially indicated. "*The Hymn to Proserpine*," he says, "and *Dolores* are wonderful lyrical versions of Mdlle. de Maupin. In form *The Leper* is old English, the colouring is Baudelaire"; and does not *Before a Crucifix* call to mind the verses of La Charogne? In this poem Swinburne was fascinated by the gibbet, and he recoiled from a symbol that would have seemed to the pagan age with which he was in sympathy ignoble in itself and in its associations. Poems of this kind were, among other things, a protest against the current critical prejudice that pleasure could be taken only in the representation of subjects that were pleasant in themselves. As late as in the seventies Mr. George Saintsbury found it necessary to formulate the principle that "if any subject can be poetically treated, that subject becomes poetical," a formula which he evolved in the hope of deciding a perennial controversy. The need for a reminder of the kind was found equally necessary in France, and the attitude of Baudelaire to the art of poetry should be stated in his own words, because his point of view was adopted by his English admirers and became the formula of the whole *Yellow Book* school:

"La poésie, pour peu qu'on veuille descendre en soi-même, interroger son âme, rappeler ses souvenirs d'enthousiasme, n'a pas d'autre but qu'elle-même; elle ne peut pas en avoir d'autre et aucun poème ne sera si grand, si noble, si véritablement digne du nom de poème, que celui qui aura été écrit uniquement pour le plaisir d'écrire un poème."

This doctrine, which Baudelaire found also in Poe, was the one to which the English writers appealed when they were attacked, and the subjects that they chose were selected partly because, in the words of Gautier, " donner au goût une sensation inconnue est le plus grand bonheur qui puisse arriver à un écrivain et surtout à un poète," and partly because of a sense of disparity between the nature of man and his aspirations. The aspirations had had full play at the beginning of the Romantic movement. They had become indeed an established convention, and the instincts that formed the source of man's higher energies were to be similarly celebrated at its close.

It has always been the mark of great literature to satisfy *both* extremes of man's desires ; and when the art of a period reaches one of its recurrent phases of over-sophistication, when it busies itself too much with the soul and too little with the instincts, then the instincts reassert themselves to supply a wholesome corrective. So far, at any rate, as the choice of subject is concerned, this observation does much to explain the reactions that seem to make the history of literature little more than the record of fluctuations of taste. Only perhaps in classical times were the higher and the lower impulses of man reflected with equal and simultaneous ardour. It is this, one fancies, that contributes much to the spell that Greek and Latin literature exercise over us. We feel there, as nowhere else with the same completeness, that the whole of man's nature is presented impartially to

our gaze, and the presence of the two contrasting extremes gives a balance that satisfies, as neither alone can do, our appetite for truth. Something of the same catholicity attaches to the literature of the Renaissance and the humanistic period, in which, however, the religious impulse was weak ; but, with this exception, Shakespeare was classic in that the whole of man, and not merely the higher or the lower part of him, possessed Shakespeare's imagination. It was natural, therefore, apart from the changes that moulded the succeeding age, that the next great poet should take a religious subject for his epic, and that the extravagant prohibitions of the Puritans should be succeeded by the Restoration comedy. Since then the law of fluctuation has dictated the changes of taste, while each successive reaction has seemed a progressive step to its supporters. After Wycherley no comedies could be more innocent than those of Goldsmith, but decorum, like other good things, can be overdone if it is purchased at the price of falsity or suppression, and the Beardsley period brought the ideal element in letters to a proper pause by reminding us of the other instincts that it was neglecting. It was once again to France that the English imagination turned for inspiration, for the Mediterranean remains the cradle of humanism, and the Latin south has never been in danger of forgetting those instincts that the more Puritan north has tried so often either to repress or to ignore. The bias shown during the nineties was the correction of an excess, and in that sense deserves no less

respect than previous reactions, but the great age is one that ignores neither extreme of man's desires, and it is to the honour of Mr. George Moore, the novelist (at one time) most in sympathy with *The Yellow Book* school, that he is equally in sympathy with both of them. The tendency, of course, was to a partiality as extreme as that which it replaced, but the attitude of Baudelaire is not easily mistaken once the immediate novelty of his point of view has passed away.

A characteristic section of his poems in *Les Fleurs du Mal* is inscribed " Spleen et Idéal," and the emotion of disgust conveyed by some of the verses represents the recoil of the soul from the facts or conditions that obsess it. An English poet has lamented

> " The heartless and intolerable
> Indignity of earth to earth."

Did Baudelaire really do other in the putrescent lines of La Charogne ? To convey such emotions poetically implies in the artist a superiority over his material ; and the keen imagination which can penetrate into the recesses of beauty may be accompanied by a power of realizing ugliness or evil that is appalling to less imaginative minds. No Frenchman, for example, has surpassed in malignancy of horror the two curses that Shelley composed in his dramas, yet no poet of either nation was superior to Shelley in delicacy of feeling. The most remarkable example in English literature of evil and horror is to be found in *The Cenci*. A

F

similar faculty was possessed by Baudelaire, only
he confined himself to other manifestations of it.
Of this preoccupation Gautier says :

" S'il a souvent traité des sujets hideux, répug-
nants et maladifs, c'est par cette sorte d'horreur
et de fascination qui fait descendre l'oiseau mag-
nétisé vers la gueule impure du serpent ; mais
plus d'une fois, d'un vigoreux coup d'aile, il rompt
le charme et remonte vers les régions les plus
bleues de la spiritualité."

Such writers become satirists in spite of them-
selves, and their effect is the more powerful because
they do not pass beyond description but allow our
" astonished heart " to make the inevitable recoil
that their almost impersonal art produces. Horror
is never so powerful as when we are half fascinated
by some disgust, but to achieve such an effect in
art seems, at first sight, to pursue the horrible as
if it were a pleasure. The test of great satire lies
here. The language of great satire is impersonal
to the point of seeming to identify its sympathy
with its object, and the classic instance of this in
English literature is condensed in the title chosen
by Swift for the most terrible example of the kind
to be found in his quiver. He called it *A Modest
Proposal*, and it would almost be possible for an
unsophisticated person to read the essay through
without realizing that anything very dreadful were
being suggested. The entire force of great satire
resides in this apparent identification. Unless this
be carefully remembered, the attribution of satire
to the work of artists and writers who occupy them-

selves with dreadful or unmentionable things will
always seem an evasion of their quality, a weak
attempt to explain away that which cannot be
admitted openly. Such a course has often darkened
counsel ; we have to see that satire is great in
proportion as the author's detachment is unob-
trusive. Such a thought must have been at the
back of Baudelaire's mind when he wrote :

"Je dis que, si le poète a poursuivi un but
moral, il a diminué sa force poétique, et il n'est
pas imprudent de parier que son œuvre sera mau-
vaise. La poésie ne peut pas, sous peine de mort ou
de déchéance, s'assimiler à la science ou à la morale.
Elle n'a pas la Vérité pour objet, elle n'a qu'Elle-
même. Les modes de démonstration des vérités
sont autres et sont ailleurs. La Vérité n'a que
faire avec les chansons ; tout ce qui fait le charme,
la grâce, l'irrésistible d'une chanson enlèverait à
la Vérité son autorité et son pouvoir."

The function of art in arousing the imagination
is never so powerful as when it is indirect, but its
effect and its immediate method have often been
confused, and this confusion has given occasion
for many controversies. It remains true that the
imagination of an artist will not be used amiss
whatever subject it may be employed to create or
to illumine. Its province is the entire world of
the flesh and of the soul, and its primary duty is
one of revelation simply. The things that are
revealed will depend partly on the temperament
of the author and partly on the circumstances of
his time, for the latter will continually drive him,

in the search for new subjects, to the region that
has recently been least explored. There is, of
course, no such thing as the human imagination
exercising itself in the void, and the imagination
of each artist will reveal not only the instincts
common to humanity but also that differentiation
of them which is peculiar to himself. The whole
can be displayed only through the mind of an
individual, and in so far as this may be eccentric
or peculiar it will necessarily emerge into his work.
This is the only condition under which the imagi-
nation is bound, and to quarrel with the idiosyn-
crasy that it includes is to quarrel with human
nature. The fluctuations of taste in the matter of
art, then, the oscillations of the imagination itself,
are no more than the search for that sanity which
will ignore no mood of the senses or the mind,
but present us with an image of life as complete
as possible. The forms of art undergo similar
changes, because no form can be found in which
every resource of language can be exhausted. The
Elizabethans seemed barbaric to the age of Pope,
and the classic polish of the couplet a sterile per-
fection to the Romantic movement. Baudelaire
was as curious in his manipulation of language as
in his choice of subject, and this double curiosity
especially appealed to English writers who had
grown weary of a too explicit, too prosaic, style.

We find indications of this weariness in unsus-
pected places. Writing in 1875, Mr. George
Saintsbury said : " It is not merely admiration of
Baudelaire which is to be persuaded to English

readers, but also imitation of him which is with at
least equal earnestness to be urged upon English
writers. We have had in England authors in
every kind not to be surpassed in genius, but we
have always lacked more or less the class of écrivains
artistes—writers who have recognized the fact that
writing is an art, and who have applied themselves
with the patient energy of sculptors, painters, and
musicians to the discovery of its secrets. In this
literary salt of the earth our soil has not been
plentiful. . . . If in the matter of prose style
' nous avons perdu le chemin de Paros,' it must
be rediscovered," and to that end, he concludes, " I
know no author more suitable for study than
Baudelaire."

This advice was heeded, but while the new
school of writers looked primarily to Baudelaire
for the new range of themes, it was in Flaubert
that they found the gospel of style and that absorp-
tion in the form of prose that has been found
in English too rarely, in narrative especially. A
difference in the temper of the two nations probably
explains this. The temptation of our writers is
rarely, if ever, towards pedantry ; and such experi-
ments as have been made in English prose, those
of Lyly and Carlyle and Meredith say, seem wilful
and wayward, as if designed to preclude the possi-
bility of a classic tradition. A model could be
found in Froude, but his virtue has prevented him
from becoming influential. We are by preference
a nation of anarchists, content to temper the con-
sequential disorder with much patience and easy

goodwill. The natural quality of French prose is unmistakable. Its workmanlike precision and exactitude of phrase are extraordinarily refreshing, and it cannot be put to the simplest uses without betraying delight in itself. The same character distinguishes French narrative. *Manon Lescaut*, *La Dame aux Camélias*, seem to be pure stories, stories told for nothing but themselves, and to realize Mr. Moore's ideal that a narrative should be a rhythmical sequence of events in a rhythmical sequence of words. But in Flaubert this quality became almost too deliberate, and with his search for the unique word and the perfect form there occurs a loss of spontaneity which makes the machinery, of the *Trois Contes* even, creak a little. There can be no doubt, however, that his influence has been beneficial in England, where our weakness lies at the opposite extreme ; and his example was the more attractive here because he also chose recondite subjects, and these, too, were to form part of the attraction of the Beardsley school. In *Hérodias*, in *La Tentation de Saint-Antoine*, in *Salammbo* another exotic field was explored, one which gave the richest possibility for extremes alike of colour and of conduct. The saint and the sinner, the mystic and the sensualist, were appropriate characters, and there was an added savour for a respectable age in the observation that the saint was much more obsessed by sin than was the sinner. Think of Anatole France's *Thais*, later on !

It was impossible that the human imagination could be content to play for ever in the rectory

gardens of Bernardin Saint-Pierre or Goldsmith, in whom the Victorian spirit seems to have been foreshadowed. Life was more complicated than that, and the first to recognize the modern complication, and to explore the possibilities of the passions and the situations of the modern city, had been Balzac, who delighted in its extremes of opulence and misery. In his novels the modern capital was captured for literature. For his characters money has the same importance that it possesses in metropolitan life, where a struggle for the prizes that are flaunted in the streets, but beyond the reach of all but a handful of the population, has given an imaginative excitement to the pursuit of luxury, which was almost the only active excitement left in the ugly but apparently stable social order that reached its climax at the Diamond Jubilee. The question how people were really living beneath the mask of routine and respectability became the curiosity that modern society imposed upon imaginative minds. The attempt to answer it was the real motive of the naturalistic novel. Flaubert's essay in this direction was as curious in its search for revealing detail as his search for archæology had been in *Salammbo*. He wanted to penetrate beneath the surface to the wills of the individuals of his time. It was apparent to all who paused to reflect that the instincts of men had not become as orderly as the society in which they lived, and that though the major part of their lives, of their days even, was a routine of repeated action, there lay behind the old passions,

weaknesses, desires. If the lives of the respectable
wage-earners were, in the vivid phrase of Mr.
Wells, a continuous crawl along a drain-pipe, there
were secret satisfactions and aspirations very differ-
ent from those that were publicly admitted or
professed. Most of the mentionable details were
either familiar or dreary. The search for the
unmentionable therefore became the imaginative
impulse of the day. A sanction was found for
this search in the rise of the scientific spirit and
the accompanying appetite for facts. The news-
papers seized busily upon the grosser scandals,
by way of imaginative relief, and the police court
and the divorce court became the staple romantic
reading of the multitude. To redeem this to
artistic uses an artistic theory was desirable, and
theory and practice both arrived with the natural-
istic novel.

Émile Zola, who reached maturity in the sixties,
at the very period when Flaubert was writing
Madame Bovary (1857) and *Salammbo* (1862),
found in Flaubert a master of the romance of
modern life. *Madame Bovary* contained a scru-
pulous portrait of a contemporary woman, an
almost scientific study of the details of a French
provincial town. The contrast between this living
detail and the laborious resuscitation of ancient
Carthage must have confirmed Zola's journalistic
belief in the superiority of contemporary material
for art. He proclaimed that the novel should
devote itself to the analysis of the living age as
the richest and most difficult subject, that a romance

should find its chief attraction in fathoming the chaotic medley of modern society, a medley none the less felt despite the irresistible working of the machine. He therefore conceived a kind of epic narrative that should pursue all the ramifications of a single family. Modern science, particularly in the discoveries connected with the hypothesis of evolution, had presented the human mind with one motive especially that could not fail to waylay his imagination and to excite the story-teller's interest. This was the theory of heredity, which related individuals to families, which saw each member as no more than a variation on a common stock, and provided at least partial explanations of tendencies hitherto regarded as unaccountable, or simply wicked, or obscure. It proved that the children often suffered in unsuspected ways for the sins of the parents, that foreign blood did not exhaust itself in a single generation, that the effects of disease might be transmitted in alternate generations, that extraordinary effects were produced by the mixture of different nationalities, that the tables of consanguinity had a physical basis, and that throw-backs or reversion to type were common in all families. Here was a conception, the minor aspects of which anyone could verify for himself in the circle of his relations. It suggested unlimited possibilities for the novelist. Zola resolved to plunge into his immediate surroundings as excitedly as the romantics who preceded him had resolved to escape, and his novels often resembled complete special numbers

of a newspaper given up to the history, develop-
ment and reactions, in illimitable detail, of some
family or industry or 'problem' of the day. His
imagination found satisfaction partly in the vigour
of his descriptions, and partly in bringing to light
the scientific truth, the underlying substance, of
each. He could describe crowds as no one else
could describe them. He has written three volumes
on separate cities ; he has isolated the subjects of
population, of religion, of industry, of drink ; and
all became interesting from the energy with which
an enormous mass of detail and of information
about our classes, our professions, was digested,
so that at the end, though we have learnt more
than we can ever use or even remember, we feel
that we have gained a deeper insight into the vast
spectacle of existence, and that all its complexities
can yet be reduced to the comprehension of a single
brain.

The reporter's method of Zola was certainly an
exhilaration, on its appearance. The age which
had seemed ugly and hostile to the imagination
became comprehensible and interesting ; and such
was his descriptive power, and so vivid was his
use of detail, that the bare record of fact alone,
which was giving rise to the new study of statistics,
seemed more than enough to satisfy curiosity.
There was a salt too in the thought that science,
which had been regarded as the peculiar glory of
the age, the source of its wealth and its comfort,
at once its foundation and security, was now search-
ing with its tried methods the age itself. It was

prying into concealed corners, dragging the souls of its own generation into light, and revealing by statistics in the mass, and psychology in the individual, the nature, extent, and ramifications of inconvenient phenomena. The servant had begun to criticize his master, and the spirit of research, to which nothing external had been denied, was now asserting its freedom to analyse the home, the family, the cherished secrets of human beings.

But what, after all, are such influences as these until we see them transplanted to England and embodied in the literature that they inspired, insisting on the difference of their origin from that of the work of the contented islanders? If they are early apparent in Swinburne's youthful poetry, and so made his *Poems and Ballads* the precursor of much that was to be typical of the Beardsley period, they produced in the *Confessions of a Young Man* their first deliberate and self-conscious work in English prose. The first English edition of this curious and typical volume, characteristically written first in French by an English author who had lived longer than any of his contemporaries in Paris, was published in 1886. Two years later Whistler delivered his *Ten o'Clock* lecture, and its delicate, self-conscious style, intended as much to exasperate as to awaken its audience, helped with the *Confessions* to define the new attitude. Whistler's wounding and deliberate manner was to become an inspiration to the succeeding decade. The two volumes present the oddest contrast and affinity. Mr. George Moore was raw, brutal but

sincere, with the greenness of an unripe apple,
destined, as it has happily proved, to become
mellow, ripe, human and spiritual in its author's
autumn season, in which he has attained the pleni-
tude of his powers. Whistler's lecture was deli-
cate, full of pin-pricks, with the sting of a wasp
in every paragraph ; yet in its more mellow pas-
sages—such as the concluding lines—it employed
the cadence and antithesis of Ruskin, its unwitting
model, whose teaching it set out successfully to
overthrow. Of the arguments employed Mr. Moore
proved to be the best critic,[1] for his evident delight
at the style did not blind him to the apology for
Whistler's own aims and circumstances that the
arguments disguised. The style of this lecture,
which I confess to find over-nice and dandified in
its avoidance of the commonplace, in its inversions
and general prettiness, sought more than prose
expects to accomplish, without the spontaneous
creation and glow that this search sometimes
achieves. But it had the colour, spaces and bril-
liance of one of its author's etchings. In Whist-
ler's book even typography becomes a decoration.
The prose lines wander and waver across the
printed page like the lines of a composition, and
the words on the cover and title-page are so spaced
as to make them, apart from their meaning, a
decoration. The lecture and the correspondence
that fill the volume are similarly disposed, and in
place of decorative designs there are annotations
and waspish comments. " Reflections " grow like

[1] Cf. The essay on Whistler in *Modern Painting*.

thistles upon the ample margins, or buzz with
annoyance as we read them as if a swarm of wasps
had been disturbed. Few books, relying entirely
upon the resources of ordinary type and italic,
appeal so much to the eye as the *Gentle Art of
Making Enemies*, and no book in the disposition of
its print is more characteristic, more like a black
and white etching, of its author's self. It deserves
to be regarded as the earliest of the decorated books
that were characteristic of the period, and appro-
priately enough it was published in the first year
of the decade in its ochreous yellow cover.

Whistler too had spent much time in Paris, and
was in sympathy and upbringing, as the period
proved to be, cosmopolitan rather than national.
Paris came to be regarded as the metropolis of art
and letters, though those who contrasted its recep-
tion of art with the hostility of which they had to
complain in London, forgot that Paris too had
persecuted Baudelaire, Flaubert and the Goncourts.
It represented however the city of movements and
experiments, and its reputation for gaiety and
freedom seemed to indicate a population, the imag-
inative workings of which were not limited to pic-
tures, books and ideas. The contrast between
Paris and London in its literary aspects has been
described in the *Confessions*, and the page must be
quoted to present, in the life of one who would
have been the loveliest prose writer of the period,
had he not transcended it, the influences at which
we have glanced above. " Turn your platitudes
prettily," Mr. Moore wrote with a glance at English

letters in the person of Stevenson, " but write no word that could offend the chaste mind of the young girl who has spent her morning reading the Colin Campbell divorce case ; so says the age we live in."

The threads out of which these and kindred reflections are woven are the flesh, decoration, theory, workmanship, the joy of natural things, the worship of the visible world, and the " incurable belief that the beauty of material things is sufficient for all the needs of life." It is a frank appeal to humanism. " One thing," Mr. Moore goes on, " cannot be denied to the realists : a constant and intense desire to write well, to write artistically. When I think of what they have done in the matter of the use of words, of the myriad verbal effects they have discovered, of the thousand forms of composition they have created, how they have remodelled and refashioned the language in their untiring striving for intensity of expression for the very ozmazome of art, I am lost in ultimate wonder and admiration. What Hugo did for French verse, Flaubert, Goncourt, Zola, Huysmans have done for French prose. No more literary school than the Realists has ever existed, and I do not except even the Elizabethans. And for this reason our failures are more interesting than the successes of our opponents ; for when we fall into the sterile and distorted, it is through our noble and incurable hatred of all that is commonplace, of all that is popular."

The reason which he goes on to give for the

change is that the motives desired and pursued by the Victorians had become exhausted, and consequently with the motives the convention also : "The healthy school is played out in England ; all that could be said has been said ; the successors of Dickens, Thackeray and George Eliot have no ideal, and consequently no language. . . . The reason of this heaviness of thought is that the avenues are closed, no new subject matter is introduced, the language of English fiction has therefore run stagnant. But if the Realists should catch favour in England, the English tongue may be saved from dissolution, for with the new subjects they would introduce new forms of language would arise." Has this proved prophetic of *Ulysses* ?

This is the artistic criticism of the Beardsley period upon the epoch that it was destined to close, and it has the historic importance of the formal indictment that the decade was to launch against its predecessors. When we remember that the volume in which this passage appeared not only abounds in references to French authors of the time, but contains translations, the first in English, of two of Mallarmé's poems in prose, the importation of French influences may be dated from this book. In Mr. Moore's *Confessions* of 1886, the first book of the Beardsley period was written.

CHAPTER IV

The Last Decade

SUCH ferments as these were beginning to fructify the minds and to colour the imaginations of certain writers who reaped their reputations in the last decade of the century. To see them as they first appeared we must recall as vividly as we may the immense background against the apparent serenity of which this small cloud was barely discernible. The minds of the majority are little concerned with poetic and artistic achievements, and we need to see the period in which the nineties found so much provocation through the normal eye. Let us take, then, a description of the eighties as they present themselves to an observer concerned with an aspect remote from ours. By fixing at once upon its delusive appearance of finality, the writer does much to explain the impulse to reaction that the period aroused in imaginative minds :

" Upon its surface and in its general structure that British world of the eighties had a delusive air of final establishment. Queen Victoria had been reigning for close upon half a century and seemed likely to reign for ever. The economic system of

unrestricted private enterprise with privately owned capital had yielded a great harvest of material prosperity, and few people suspected how rapidly it was exhausting the soil of willing service in which it grew. Production increased every year ; population increased every year ; there was a steady progress of invention and discovery, comfort and convenience. Wars went on, a marginal stimulation of the empire, but since the collapse of Napoleon I no war had happened to frighten England for its existence as a country ; no threat of warfare that could touch English life or English soil troubled men's imagination. Ruskin and Carlyle had criticized English ideals and the righteousness of English commerce and industrialism, but they were regarded generally as eccentric and unaccountable men ; there was already a conflict of science and theology, but it affected the national life very little outside the world of the intellectuals ; a certain amount of trade competition from the United States and from other European countries was developing, but at most it ruffled the surface of the national self-confidence. There was a socialist movement, but it was only a passionless criticism of trade and manufacturers, a criticism poised between æsthetic fastidiousness and benevolence. People played with that Victorian socialism as they would have played with a very young tiger-cub. The labour movement was a gentle insistence upon rather higher wages and rather shorter hours ; it had still to discover Socialism. In a world of certainties the rate of interest fell by minute but perceptible

G

degrees, and as a consequence money for invest-
ment went abroad until all the world was under
tribute to Britain. History seemed to be over,
entirely superseded by the daily paper ; tragedy
and catastrophe were largely eliminated from human
life. One read of famines in India and civil chaos
in China, but one felt that these were diminishing
distresses ; the missionaries were at work there
and railways spreading.

" It was indeed a mild and massive Sphinx of
British life . . . but beneath its tranquil-looking
surfaces many ferments were actively at work, and
its serene and empty visage masked extensive pro-
cesses of decay. The fifty-year-old faith on which
the social and political fabric rested—for all social
and political fabrics must in the last resort rest
upon faith—was being corroded and dissolved and
removed. Britain in the mid-Victorian time stood
strong and sturdy in the world because a great
number of its people, its officials, employers, pro-
fessional men and workers honestly believed in the
rightness of its claims and professions, believed in
its state theology, in the justness of its economic
relationships, in the romantic dignity of its mon-
archy, and in the real beneficence and righteousness
of its relations to foreigners and the subject-races
of the Empire. They did what they understood
to be their duty in the light of that belief, simply,
directly, and with self-respect and mutual confi-
dence. If some of its institutions fell short of per-
fection, few people doubted that they led towards
it. But from the middle of the century onward

this assurance of the prosperous British in their world was being subjected to a more and more destructive criticism, spreading slowly from intellectual circles into the general consciousness." [1]

This description by Mr. Wells is balanced and comprehensive. It transplants all but the youngest of us into the atmosphere of our early years, an atmosphere mysteriously lacking in a certain salt, the dimly felt absence of self-criticism. Complacency at the time was so innate that, to children, the gravity and decorum were almost like the gravity of a successfully suppressed smile. Even their elders sometimes wondered privately what their utmost efforts at solemnity on ceremonial occasions, the visit of Royalty to St. Paul's, the Lord Mayor seated in his coach, mysteriously lacked. The Dead March in *Saul* was played by the Guards on appropriate occasions, but at funerals of peculiar solemnity, on occasions of national grief, it was played by the " massed bands " in an attempt to arouse in the heart the feelings to be inferred from the habitual expression worn in public by Mr. Gladstone. People talked about the massed bands in a sacred whisper, and one felt, in sympathy with their unrecognized need, that the words consoled them for an inner vacancy and want that the massed bands had been invoked to supply. If, after all that man could do to solemnize an august occasion, the imagination refused to respond, then the inscrutable purpose of Providence in denying the

[1] *The Story of a Great Schoolmaster,* by H. G. Wells. (Chatto & Windus.)

emotional satisfaction must be confided obediently to him.

The seed of disillusion, the worm in the blossom of the Victorian rose, was already there. It had shuddered with the moment of its silent quickening, but *The Germ* passed almost unperceived, and permanence seemed assured when the time came for the Jubilee celebration to be repeated. Thus, when the year 1897 announced the Diamond Jubilee, men immediately began to ask themselves what title would be chosen for the occasion ten years ahead when the seventieth year of Queen Victoria's reign would undoubtedly be solemnized. The year 1897 marked the apex of Victorian prosperity, a date which, in the uncertainties and dangers of the succeeding twenty years, we already begin to fancy will come to be regarded as the beginning of the visible decline of those institutions, beliefs and hopes on which the Victorian spirit was founded. Respectability and morality were outwardly triumphant then ; the Philistines ruled in all departments of life ; Mrs. Dombey had been crowned Empress of India. Their triumph indeed was so complete as to be devastating ; even to its admirers the foe was too invisible, the field too clear. The Diamond Jubilee celebrations had a vague suggestion of make-believe, for what were we celebrating if not Victoria's victory over Time ?

Contact with reality was suddenly re-established by a young poet who touched the unsatisfied heart of the nation as nothing else touched it, by publishing on the morrow of the festivity, of all strange

poems on the occasion, a hymn of warning. The
most sincere emotion aroused by the celebration
was the instant response given to the *Recessional*
by Rudyard Kipling. Its publication marks the
ebbing moment of the Victorian tide, the sudden
doubt in the heart of respectability, as none of the
gathering criticisms to which the century had
listened could do. Carlyle and Ruskin had uttered
innumerable warnings, but they had been regarded
both eccentric and perverse. Matthew Arnold,
respectable by tradition and temperament, had
seemed no more than the voice of university culture
turning upon a material society on which, after all,
the university and everything else reposed. But
Mr. Kipling, though he belonged by birth to the
new generation, to the younger writers of which
the Beardsley period was composed, was a plu-
perfect Victorian in temper, and utterly distinct
from their circle of sympathies. Tennyson and,
occasionally, Browning had flattered Victorianism,
and were the laureates of contemporary England,
but neither had flattered the Queen, the empire,
the army, the race, as Mr. Kipling had already
flattered it. His complacency was almost embar-
rassing, and his intoxication had proved the more
infectious because he was neither London bred
nor London born. He was an Anglo-Indian, one
who had returned from the confines of the empire
to remind us, from his own experience, of the
benefits of British rule, of the trust which Providence
had confided to us, of the white man's burden of
riches, responsibility and power. He was the

darling of our prosperity, the devoted grandchild, as it were, of the century's achievements, with no hint of doubt or question concerning the destiny of an imperial race, or that its civilization was the culminating product of history. When Tennyson died, Mr. Kipling was a popular candidate for the laureateship. Perhaps it was only his want of the scholarly restraint that Tennyson had carried to its highest point in the tradition of that office, which hindered his appointment to it. Mr. Kipling was a little young, after all, to be officially rewarded for praising that which was above popular praise. He was, in his very eagerness to serve, too presumptuous to be safe. To pass him over would dignify authority more than his appointment would be certain of dignifying him.

On the other hand, if a superfluous but grateful ode were to be written to express the sentiments of her subjects on this august occasion, if the heart of her people would not be denied a spontaneous gesture of gratitude to the throne, Mr. Kipling could be trusted to find the appropriate key for the reverent eloquence that the event demanded. It was with a momentary shock, then, that on the morrow of the pageant, his *Recessional* was read throughout the English-speaking world. How oddly it contrasted with Tennyson's lines evoked by the Jubilee of 1887 :

> " Fifty years of ever-broadening Commerce !
> Fifty years of ever-brightening Science !
> Fifty years of ever-widening Empire."

A moment's reflection, however, showed that, for all their solemnity, the Diamond Jubilee celebrations *had* somehow missed the sobriety of a day of devout thanksgiving ; and the nation needed only a second thought to discover, now that it had been reminded, that the genius of the young poet had properly dwelt upon the one solemn chord that had been a little blurred in the universal orchestra. There *had* been, perhaps, " foolish words " uttered, even a " frantic boast " or two in the excitement of the occasion ; but now that we had enjoyed to the full all the splendour, and the congratulations of surrounding or tributary peoples, now that all had been completed without hitch or flaw, it was well to remember that gravity and even heart-searchings were not unbecoming, on the day after the feast. The bishops especially were delighted. All that they had sought to insinuate between the pauses of their sermons, without undue intrusion of a perhaps unpopular note, had been explicitly stated for them in this almost sacred poem. It evoked a response that demanded a true English welcome. The poem became a hymn acceptable to the Church, and its author was canonized by admission to the appendix of the Book of Common Prayer. It was felt that the mood expressed by the Diamond Jubilee should somehow be assimilated to that. By a providential arrangement the Jubilee had produced its own great hymn, and English poetry, which (with the tragic exceptions of Swinburne and Rossetti, the latter of whom was not really of English blood), had been making in

this direction with increasing seriousness, had now definitely surrendered Parnassus to Westminster Abbey wherein the Poets' Corner had been, as it were, the pew reserved by the nation for the Muse for two centuries and more. But if the poet, after his death, had his reserved place in the cathedral of the nation, should not poetry dedicate her living word to the pages of the hymn-book too ? It was a singular favour indeed that the opportunity should have been granted on the most glorious date in the national history. Queen Victoria's triumph was unparalleled, for she ruled not only the waves but the Muses, and east and west had met at her footstool. Queen Elizabeth, and doubtless other sovereigns, had inspired allegory and flattery, but she inspired solemn objurgation and religious hymns, not in honour of herself, of course, but in honour of the duty and responsibility of which she was the symbol and trustee. These had traditional forms for the awe that they must excite, but that the people's own heart should find spontaneous and dignified expression for them was immensely gratifying.

The hymn itself is perhaps the single example of its author's genius in which all can concur without reserve. Too often his manner or his matter has been repugnant to the critical reader ; and a blatant vulgarity, superbly rendered, has seemed to explain the popular applause. But in the *Recessional* both the manner and matter were fit, and fitly used. There had always been something wonderful in his control of the English language,

a language the varied resources of which in word and rhythm had been at his command from the first. He used the whole of our tongue, or at least an extent compared with which the vocabulary of many famous authors was but fractional.[1] His style, a curious blend of journalistic flourishes with Jacobean prose, was rich and varied, coloured and tense, with a strong vibrant movement sometimes in startling contrast to the service to which it was set. The author and the descriptive reporter were strangely mingled, as if Swinburne had taken to writing leading articles, or the newspapers to render their police news in ballads of great technical accomplishment. But the *Recessional* had none of these incongruities : it was simple, direct, sincere, lofty and eloquent, with more passion indeed than is customary in our hymns, but not too much to render incongruous an *obbligato* on the organ.

It is proper to insist upon his achievement here because he was the antithesis of the contemporary *Yellow Book* school ; this and his subsequent indictment of the playing fields of England, with the famous phrase about the flannelled fools and muddied oafs, suggest that the Victorian ethos was begetting its own critics from within, even if those most critically detached and sympathetic to foreign influences had not been combining for its overthrow. From this point of view Samuel Butler becomes a portent. Have the children of any age so recoiled from their parents as those of the Victorian have done ? Nature allows such ample

[1] Cf. Mr. Moore's analysis in *Avowals*,

margins of affection for parental error that the revolt of children becomes a serious indictment indeed. Beardsley died in 1898, about the year in which Mr. Kipling's famous phrase was uttered, and the force of the decade, on the artistic side that we are observing, was spent in the first five years. But the Diamond Jubilee was no more than the public confession of a mood that had prevailed for more than a generation, and it is proper to pursue Victorianism to its apex before considering in more detail the artistic influences that were sapping its foundations. With the turn of the century, the adjective Victorian has passed so rapidly from its exalted to its opprobious significance, and again towards a more balanced use, that it is well to ask ourselves why, whatever attitude we adopt, it continues to excite our curiosity.

The future is too ill-defined to concentrate the attention of any but peculiarly constituted minds. Mr. Wells seems to be the only man alive who can think and live ten or twenty years ahead without mental discomfort and haziness. It might almost be said that he is only comfortable in the decade that has not dawned, and the proof of this is his strange power to render the future not only plausible but palpable and living. To-morrow is at least as vivid as to-day in all his best work ; it is as if he possessed a sense additional to those of the rest of humanity, and his talent is to give a new excitement to thinking. But unhappily for us, and still more for himself, this extraordinary gift is the exception. The past, on the other hand, however imperfectly,

is defined for us. We resent indeed revelation or criticism that reminds us that a favourite period was not static and single-minded, but itself a ripple on the stream of change in the uninterrupted transit from more to less remote periods of history. In the present we are too busy living to be conscious of all that is slipping beneath our feet or emerging into recognition. An occasional lifting of the veil, a sudden evidence of change, startles us for the moment ; we wonder, and quickly accept its accomplishment without pausing to consider all of which it is the symptom or the extensive reactions that it must create in the familiar society that we know. It is not on the future, the past or the present that the imagination most curiously plays. The field that allures it most is that of the penultimate years, the latest period beginning to be recognized as history. For the awakening to a phase that is over, the end of a chapter, the turning of a familiar page, is no less exciting than the sense of a new beginning. Rather it is more, for the materials for reflection are present, the evidence is collected, and there is therefore more promise of understanding than is offered by anything appealing to the appetite for novel curiosity. Moreover, when the penultimate years happen to coincide with the end of an epoch in which we were born, we recover as by magic the usually absent sense of historical perspective ; we gain, as it were, a glimpse at ourselves from the critical eyes of history ; we become suddenly aware of all that has conspired to our own making, and feel with a tonic touch of humility

how much more the tendencies of the time con-
tribute to our thoughts and attitude of mind than
we to their moulding and character.

A peculiar zest is given to the determination of
the Victorian period because its own habit of mind
and the length of the reign combined to create the
illusion that it was exempt from dissolution. We
feel that we may comprehend it at last, that the
detachment of gaze (which Zola promised but
which time denies to all contemporaries) may soon
be given to ourselves ; that the scale is weighed
for the balance, and that the long-delayed day of
intellectual reckoning has begun. When some
historian tells us that future students will not define
the period as the Victorian, but that it will be
regarded as the " advent of the new communica-
tions," our amused response to the perspective
suggested more than compensates for its challenge
to the ideas in which we were brought up. The
confusion begins to settle ; the lees subside in the
glass of time, and we can now test the taste of the
vintage. How will that age in which we were
born, or which stamped with its superscription
all that was characteristic of our early conceptions
of society, how will this appear upon the page of
history ? It is this tantalized curiosity which
excuses the interest aroused by the adjective Vic-
torian, for the recoil and the defence are alike wit-
nesses to an imprecision, alike searches for a fair
and lucid summary of the time.

It is now in process of definition, towards which
Mr. Wells, as we have seen, and Mr. Lytton

Strachey have conspicuously helped. But in the nineties it was not known that the period was over. On the contrary, it was still oppressive and supreme. The attack came from within not from without, in the form of a protest rather than a definition.

The quality that gives interest to this reaction is that it came from several quarters and occupied several talents, all in some degree related by the sympathies and the common influences that had moulded them. In poetry, in criticism, in the novel, in art, in the drama and the short story, the jaundiced note was heard ; and since the protagonists were sympathetic to each other, and in several instances personal friends, we have the always interesting and suggestive fact of a movement to chronicle. The principal figures in our special group are familiar enough. Aubrey Beardsley, the greatest of them all, was its draughtsman; Oscar Wilde its dramatist ; Arthur Symons its critic ; Lionel Johnson, Ernest Dowson, Arthur Symons, Richard Le Gallienne its characteristic poets. Max Beerbohm and John Davidson were of its company ; Hubert Crackanthorpe contributed to its short stories ; and there are numerous other names, but any list is chiefly important for its exclusions.

If our assumption has been correct, the Beardsley period was the autumn and not the spring of a certain imaginative ideal. The nineties saw the dissipation of the Romantic movement ; its vision of light, which had touched the top of the hills with morning a century before, and had risen to dominate

the meridian of the long Victorian day, had reached the term of its impulse. Men believed indeed that it was lifting the fringe of the horizon and prolonging the cycle of its hours, but the new rays that it was shooting along the heavens, if rich in their veins of colour, or mysterious in the shadows that they cast, were the signals of a setting sun, the dissipation of an energy that could not survive the limits of its period. The glow seen at dawn becomes a wound in the heart of the evening, and the inverted energy of decay can deceive contemporaries into thinking that the slanting rays that spread towards their horizontal rest are replicas of those others which, occupying a similar point in the eastern sky, are travelling vertically toward the zenith. Therefore we must discriminate from these the several other talents, which had not been born under the romantic star, talents contemporaneously stirring vital currents, breaking new ground, inventing new motives in place of refining upon the old, with an eye turned not to the past, but to the future. Some were endeavouring to create a new synthesis of belief, others accepted the age for what it appeared and did their best with it contentedly. A few again found their impulse in the criticism of the Beardsley spirit, endeavoured to maintain the Victorian ideal, for instance, Mrs. Meynell ; or survived from it undismayed, for example, Sir James Barrie and the present poet laureate, Dr. Bridges.

With these latter groups we shall have little to do, because they lie outside the narrow scope of

our special study. Neither Mr. Wells, nor Mr. Shaw, nor Mr. Kipling, nor Mr. Bennett, all of whom were coming to the front during the last decade of the century, can be included, for they have nothing in common with *The Yellow Book* school, though some of them were keenly alive to one or other of its artistic or intellectual sympathies. The atmosphere that these living writers suggest, even in their early works, is very different ; and it is because Mr. Holbrook Jackson has included them also, and sought to cover every intellectual activity of the period, while yet aware how distinctive is the mark of a special group within it, that his volume has lost in definition what it has gained in comprehensiveness. The new cover of his book suggests that he is to follow the primrose path of those who chose it for the binding of their own quarterly, and I fancy that these were the original interest of his mind. But he had other sympathies also among the active spirits of the decade, and the problem was how to relate them. Their only common quality is that they were alive during the same years, and yet the nineties has become a term suggestive exclusively of one group. You may regard it to be minor, but it has proved the most conspicuous colour-element in the period.

This special group has one peculiarity, which may suffice perhaps to distinguish its members and disciples. The contemporary movements that it respected were foreign, particularly French, movements. It was oblivious of the English currents of its own time because they were scientific

or social or coldly intellectual. The exact contrary is true of its contemporaries, outside this movement. Ruskin, Herbert Spencer, Robert Owen, Darwin, our men of science and social reformers, were the main inspiration of Mr. Wells and Mr. Shaw, while Mr. Kipling was positively peninsular in his contented insularity. These men shunned literary coteries and took little note of Baudelaire, the Parnassians, and the symbolists. The special group was composed of the individualists of art at the tail of an expiring tradition. The active forces outside it prided themselves, justly, on being the foremost journalists of their time, and were attracted less to the traditions of art than to the rough material of life out of which eventually a new convention might be created. The special group was in sympathy with none that did not share the belief of Gautier that the perfection of form is virtue, and admired such writers as George Meredith and Thomas Hardy, for the decadent style of the one and the tragic beauty of the other. Another quality distinguishes them, and excludes all that did not share it from their company. This was a sense of disillusion, that can never dominate a pioneer with eyes braced by the difficulties in front of him, with the society in which they lived. This disillusion combined with a pagan delight in the setting that society provided for its favourites, so that the dandy and the cynic were admired, and the men of most conventional tastes in regard to dress and fashionable pleasures thought of themselves as unconventional people. This was only

true of them in so far as they scouted conventional virtues and were destructive critics of the very institutions that their personal taste preferred. Their intellects and their imaginations enabled them to become clear-sighted critics of current morality, to be keenly alive to the discrepancy between the condition of the age and its professions, but they could not conceive society in other than aristocratic terms, and their preference for aristocracy persisted side by side with hatred of the plutocracy that apes it. Thus they became destroyers of the remnant of what they loved, without identifying themselves with the disruptive forces that were preparing the ground for a different society.

CHAPTER V

Aubrey Beardsley and the Vision of Evil

A MOVEMENT, like any other circle of influence, requires a leader, one who, whether felt or not to be its dominant personality, bears in himself, in a higher degree of intensity than any of his colleagues, the centre or point of conjunction of the spiritual forces that coalesce among them. The decade was rich in personalities, in men who were interesting apart even from the work that has distinguished them, but if one were lacking without whose art the decade would feel its greatest loss, that personality is unquestionably Aubrey Beardsley's. He alone has earned without reserve the epithet of a great artist, and his personality is remarkable because in his short and crowded years almost every ounce of energy that disease left him was transmuted into his drawings. Beardsley was reckless of his health in some ways that are surprising. On a cold winter night a friend, shivering in furs, met the artist with no overcoat on the steps of the Opera House.

"Aubrey, you will kill yourself!"

"Oh, no, I never wear an overcoat. I am always burning."

He was something of a dandy, like Wilde ; he was something of a wit also ; he wrote prose and verse as characteristic as any of the prevailing point of view, and he could be considered under any of these aspects of his talent. His art is the principal product of the time, perhaps the only character- istic product of which we never weary, the sug- gestions and beauty being as inexhaustible as the resource that created them. His fame as an artist is incontestable, and it owes less to legend and a tragic ending than that of the others. To under- stand him, to define the quality and temper of his art, is to understand the period more penetratingly than can be done by lingering on the minor names, which live at least a pathetic life in the publishers' announcements at the end of some still treasured first editions.

The first thing to notice is that Beardsley's immensely rapid assimilation of all influences, the most available or the most remote, contains the pedigree of all out of which *The Yellow Book* school was ultimately to flower. He early absorbs the influence of Burne-Jones and the Pre-Raphaelites, those middle figures of the Romantic movement, the nearest artistic centre of activity to which the dying century was turned. This group was approxi- mately as remote from the Beardsley period as that is now from ourselves, and we may therefore infer the relation which that period felt toward its models.

Though the influence of Burne-Jones upon the early work of Beardsley has encouraged the idea

that Burne-Jones was one of the first men of genius
to appreciate and encourage the young artist, yet,
like most of the eminent painters of his day, Burne-
Jones was not very encouraging. Beardsley's art
was not appreciated in academic circles, with one
important exception. Lord Leighton, a man with
an artistic sympathy really catholic, recognized
Beardsley's gifts from the first, and gave him every
encouragement and sympathy. Perhaps it was in
this rôle of appreciator that Lord Leighton's artistic
instinct was most sure. In proof, we may recall,
with the aid of competent observers, his discrimina-
ting taste in sculpture. In the England of the
eighties (no comparison is intended with to-day),
the art of sculpture was little practised and less
esteemed. The noblest of the arts found small
appreciation in the age of crinolines and trousers.
The insistent question, "Shall Smith have a
statue?" was usually answered, as one contem-
porary poet observed, with a hasty shout of Yes,
and England was rapidly covered with ponderous
effigies of forgotten worthies and disastrous politi-
cians. These were swathed in appropriate robes
and uniforms, for few of them were athletes. In
truth the frock-coat was preferred to the figure,
for the figure, proper to sculpture, was tabooed.
Perhaps for these reasons the work was not usually
entrusted to sculptors but to masons. The Vic-
torians carried the cult of monumental masonry
to its loftiest pretension, and this forbidding craft
escaped from the cemeteries to solemnize our
public squares. None the less, it was at such a

moment that Alfred Gilbert and Hamo Thornycroft
found a sympathetic admirer in Lord Leighton.
Those who remember tell us that his artistic sym-
pathy and insight were unfailing, no matter which
art was presented to his eyes, and that his fine
critical sense for the work of others did not falter.
Beardsley remains the latest and perhaps the most
familiar instance of this discrimination, but he was
only one of many whom Lord Leighton was the
exception in recognizing at their proper value.

The Burne-Jones designs, as we may call them,
were followed by Beardsley's decorations to the
Morte d'Arthur, a book intended to rival the volumes
of the Kelmscott Press. William Morris differed
from his fellows in the brotherhood in that he sought
rather to recover a perished tradition at the point
where it had been lost than, as was their tempta-
tion, to return to the Middle Ages. He did not
imitate or refine upon an ancient convention ; he
carried it on to a new creative phase. Thus Beards-
ley, profoundly original always in the use to which
he put his own assimilations, received a very inter-
esting challenge to compete with an artist who was
also a great inventor of form. He was presented
with the problem of decorating in black and white
a printed page, the text of which was a mediæval
romance that Morris might have chosen. The
text, indeed, might seem to dictate a decorative treat-
ment that Morris had already determined, and
any departure from the Kelmscott convention
promised to anything but genius either a failure
to attain that standard or a feeble variation on it.

We can hardly imagine a severer test for a young
and unknown artist than that which Aubrey Beards-
ley received in the form of his first important
commission. Any other book, a translation of
Apuleius, a translation of *Don Quixote*,[1] would
have encouraged a free hand, a personal invention,
but the book chosen seemed deliberately to exclude
any comparison but that of the master-printer's
work. The result was the revelation of a talent
as original as Morris' own ; and though Beards-
ley's decorations were inevitably judged from the
Kelmscott standard, they survived this test also, as
contemporary criticism confessed, if only between
the lines. If the contrary were true, the Beardsley
decorations would not have excited so much com-
ment. There was immediately observed an eager
life stirring in his patterns, a life like nothing that
had gone before ; an unexpected quality of line,
an almost mischievous fancy, that was unfamiliar
and disturbing. There could be no question that
the printers of the age which Morris loved could
never have conceived such decoration. The spirit
was modern, as if in a moment of waywardness it
had bewitched the pages of an old book.

In place of the involved and occasionally heavy
decoration that Burne-Jones and Morris had spun
in an intricacy of brooding fancy, we find the page
regarded no longer as a garden enclosing abundant
foliations, but as a small white surface for the play
of scattered shadow and intense light. The small

[1] Did not the idea of decorating *The Shaving of Shagpat* early
appeal to Beardsley's own mind ?

page was suited to his concentrated energy ; and
there is no difficulty in accepting the judgment of
Robert Ross, that, on a surface of this size, Beards-
ley surpassed William Morris, whose exuberant
fecundity, like that of the hedge and tangle of
wild flowers that inspired so many of his patterns,
required the amplitude of a wall or a ceiling on
which to spill the wealth of an energy almost like
that of nature in the abundance and diversity of
its forms. Beardsley's decorations, on the other
hand, achieve the most with the smallest space and
the fewest means. They are marvels of economy
of line. Morris' flower like a whole countryside,
almost overburdened with the weight of its summer
foliage. The vivid, eager life in Beardsley's designs
gives an intense, almost a dramatic, quality to
every curve and line within them. All excrescences,
all confusion, have been pruned away. The design
springs to life with the swiftness of a perfected
miracle, nor is this effect an effect merely. Each
design will bear strict and curious examination.
Every foliation can be traced to its authentic source;
nothing is weak or wayward, or intruded merely
to fill a corner or disguise an unrelated fragment
of the pattern. The blank spaces are as much
alive as the revealing lines that are traced upon
them. Often with a sparing amount of pattern
each page is scrupulously filled, for the spacing
becomes an integral part of the design, and is always
more than a background to it.

From this it follows that the critical intellect of
the artist has been no less severely awake than his

imagination. The two go hand in hand, to produce work that, in the strict sense of the word, is beyond criticism because every criticism has been already allowed for. The result is a strange effect of austerity, an intense, almost cold, perfection, which we know not whether to call passionless or impassioned, to such a pitch has it been brought. The treatment of the folds of the draperies is classic in its economy of means, and yet the lines are troubled by the souls of the figures, which move in a bitter ecstasy of contemplation or thought, for their bodies have become transparent with the feverish life within and can hardly sustain the burden of an existence so intense. There had been a fragile innocence in Burne-Jones's figures ; a spiritual refinement had paled their faces and hollowed their cheeks, but in Beardsley's the very children were living in an age of experience, and his figures suffer from their souls as from a malady of the nerves. The flowers and trees have undergone a similar intensification, as if consumed by the energy of their own sap, and no branch or spray but is alive with the consciousness of its own beauty and aware of its own place in the design.

The intellect of an artist cannot be so critical of the form that his imagination creates, or subdue it so thoroughly, without the suggestion of satire ; for the intellect is an analysing faculty, sad under the doom that it must take its material to pieces and, as it were, reverse the process of creation that the imagination has achieved, since it works in detachment rather than in sympathy with its

material. Therefore, when we find the flowerlike
or merely fanciful forms of these designs refashioned
by Beardsley to express no more than the essence
of themselves, we should expect the quality of his
genius to be even more apparent in his figures,
where a detachment that seems malicious betrays
itself. The introduction of beings as of flowers
would suggest ideas to him, and to him every idea
was a piece of intellectual criticism. His imagina-
tion would make mischief for his intellect, and
his intellect would dispassionately criticize his
imagination, and from this curious detachment
we should expect the satirical suggestion that we
find. It was not so much that he started deliber-
ately to satirize his subjects, but that his glance
was penetrating, so that his intelligence coldly and
quickly responded to every image recorded by his
eye. He penetrated immediately to the soul, and
compared it with the substance, as we ourselves
contrast ourselves with our own shadows when we
happen to stand before a strong light. Beardsley's
eye was like such a light, and when his eye fell
upon an object it placed that object in intense
relief, an opaque form on a brilliant background.

If we glance merely at the vignettes that decorate
the vacant corners of the *Morte d'Arthur*, vignettes
in many of which the forms of flowers are the
principal motives, we observe the same treatment
as that which was to inspire his terrible figures
later on. The flower-forms seem, intellectually,
to be the satire of their originals because the pat-
tern that they have suggested is a form beyond

their own consciousness, and has been rigidly controlled by a critical intellect which has cared for them merely as motives, to be bent and shapen to the decorative scheme he had in mind, a scheme which represents more nearly than life itself their inner nature, their hidden soul. At the same time, the result is exquisitely beautiful : more beautiful than the original suggestion, for nothing competes or falls short because the conditions of the pattern have been fulfilled with an unnatural, that is to say a flawless, integrity. A new kingdom seems to have been conquered because some heaven of imagination has been reached.

So vivid are the whites and the blacks that all colours seem to have been absorbed by them. By denying himself every resource of the painter's palette, the artist produces an effect more vivid than that of colour. This, indeed, carried him to a point which seems not surpassed in the range of black-and-white drawing : the power of drawing white on white and black on black. On the same surface and without shading or factitious aid, the white spaces within the pattern detach themselves from the white background as if the two had the quality of different tones. The later design called *St. Rose of Lima* is an example of this, though the dividing line between the white spaces is extremely delicate and narrow. Black and white, keeping the while in the utmost strictness their several qualities, become capable of suggesting varied grades of tone. The effect is uncanny, because black and white are made to do more than had

seemed possible, so strict was the intellect which controlled and the imagination which suggested their combinations. (His coloured drawings and single picture are less good, but then he died too young to be judged by them.)

It is well to insist on this quality at the very foundation of Beardsley's work, because we are accustomed to observe it chiefly in the decorations of his later manner. There has rarely been a greater play of fancy than in the details with which his designs abound. Whenever he used the same motive twice, he displayed some fresh invention. The perfumer at Grasse sacrifices flowers almost cruelly for the scent that he can distil from them by a ruthless chemistry. Beardsley sacrificed them with equal detachment for the designs that they enabled him to evoke. Spray, stem or foliation showed continuous invention; each was a decoration, as minute, but as complete, as the whole design to which it contributed.

This decorative sense was his master-gift, and to it form, flower, figure or convention even, was subdued successfully. The untrammelled imagination, which saw everything that could be represented by space and line merely as a motive for decorative effect, was most startling when the human face and figure were introduced. These last, being treated with equal artistic detachment, were bound to seem satirical because all treatment of them that is not mainly representative must appear in some degree a caricature to the human observer. At this point in his development it

was as if the forms of nature in plant and spray had been given their revenge. Human imagination had evoked them for a delight of its own, for an alien purpose, and now it was to mete the same treatment to its kindred. If we possessed drawings of human beings, or any representation of them, by flowers or beings of sub-human or superhuman life, we might expect something like Beardsley's vision of us. An unprejudiced imagination conceived his work, and in that sense it is the most pure that the world of art possesses.

All through the century, with the exception of certain peepings of elusive romance that marked its course at intervals, the normal art of the time lacked and desired to lack this critical freedom of imagination. Industrial man had become the measure of all things; present-day society, the current formal standards were the soil in which all that was acceptable in art was expected to grow. It was therefore inevitable that the genius of Beardsley, being genuine and consequently destined to create something new, should arrive as a challenge even if the accident of history, or the caprice of the Muse, had not chosen to relate it to a movement that expressly contested existing standards and ideals. If we are to do justice to the period and to himself, we must put in the foreground the foundation of his talent, trace the reason for its appearance of satire to the nature of its peculiar technique, before discussing the subjects on which it was employed, and the critical point of view that it brought to bear upon them.

In that beautiful drawing, *The Mysterious Rose-Garden*, we can see a symbol of the artistic instinct of the century set in the cultivated garden of the time, which first subdued and then was to be questioned by itself. The rose-garden was the Victorian parterre in which the spirit of imagination was domesticated, and employed to beautify and delight its contented guardians. A virgin art she was, protected from all disturbing influences, and allowed to wander, like another Eve, in this sanctified precinct that had been retrieved from nature. The soul of the girl was asleep while her body grew, and it was in this state of innocency that her parents delighted. Nature—nature, that is to say, in this carefully cultivated garden—had no fears for them or for her, but they forgot that, though mankind may subdue the flowers of the field to the selective fancy of the gardener, it is yet only imposing a particular form upon an essential energy that eludes him. Nature in a garden is nature still. So at length it chanced that when this virgin one summer day was walking against the rose-trellis, the petals of the flowers open as they dozed intoxicated with their own scent in the summer heat, her soul awoke within her ; a thrill ran through her body from the same sun, and she became aware of the voice of her instincts which whispered curious questions almost audibly in her ears. They told her that beyond this small garden was a more adventurous world, with trees and wild flowers and forest things, of which the garden contained only a selection of tamed varieties ; but that the

spirit of the wild no less than that of the tame was also in herself, and that to follow this spirit was to live and to deny it was to die. She had heard of sin and temptation, but only of them as ugly and uninviting things, and it was impossible to believe that the adventure to which she was being beckoned in such magically sympathetic tones bore any resemblance to the ugly voices of which her parents had told her. She listened : every tissue in her body tingled in unison with these voices. Her awakening nature responded as it had not responded to anything that she had heard previously, and yet there was a pause, a delicious moment of suspense, a passing suspicion of misgiving. We are shown no more in this design than the roses, the figured voice, and the listening virgin, but we know that she is destined to yield, and that in the moment of yielding she has become a different creature, mysteriously deeper than the child of yesterday. The forces that have wrought this miracle are forces of freedom and growth. It is conventional art listening to the whisper of creative imagination in the familiar and formal garden of Victorian times ; it is the return of Pan, the repudiation of authority. The waters of its marble fountain have been troubled by an angel, and the sheltered pool is endued with alien life. If it has stood too long deserted by the spirit, it will have grown stagnant, and the stirring of the scum upon its surface will be the first sign of the presence of the angel's wings. Thus it was with the Romantic movement and with the decadence with which the century closed,

a decadence that affected, but neither explains nor created, the genius that chanced to flower upon it. The decadence was an accident of the time ; the genius was above it, but genius has no power over the moment of its birth.

This drawing is a symbol that we may interpret endlessly, but it is a convenient design on which to linger, a point of rest between Beardsley's earlier work and the later and more startling product that was to follow it so swiftly. After the Burne-Jones drawings and the decorations to the *Morte d'Arthur*, he awoke to full consciousness of his powers, and the public reception of his work confirmed, as Mr. Arthur Symons has justly insisted, his natural love of notoriety. If he could not seem other than startling, if he was expected to scandalize, the public should have its fill of shocks, the public which, like many of his type and generation, he at once courted and despised. He entered upon his middle period, the period of *Salome* and *The Yellow Book*, and from these we may select what examples we choose to illustrate his characteristics. The *Salome* drawings are admitted to contain some of his finest work, and the temper of the play was congenial to a certain mood of Beardsley's talent. These drawings were foreshadowed in (I think) an earlier design, *Of a Neophyte, and how the Black Art was Revealed to Him*, but the three phases into which his work naturally falls make dates less important than development. Much of his work remains that of an illustrator, a supreme illustrator, whose drawing begins at the point where the text

stops. The words pause, but the drawing goes on
to evoke a new world of imagination beyond them.
His decorative sense knows no bound beyond the
demands of each design as he conceives it. Salome
may be shown naked, or in modern dress, or in
antique costume, as the pattern itself chooses. In
the play Herod declares Salome to be the victim
of a monstrous passion, and Beardsley treats its
manifestation in the same catholic spirit as any
other subject presented to him. The *Coiffing* of
the final period and the *Hail Mary* of the earliest
are equally self-sufficient to themselves. Here was
an art unlike any produced in the same century in
that it was without prejudices ; a decoration taking
every form and subject for the material of its
patterns. The rose had escaped from the trellis
to the wilderness, climbing by the aid of anything
that would lend support to its outward flight.
Some supports that were near to hand happened
to be the wilder growths, and it delighted in these
by way of freedom from the trellis to which it had
been pinioned for so long.

When a great imagination is at the fullest fling
of invention, it delights in play and extravagance ;
indeed, only such an imagination can play without
reserve. It does not see in these extravagances
anything incongruous with the impulse toward
beauty under which it works. This is especially
true of a great imagination, whose symbols suggest
so much to our minds that we are in danger of
forgetting the playfulness that wanders over them.
At a certain height of imagination, indeed, profundity

and play are inextricably bound. Such playfulness
may be profound : such profundity must be playful.
Mr. Thomas Hardy has remarked that there is
no better sign of the vitality of art than the delight
of its master-spirits in grotesque. One reason why
Beardsley was great was that he shared and indulged
this impulse to the full. The true artistic criticism
of Victorian art is that it lacked this playfulness,
that it created a convention in which there was no
room for the grotesque ; the final gaiety (even in
Dickens) was beyond its power. It barely tolerated
Punch, until it had made him a pillar of respectable
society. It is the only recent age that attempted
to ignore Pan and Punch and Pierrot. The Beards-
ley period was the moment of their long-delayed
revenge. This explains why Beardsley's imagina-
tion seemed so alien to his contemporaries. A
grotesque is the invention of a form that does not
exist in nature, and is usually a fusion of animal
and human shapes. Beardsley devised innumer-
able examples, which were as true to his artistic
ideal as those on the walls of Gothic buildings to
the mediæval. The newly recaptured impulse of
which his imagination became aware, was not
content with their invention, but treated human
beings in a grotesque way, a way at first suggested
by his subordination of every form to the pattern
chosen, and later frankly indulged for its own sake
and because of the protest with which it was received.

The beauty of these designs is evident, but the
appearance of satire, which the technique natural
to his genius encouraged, became dominant when

I

the subjects became symbols of human appetite or passion, or human beings drawn to typify the corruption of human souls. To what was due this apparent preoccupation with diabolical manifestations, with an extremity of beauty that infused malignant forms ? It was partly an accident, partly a criticism. With the accident of technique we have dealt already, and in regard to its satiric effect the line between great satire and the great evil which provokes it, as we saw in a previous chapter, must always be narrow. Through the oppression of popular standards, of the crowd upon each man, the imagination of the time became preoccupied with the sport of sin, which Blake had been the first to identify with virtue. His words received no hearing before the sixties, and then through Gilchrist, Swinburne and Rossetti, gave imaginative sanction to the desire to explore forbidden ground with the same freedom that had lately been accorded to science. The frequent use of the word sin, often coupled with an epithet of praise or eager curiosity, is often enough to mark the affiliations of a book produced at this time. The virtuous, sane, healthy motives had been exhausted ; faith in these and in the conventions of art and morals that they dictated was evaporating, and for the most part no new faith had come to take its place. The work of the house-breakers had to be completed before a new temple could be begun. The genius of such writers as Tennyson, Thackeray, George Eliot, Dickens and Browning had reaped the harvest of the familiar field, and,

as always, their legacy was a barren ground for
their successors. These, if they were not to imi-
tate, had to turn to those confines that their great
predecessors had ignored, and they found in them
food for their curiosity and scope for their invention.
 The new subject was the antithesis of the old
ideal : the soul in the stage, not of innocence, but
of experience, weary in the pursuit of a now ex-
hausted conception ; the soul, and also the body,
now curious of its own appetites because the soul
was no longer able to command obedience on
behalf of precepts in which it had ceased to believe.
Plainly this freedom involved the criticism of the
convention that it was superseding, and this con-
vention had been deliberately narrow and excluded
many of man's desires. His aspirations had been
the theme, and such shortcomings only as served
to emphasize his quest for them. His character,
necessarily below his aspirations, was now to be
displayed with equally remorseless concentration,
and its definition was to include not only those
appetites that he was ready to confess, but the ones
that he had concealed most carefully. The soul
of man, as it was beneath its habiliments and
professions, the unmentionable truth, became the
subject with an eye specially directed to those
desires of which, because they were unavowed, he
was most ashamed.
 Beardsley, then, was reacting from an exhausted
convention, and being constitutionally indifferent
to motives from his artist's delight in all that his
imagination divined, was impelled on every side to

concentrate on the hidden and the evil. Our convention that evil consists in *admitting* unpalatable truth, shocked his conscience, for an imaginative conscience is one that suffers acutely from the dread of being deceived. To forbid the mention of evil things encourages their further invasion, and decorum, which is often the polite name for censorship, may become a form of suppressing the truth, and be loved by men for the same reason that they prefer darkness to light, because their deeds are evil. The source of man's energies is his instincts, and the Victorian convention imposed, in the name of decency, a conspiracy of silence concerning them. Its effect produced a result directly contrary to that which had been first intended : the elimination of words led to an ignoring of facts ; it enthroned a lie in the soul because the soul had lost the vision of evil. The last state of corruption was worse than the first, and the consequence was that hypocrisy became worshipped as a virtue. The facts about industrial life, social life, private life, were suppressed, and the fate of anyone who mentioned their shortcomings was to be denounced as a corrupter of morals. Evil had become our good, and good our evil, and the only remedy was ruthlessly to strip the masks from the realities.

When pretence and reality have become divorced to this extent, men cease to be aware of the extent of either, and there arrives an age without convictions. Mr. Symons' summary verdict : " Beardsley was the satirist of an age without convictions,"

is the final verdict on this aspect of Beardsley's art, and the subject of his satire is not usually this or that corruption, but the state of soul to which an age without convictions is reduced. Sometimes, indeed, he shows us side by side the pretension and the reality, but this is the exception. The combination gave us the design called the *Wagnerites*, where an auditorium, crowded with rich and lecherous cosmopolitans, is listening to an opera, and that the full force of the satire may not be missed, it is explained that the opera is "Tristan and Isolde." In *Lady Gold's Escort*, another group of young men is paying court to an old woman, whose possession of a purse is the real object of their hospitable courtesies. When the pretence and the reality were thus placed side by side, an obvious piece of satire resulted, the effect of which is immensely heightened by the beauty of the black and white design. But neither comes home to the conscience of the observer, because, being localized, he does not recognize his own portrait there. The satire is not less real and becomes far more wounding when the instincts and the soul are the only subject of the drawing. The *Lysistrata* series, for example, seems to say : these are the impulses that really drive you men and women ; your ideals, your professions of love and disinterestedness, disguise creatures of appetite and gross desires, and anything that you have achieved beyond the limits of the beasts has ended by plunging you below them. For you have souls, and your souls have become as animal as are these

your physical satisfactions. You have looked long enough at the flattering image which your profession of decency provides : turn now with me from that distorting mirror and see your souls as they really are.

These drawings confine themselves to the abyss with nothing, except the saving beauty of their line, to remind us of the height from which it falls. There is no other contrast but that, and, whenever this is overlooked, evil seems remorseless here.

The Victorian age in its culmination had grown sceptical of its professed religion, its institutions, its moral ideas. It had many reasons for being so, and did not intend the squalor and discrepancy which had occurred. But its conventions would neither admit them nor the criticism that they provoked. Fundamentally it remained convinced only of its wealth, still clinging to the convention that this was equivalent to beauty and virtue. The consequence was to lend, by the aid of the very masks that it approved, an added air of unreality to its professions, for the same artistic convention that expresses nobly a living impulse becomes the empty mockery of a decaying one. If we admit the sincerity of the age's intentions, and contrast this with the ugliness and misery and degradation of the period, the growing disillusion is comprehensible. It was the one reality left, and on its insistence, therefore, the art of Beardsley and the period was concentrated. The corruption of the soul that he depicted was no nightmare of a disordered imagination. The pretension of health

was the fantastic dream. To give outline and definition to the sense of corruption, to recover the vision of evil, was a sign of healthy vitality in his work. The forces that make for corruption are no less living than their opposites. Death is only matter in the act of changing its mind.

The line of beauty in Beardsley's drawings is the current of vigour in a decay ; and it may be regarded either as the principle of vitality in the completion of a necessary process, or as the final survival of a higher life departure from which has occasioned the ruin. Only a spiritual force can create convincing images of spiritual corruption, and the eye of the soul must be stricken indeed with blindness if it cannot see, beyond the evil depicted, the line of beauty by which it is circumscribed in Beardsley's work. For this reason it is always to be regretted that any drawings by a great artist should be destroyed, for, be the subject what it may, the beauty is in the line that defines them ; the spiritual quality is there. Ruskin forgot this when he destroyed the sketches of Turner.

From the foregoing it will be perceived that the word satirist applied to Beardsley does not mean that he was on the side of the conventions, but on the side of the reality that they ignored. It came to him directly as a vision of evil, and he transcribed his vision, not with a self-conscious satirical purpose, but simply as a decorative artist. It is this artistic single-mindedness, indeed, which makes the designs terrible ; for most of us see

only what we wish to see, and shrink from the eyes
of truth as from the unabashed gaze of a child.
Thongh all Beardsley's drawings depict states of
the soul, it is not often that he chose to show the
development of the same soul at different periods.
His power of draughtsmanship consists in convey-
ing the feeling of the form, whether or not it shapes
its likeness, as in the feeling of virginity in the
girl in *The Mysterious Rose-Garden*, the limpness
of death in the tail-piece to *Salome*, the change in
the soul of Pierrot in the two drawings that mark
the beginning and the end of Ernest Dowson's
lyrical drama. The face is the same in both,
but how changed by the intervening experience !
Innocence and the knowledge of good and evil
succeed each other, and into these two drawings
all the little drama is condensed.

The designs for *The Rape of the Lock* and *Volpone*
fill the latest period of his life, and without ques-
tioning the view that they open a new phase, in
a sense the culmination of his genius, we may note
a less startling character in them. The *Coiffing*
is as innocent as the early *Hail Mary*, and the same
is true of such drawings as *The Baron's Prayer*.
It is as if the satirical impulse had exhausted itself,
as if Beardsley had found in the sophisticated con-
vention of the eighteenth century, in the civilized,
formal, polished art of the age of Pope, a mood
and manner in which he could believe. The effect,
consequently, is of more simplicity and of less
assertion, of more repose, of less detachment ; and
I fancy that the reality corresponds.

The story how Beardsley came to decorate the work of Pope and Ben Jonson has not, I think, been told before. Mr. Edmund Gosse once suggested to Beardsley that his gifts were being lavished too often upon trivial books, and begged him to consider masterpieces. Beardsley, that voracious reader (a curious student of the Jansenists, who, on another occasion, told Mr. Gosse that the *Port-Royal* of Sainte-Beuve was the prose masterpiece of the century), replied characteristically that he could not think of any. His prompter thereupon proposed *The Rape of the Lock*, *The Way of the World*, and *Volpone*. As we know, Beardsley's edition of Pope's poem is dedicated to Mr. Gosse, and this conversation was the source of the illustrations to it and to *Volpone*. The decorations for *Volpone* were published after Beardsley's death, which prevented him from finishing them. The decorations for Congreve's comedy were never carried out, but Beardsley spoke of his intention during the last conversation that he and Mr. Gosse enjoyed together. Happy is the critic whose words, like bees, can marry two imaginations in this way !

As we saw in an earlier chapter, the eighteenth century fashioned a synthesis of its own, a convenient compromise between the reformed religion and the new humanism, a point of rest in the process of that disillusion which the Reformation came to involve. Philosophy and religion found a temporary accommodation for their differences, and the morals and manners of the time reflected a

compromise between the natural man and Christian ethics. The interesting *Argument* of Swift *Against Abolishing Christianity* was careful to explain that this had no desire to revive its primitive form, or that other-worldliness which threatened all the subsequent achievements of civilization. Religion was restrained from encroaching too far, and enthusiasm prudently discountenanced. The Church of England was established not only by statute but by public opinion. The new nobility had similarly found its centre of gravity, and an aristocracy and squirearchy formed an order of society that had successfully struck its roots in the national soil. The strength of the new order was indicated by the fate of the risings of '15 and '45, which showed that the controlling minority was not concerned in them. England under foreign kings was governed by a native aristocracy, at once supreme and undisputed, and the aristocracy became the patron of the arts which ministered to a rich and cultivated minority. Among the exquisite things produced by such a society, manners take a high place, so that conspicuous insincerities, and cruelties even, are expected to be beautiful. To beauty of technique almost anything is sacrificed. The colour of rouge becomes preferred to the complexion of nature ; the hair must be powdered white before it can be admitted to the admiration of visitors, and art itself must create lovely defects as in the heart-shaped patch upon the cheek whose native hue would be as great an indiscretion as a real pimple. Religious services are respected for

the formal ceremony that they foster ; the pulpit is the prize of eloquence ; sermons are read for their style, and society beauties will "return to nature" that they may provide a new triumph for the milliner in the creation of silk gowns that convert the wearers into Dresden-china shepherdesses and milkmaids. The element of unreality contributes to the charm, which is designedly dainty and artificial ; and, as there is nothing for which the convention does not provide, though there may be evasions, there is little hypocrisy. The passions are similarly provided with appropriate channels. Men and women marry for the excellent reasons laid down in the Book of Common Prayer and for the convenience of an orderly entail; but love, which may not be included in the advantages of these arrangements, is not forgotten. If the wife has her status in society, the mistress has hers also, and within the convention the wife may have her lover too. It is difficult to deny that, so long as neither war, nor revolution, nor sudden economic change, nor pressure of population attacks the foundation of such a society, it offers an approximately complete satisfaction to the diverse instincts of man. It does not attempt too much. It possesses order and security ; it is built on well-recognized tiers ; and it begets the graces that flow from these conditions. But in time the abuses to which it is liable fester because the order of society is too rigid. Only exceptional ability can climb the ladder from the peasantry to the peerage, and this may easily be corrupted by the ardours

of the struggle on the way. The able man, who is
not exceptional and born at a disadvantage, is un-
provided with a means to advance himself ; unless
he finds a patron, he becomes a poison beneath
complementary to the cynicism above. The joint
working of these two corrosive forces undermines
the faith which holds such a society together. But
for the little while that the old basis remains, for
the little while that the faith in this order is not
disappointed, the result is a high civilization that
offers perhaps as wide a satisfaction as any to the
complex instincts of man.

More than this, such a society is the latest
synthesis yet achieved since the dissolution of the
mediæval system. Society in the eighteenth cen-
tury is the most recent memory we have of a national
life in which the ideal and the real, the profession
and the practice, the faith and the result, did not to
any undue extent contradict or excommunicate each
other. That is why it retains so many admirers,
especially among imaginative minds, and why
Aubrey Beardsley returned to it without the sense
of discrepancy that oppressed him in his own age
and in the nineteenth century. He found at last
a convention suited to his mood, a society wherein
he would have been content to live, and could
fancy himself to have been living. For the Baron
in his drawing there was a prayer to make, because
prayer is natural to man even when he is not sure
to whom or to what it should be directed. At
the same time his secular desires were equally
respected. If he wanted a mistress, he could have

one without hypocrisy or deceit ; if he desired the
things of this world, the delights of the eye, and
the pride of life, society was so arranged that a
connoisseur could enjoy them. If life were vanity,
the preacher on Sunday would make this a text
for a sermon so aptly composed and delivered,
that the imagination would be satisfied whether,
on reflection, the thesis seemed triumphant in the
proof, or the proof so delicately conducted as to
pluck the sting from disillusion. Beardsley's imagi-
nation found a haven here ; and it was perhaps
because such a synthesis was only a memory that
he turned in the end to an earlier communion, to
the Latin Church that did survive the disruption
of the Middle Ages.

In the *Volpone* drawings nature reappears, and
she reappears almost as we are accustomed to see
her, as if there had ceased to be any discrepancy
between her creative impulse and his own. As
Mr. Symons says : " The care is over, the trouble
has gone." Beautiful as these last drawings are,
with a peace added to the repose that came with
the preceding series, why is it that the malicious
smile has ceased ? Because, I think, his criticism
was accomplished, and his imagination happy in
a convention congenial to itself. Satire is always
inspired by contemporary subjects. It is a present
corruption that begets an irrepressible sense of
human worthlessness in the artist whose eye can
detect the object before him and compare it with
its favourite mask. Satire, like comedy of which
it is the ruder cousin, is a criticism of morals. Its

principal weapon is an unabashed description of the evil thing itself. The age was not deliberately worse than its predecessors, but it had broken its moorings, and through changes unintended and perplexing men found themselves in a condition that seemed inevitable, one moreover which, if admitted, convicted their professions of dissembling and their conscience of pretence. In so far as conditions had already corrupted them, the pretence made the corruption deeper ; and there had perhaps never been a greater disparity between the mask of respectability and the visage of truth.

So Beardsley's most characteristic style was not the invention of evil in a virtuous age, but the depiction of an underlying corruption. After these drawings had appeared, people professed to see Beardsley faces in the streets, as they had previously seen Rossetti ones. A characteristic whim of the period was that life copies art, and excellent play was made with it. But the deeper truth is otherwise. Fogs did not arrive in London upon the tips of Whistler's brushes, but he was the first artist to see them imaginatively, and when he had opened our eyes to their quality, we began to refer the images on our own retina to the canvases that we remembered. The same is true of the faces created by Rossetti, Burne-Jones and Aubrey Beardsley. We were on the look out for such faces among the people whom we met, and felt flattered when we discovered them. At first, as there was little to minister to our vanity in his contours and

expressions, they were supposed to be a corrupt invention. In reality, of course, the Beardsley face, like the London fogs, had been beforehand with us, but the prevailing artistic convention had made men blind to all departures from it, and the blindness was cherished since the pictorial convention was limited to pleasant truths. Beardsley, because of his genius, had the clear eyes of a child, and accepted all that they showed him. To such eyes the hatred of being deceived corresponds to the pleasure of being flattered in duller men. The evil that informs the Beardsley drawings was an evil that informed the typical soul, and so the typical face, of his contemporaries. We can admit this without boasting much difference, because in the meantime we have learnt more than they of the causes and nature of this corruption. That is why I have not called Beardsley a satirist without explaining that a great satirist is one with an eye for corruption that seems inevitable, and even respectable, to smaller men. As Beardsley's contemporary remarked : " The nineteenth century's dislike of realism is the rage of Caliban seeing his own face in a glass." Caliban, knighted, was Beardsley's subject, and it was Caliban whom they filled with disgust, for he could not see beyond himself to the line of beauty that circumscribed him. We may apply to the artist the remark of Gautier in his preface to *Mademoiselle de Maupin* : " Books follow morals, and morals do not follow books. The Regency made Crébillon, and not Crébillon the Regency. . . . The centuries succeed each

other and each bears its own fruit. Books are the fruits of morals."

The art of Beardsley is another example of this truth, which also enables us to do justice to the good side of the early Victorian reaction from the Regency, and to the truth to that effort of the best Victorian art. But a convention endures longer than the original impulse which produces it, and the Victorian convention came to mask a corruption which it was a return to sanity to reveal. This is the revelation of the Beardsley drawings, which became an extraordinary illustration of Gautier's profound text, that *la correction de la forme est la vertu*. That is the final virtue of Beardsley's famous line, which was employed to recapture the Vision of Evil for a century which, in losing it, had lost also the vision of good.

The theory of the man and the moment is justified of Beardsley too in this : his genius appeared at the moment when the line-block also was perfected.

CHAPTER VI

The Man of Legend

IF Beardsley recaptured the vision of evil for an age without convictions by drawings that revealed the corruption that accompanies this condition of the soul, the artistic group of which he was the dominant figure was to challenge convention no less startlingly in the sphere of conduct. The writers and artists of the time were often involved as much in a moral as in an artistic reaction. Their interest, indeed, largely consists in the degree with which their lives and their creations combined in the same experiment and opposition, so that they often interest us as much by their legends as by their works. Each quality enhances the other, and the exaggerated esteem which they have been accused of having excited is explained by this double appeal to imaginative minds. For we demand legend of the personalities whose work invites the attention of posterity. It is curious that those great Victorian figures, who produced work under the convention that it should not offend respectable morality, are now suffering themselves from want of legend. If much of their

work begins to date, if much of it has come to seem more of the age than above it, this quality is the reflection also of lives strictly guided by conventions of the moment. For example, the biographies of Tennyson, Browning and Arnold are almost destitute of incident, and we seize upon Dickens' period in the blacking factory, Browning's elopement, and even Tennyson's peerage, to assure our imaginations of vitality in a story which in its suave formality seems uneasy to reconcile with the works of genius that they produced. It is as difficult to believe that Shelley's poems could have been written in the moments of leisure found by a tradesman-churchwarden, as that the lives of his great successors could really have been as uneventful as official biographers record ; and when some later independent research happens to reveal the French adventure of the young Wordsworth, our imaginations are relieved of this mysterious sense of disparity, and his natural child, Annette, comes like some angel to bear witness to all tradition and experience : that men who see visions and dream dreams do not behave as if their imaginations were unvisited. The imagination, more than the apparel, should proclaim the man. Where it fails to do so except in his artistic productions, there is a sense of bafflement and enigma. The life is more than meat, more than artistic creation, and the human instinct that those who feel more vividly and think more acutely than their fellows should likewise act differently, will not be denied without misgiving.

The life and poetry of Christina Rossetti were the fit reflection of each other. Her seclusion was proper to a contemplative mystic. She was a poet and a saint, one of those whom the Church of England has placed its soul in peril for neglecting. But Christina left no legend, and legend is the *customary* proof of accord between practice and theory. The anchoress may shun disciples and leave no legend of her grace, but the other great Victorians lived in the world. If Tennyson had not written *The Lady of Shalott* and his best pieces, there would be no puzzle. A Laureate should live at Farringford, and compose odes on official occasions. In a word, the lives of these others, as recorded for us, seem the reflection of their least beautiful poetry ; the lack of legend is a consequence of this. The reader will recall Matthew Arnold's reflection, already quoted on page 51. The soil was not propitious for " totality."

The men of the Beardsley period, by satisfying this instinct for legend, have won a measure of regard that some of their greater predecessors seem to have forfeited, for our cry is still for the unitive life in all who affect our imaginations. Those artists whose work and whose lives seem, *at whatever level*, the fit reflection of each other, are felt to be more convincing essays toward the complete man than others whose lives and productions appear to be on diverse planes. It seems as incongruous that a great religious teacher should die in comfortable circumstances as that a man of genius should put all his individuality into his

work, and live a completely colourless existence. In regard to the personalities of the nineties : with the example of their immediate predecessors before us, we find it more convenient now to ignore their lives, and then, having divided the seamless vesture of their temperaments, and so deprived ourselves of part of their real importance for us, idly protest that the artistic quality of their work does not justify posterity's interest. But this interest remains : to remind us that art, being mainly praise of life, should enrich rather than divide the whole man, and contribute the final touch to the complete image of a vital personality. In regard to this group especially, criticism has often missed the mean between praise and dislike because it has ignored the legend when considering the books, or ignored the books to concentrate upon the disasters, excesses, or the suicides, that overwhelmed some of them. We need to allow for both, and arrive at a judgment first by distinguishing and then by combining them.

The characteristic instance of this dual attraction is provided by the life and the works of Oscar Wilde. On the stage of the decade, in the drama of the period, he was the principal figure. His immense reputation, attested by the innumerable languages into which his books and plays have been translated, rests upon the legend of his life, culminating in an immortal scandal, on the fringe of which his wit, his technical skill as a talker and writer, his plays, his novel and his verses form an appropriate embroidery. The wit, his most spon-

taneous and original possession, inevitably draws
us to the personality from which it overflowed,
and the man's life is so theatrical in its develop-
ment and so sordid at its close, that curiosity,
still unsatisfied, doubles back upon his writings
to excuse a tantalized, but half-reluctant, interest.
If Wilde had died in the spring of 1895, he would
be remembered to-day as a wit and a dandy, with
a place beside Congreve in the theatre, and as the
centre of a miscellaneous mass of anecdote in which
people have begun to take a languid interest. But,
for his contemporaries, his death then would have
removed a notorious and sometimes preposterous
figure, who tried to revive knee-breeches in the
eighties, and then assumed the rôle of a poet by
echoing with astonishing facility the surface effects
of Milton, Keats, Rossetti, Swinburne and Baude-
laire. Having gained a semi-literary reputation,
by means of intentions mainly unfulfilled and
therefore inadequate, a reputation kept alive by
the uninterrupted attacks in *Punch* and every
periodical that reported his eccentric doings, this
strange being began to seek a different effect by
writing fairy-tales in the manners of Hans Ander-
sen and Flaubert. He doffed his sunflower, ceased
to wear his hair in the manner of Nero, and, having
married a lady of some property, he became a
diner-out in fashionable society.

His instinct for the limelight had been so great
that he had consented to visit America in order
that the people there, by meeting the principal
æsthete in this country, might also enjoy with

understanding the caricature of himself contained in *Patience*, a comic opera so full of local colour and allusion that it would have failed in the United States without personal acquaintance with its victim. So perfect was his self-possession, however, that he delivered his course of lectures with no loss of dignity, and some of those who came to mock were charmed into applauding him. He returned to England with something to his credit, and a considerable addition to the number of people already interested in his name. He had not perished with his vogue, after the manner of the type he seemed desirous to imitate, but survived it. He was now more than the caricature of a celebrity on both sides of the Atlantic ; but his reputation seemed in inverse ratio to his achievements in days when the wit and the dandy had ceased to be regarded as the social equivalents of the miniature or the cameo in art. It was remarkable, and must have seemed ironical to himself, that a man so much talked of should have found no reward for his gifts except a succession of invitations to dinner. The profession of the raconteur and diner-out had perished with Creevey, who lived comfortably at other people's tables, save for a very small private income. Augustus John Hare had tried to continue it, but to him also fate had been more generous of the means of subsistence between Tuesday morning and Friday night than she proved to Oscar Wilde. His desire to maintain a rôle outmoded showed how conventional and old-fashioned he was in his social

ideals. Like that of Disraeli's fashionable heroes, Wilde's boasted antinomianism was " the pedantry of convention," not its opposite.

The appetite that one acquires between each week-end cannot wait, like other household bills, to be settled on Saturday, and Wilde never wished to desert the part for which he now cast himself, but to be what he seemed, a man of leisure with extravagant tastes and an easy flow of money. Despite the success of his first volume of poems and of his American lectures, which he continued in this country, his reputation was a source of expense rather than of income. Partly for want of evidence, partly from jealousy and dislike, no one accepted him at anything like his own valuation of himself as a critic of art or as a man of letters. For the contemporary opinion Mr. Walter Hamilton's book on the *Æsthetic Movement*, which was published in 1882, is instructive. The focus is foreshortened for us, by quotations from forgotten newspapers, to the limit of contemporary eyes.

It was, doubtless, this anomalous position which encouraged him to marry, and to consent to place his name as editor on the cover of the *Woman's World*, for which he wrote literary notes and procured occasionally a fashionable contributor. He wrote also anonymous reviews, often very witty in their phrases, for different newspapers. Reviewing is the poorest paid vocation that exists, even in these days, when pages are devoted to new books in every newspaper. It is curious that

Wilde was seldom asked to sign his reviews, though his name would doubtless have attracted new readers, and though the advertisements that would have followed them should have made it worth the while of his editor to retain him at a salary. Even editors are rarely enterprising, and the signed review was hardly thought of. Despite his indolence, he was forced to consider. Two popular forms of literature remained untried : the modern play and the novel. With his previous short stories probably in mind, he decided on the narrative. When sending the manuscript of *Dorian Gray* to his publisher, Wilde said that it would create a sensation. It did, and of a kind more disagreeable than any he had provoked hitherto. The progress of the undefined corruption of the hero is more insidious in its effect on the imagination than any stated deed, and the author deliberately made the most of it. He delineated a man whose insolent luxury of life is an affront to all that desire to enjoy luxury without identifying themselves with Tiberius at Capri or Caligula at Rome. But we must endeavour to be just.

The idea of *The Picture of Dorian Gray* is excellent. We have only to ask ourselves what Hawthorne would have done with it, to admit the possibilities of the story. It has other interests as well. The wit is there, the eager assimilation of other influences, the surface originality. The artistic development of the theme is orderly and skilful, and it is a question how far the added chapters, which deliberately waylay its progress, do not add to the

particular effect at which the author aimed. His talent being dramatic, and his taste for opulent decoration, he desired atmosphere, but his talent and his taste could not interweave themselves, so he indulged either in its turn, and hoped that the alternation would suffice. Where the book is not overburdened with the folds of its meretricious style, it is effective, dramatic, and decorative. The murder and the final scene are vivid. The writer's imagination easily solves the difficulty of the disappearance, but of character or humanity it has almost as little as Wilde's verses have of poetry or genuine feeling. The book is a sensational novel written by a man of imagination, enormously susceptible to effects of language, who mistakes technical dexterity for the substance of beauty, and prefers rhetoric to sincerity, and the stylish to style. It is a melodrama, with conscience for the detective and corruption for the crime. The precise effect at which it aims, it achieves. Wilde always achieved his effects, but our quarrel with him is that the effect is vulgar compared with the imagination and the technical skill spent upon it. He could accomplish so well what *he* wished to accomplish, that we find it hard to forgive a taste so much below the wealth of its resources. We must then, to be just, distinguish between the effect and its quality, and admit that, though the gem be paste, the glitter and the setting are excellent examples of rococo. A prey to every influence, especially susceptible to the ornate (which he could not distinguish from the grand style), he is, in his

decorative manner, the Bernini of borrowed plumes, the peacock of prose-writers.

Though the tale deals with a substance similar to that of Beardsley's most satiric drawings, it is neither the great satire nor the decorative design that it might have been, because Wilde, not being a great artist, was unable to create the line of beauty with which Beardsley circumscribed his figures. Wilde's imagination did not subdue the material in which he worked, but was subdued by it. The result is rhetorical and not beautiful, affected rather than sincere, because his technical gifts were good but his imagination inferior. He was content, he even preferred, the effect of beauty, the effect of style, to the reality. He mistook deportment for dignity, and had a weakness for the meretricious, though the meretricious has never been more completely expressed. The decorative colour that he tried to import (or revive) in English prose has only to be compared with its originals, in English and French, to seem theatrical. The fascination consists in seeing that which is false accomplished with a skill not always found in that which is true. Wilde was perpetually promising more than he performed, but there are some people who, against our better judgment, persuade us almost to believe in their promises, such persuasive and plausible advocates are they of themselves. Having a defective artistic conscience, he was content with second-rate effects, because he thought that he could always rely on his technical resources to carry him through. By this means he won the

attention of the crowd, but never the unqualified support of the master spirits, with whom he liked to arrogate himself. He was not, I think, really self-deceived about the quality of his work, but he had an incurable preference for the baroque, and also knew that his real gift was " to talk books away " and not to write them. Until he found a conversational form of literature, he never achieved the half of which he seemed capable. His novel gained him an access of notoriety and jealous distrust, except among a band of personal disciples, mostly unworthy of his mind. Then, in urgent need of money, he turned to the theatre a spectacular talent that always seemed in exile off the boards.

Lady Windermere's Fan, his first modern play adapted to the commercial theatre, had an instant success, and with its three equally prosperous successors gave to him the immediate triumph, intellectual and financial, that he had desired so long. The success, still grudgingly admitted, could no longer be denied, but even now he had more notoriety than respect or reputation. A previous fantasy on the story of Shakespeare's sonnets had given colour to certain rumours about him which his extravagant life, bloated appearance, and the residuary impression left on the public by *Salome* and *Dorian Gray* did nothing to dispel. This was the gathering background against which an almost insolent success was being enacted. The world, which he both courted and despised, worships success, but so jealously that its most characteristic pleasure is to overthrow the idol that

it adores. An unexpected event in the career of
Oscar Wilde gave an opportunity to the world to
revenge itself upon its exploiter for its adulation.

He was persuaded to begin a lawsuit against
a man who libelled him by leaving an opprobrious
card at Wilde's club. He lost his case, to become
defendant to the Public Prosecutor. The jury
disagreed. The case was re-tried. Wilde was
convicted and sent to prison for two years with
hard labour. The scandal of which he thus be-
came the centre was enormous, for two reasons.
First, there was his own position and success, the
sudden reversal of which, for a man so notorious
and so envied, would have seemed, by a much
smaller disaster, tremendous to his contemporaries.
Secondly, he had become a figure in fashionable
society. The prosecution had been invited by
a peer, and no one knew who else of note might
not become involved. A panic seized fashionable
society, and there was an exodus to France that
amounted almost to an emigration. In this coun-
try the upper classes are virtually above the law,
and when there happens to be a flutter in their
dove-cotes the whirr of flying wings is proportion-
ally great. Lastly, the nature of the scandal itself
was unprecedented, and the legend of Wilde's
life, the climax of the period, cannot be honestly
presented unless this element in it be allowed
for. Every age lays exceptional emphasis on
some crime. A hundred years ago it was the act
of which Byron was accused, for which Laon and
Cythna were condemned, and for her murderous

resistance to which, in Shelley's play, Beatrice Cenci was executed.

The accusation of which Wilde was convicted thus happened to be as horrific for him as its complementary had proved to Byron, though not brought into court, a century earlier. In other words, here too Wilde achieved the extremity of effect that was possible to the occasion. If he had said to himself—and a stray remark, made shortly before his first trial, suggests that some such thought was in his mind—" My life has been effective in the theatrical sense ; I have been the most caricatured figure of my day, first mocked, then successful, then idolized. I have been the centre of innumerable anecdotes, the hero of many dinner-parties, the lion of several seasons. I have dominated the London stage. Everything in this direction of notoriety has fallen to me. On the same plane success has nothing more to offer without repetition. Its only remaining novelty would be a scandal. If that also be granted for the climax, my public career will be complete." Had he said this, only one scandal could have met his desire to the full, and nature's caprice included the temperament that made it possible.

His entire character was a theatrical, a spectacular, one. To him as to no one else of his epoch with the same completeness, except perhaps to Disraeli, the world was literally a stage, to be valued and trod for the effects that it offered to the actor. His test of success was the attention, whether of applause or opprobrium, that one ex-

cited. Unlike many of those who love applause, Wilde had enough self-possession to accept opprobrium with composure. There can be little doubt that, had fate offered to him the choice of a career, and one less disastrous had been suggested at the cost of omitting the final scandal, he would have refused the alternative, as he might have refused a crown unless exile and the scaffold were promised with it. He courted a drama, and knew that, of the varied effects open to tragedy and comedy, a comedy changed suddenly to a tragedy is the most telling. It has often been asked why he did not leave England when on bail between his first two trials. His natural inertia, his Irish pride, his courage, the fascination of the abyss, have all been suggested by people who knew him and were competent observers. These, indeed, have their part in the truth, but the ultimate reason, I think, is simply this. Wilde was the antithesis of the man of action, but, with the passivity that goes with this constitution—for intellectual activity was the plane proper to his genius—he possessed, above all, an unerring instinct for the centre of the stage, and, at the decisive moment in his fortunes, the centre of the stage was not the boat-train to Dover but the dock at the Old Bailey. So he remained, and to his decision, as Mr. W. B. Yeats has said, he owes " one half of his renown."

The door closed, and he passed into prison, to write from there a personal explanation, in which he sought to find the appropriate literary attitude for his experience, and, after his release, a ballad

for publication, designed to show that he was still a man of letters, and that society, by placing him in prison, had done no more than to provide him with a new motive for verse, and with a personally verified proof of the infamy of which he had often accused it. It was a fair reply, for the event has proved that people will not recall his story without adding that the enemies of a man of genius, who gave the most desperate hostages to fortune and his foes, have never been more signally cheated of their triumph. On this defeat of theirs it is necessary to say a word, before we leave the legend for the writings. By revenging itself upon him with every circumstance of rancour, including, Mr. Harris recalls, a dinner held to celebrate his downfall, society, which " punished him for his popularity and his pre-eminence, for the superiority of his mind and wit," has presented him with the wider half of his reputation. By crushing him, it raised the witty author of four comedies to a legendary figure unparalleled in modern times. He grossly exaggerated his position among his contemporaries. It is difficult to exaggerate his posthumous fame. The extent to which he has been translated suggests, to one's amazement, that he is the second best, if not the best known, of any English author, Shakespeare included. This the legend has accomplished. It has one use, however, which it is appropriate to mention here. Beardsley accomplished in art the final overthrow of the complacency that had blinded Victorian eyes to the spiritual atrophy beneath the riches

that it was accumulating. He showed the soul corrupting beneath the mask of commercial civilization. Wilde, to whom life was a stage to be trod with the appropriate deportment, accomplished a similar service by projecting into general view, and with every circumstance of publicity, a diathesis held to be unmentionable ; and by showing that its possession in a man or woman is a freak of nature that, by itself, does not necessarily give an index to his or her social worth or general level of character.

Wilde had many faults. He was a man, in several respects, of conspicuously weak character. He was weak in self-indulgence, gross in pleasure, the fool of money and rank ; but he would have been so, however constituted. All, even the strain of vulgarity in him, fitted that part in the masque of life for which he cast himself. But it would be unjust to explain his reputation entirely by the legend that has contributed so much to its extent. We must pass to the writings in which, however wastefully, his gifts were proved.

In all his work he was more interested in form than in substance, in pitch than in quality, in surface than sincerity, in effect than in truth. Thus all his verse (and the ornate in his prose) is a series of echoes, relying upon a technical manipulation of phrase for such quality as it has. As Mr. Symons has pointed out, all the manners that he adopted represented his artistic " intentions," and, to him, intentions were the better half of truth because, to him, truth in art was technical

accomplishment. He loved virtuosity so much that he became indifferent to virtue, which was " only the trade-mark of the firm." He wrote no poem that is of any value, though many a verse to indicate the effects that he admired. *The Ballad of Reading Gaol* is a piece of rhetorical verse that, not only because of its authorship, will be remembered. *Eugene Aram, The Song of the Shirt, The Charge of the Light Brigade*, are familiar examples of poetic effects that endure because of their occasion, their subject, or the drama of their story, and not because they are the poems that they pretend to be. The reward of their skill and intention is an enduring popularity that no true poem ever achieves unless, like *The Ancient Mariner*, for instance, it combines extraneous interest with poetic truth. *The Sphinx* is a tissue of unusual or recondite words strung together in the loosest way, with nothing but the incongruity of the words themselves to attract attention. *The Harlot's House*, which deceived some who ought to have known better, was written for the sake of the title, itself an afterthought. Only in the last verse is there a glimmer of that electric light which did duty to Wilde for imagination. The truth is that he had no ear for verse, though one as good as Congreve's for the cadence of conversational prose. If other proof than the results were needed, a comparison of his manuscripts in prose and verse would be decisive. The pen controls the prose with little hesitation because the inspiration for the phrase was never at fault. But the manuscripts of verse

L

perpetually boggle, except when a prose phrase that happens to fit into the measure escapes from his reluctant pen. He had, by the way, a delightful handwriting, as graceful and easy to read as his own wit was to hear. It is amusing, therefore, that he should have told Mr. Frank Harris that he had carefully modelled this script in his youth, in order that it might be personal and distinctive to him ! It does not matter whether his statement be true or an intention merely ; the penmanship has the effect of a happy combination of formal and cursive writing, with the clearness of the one and the ease of the other. He may have polished a natural grace of hand, but the result is a singularly limpid mirror of the lucid prose that was his real, though often waylaid, accomplishment.

The handwriting also reminds us that in his first editions Wilde was very fortunately served. It is to Mr. Charles Ricketts that the first edition of *The Sphinx* owes all its beauty ; to Mr. Ricketts and to Mr. Shannon that *The House of Pomegranates*, as it first appeared, remains a beautiful modern book ; and it is, of course, to Aubrey Beardsley directly, and to Dr. Strauss incidentally, that *Salome* is indebted for its real beauty and much of its fame. Wilde had little love or knowledge of music, and, we are told, would not have Beardsley's drawings in the house. The reason probably was that he felt Beardsley and not himself to be the genius of that volume.

It is with the comedies, of which *Lord Arthur Savile's Crime* was the amusing foretaste, that we

reach the form wherein a theatrical intelligence displayed its proper quality. Among the later dramas, only in *Salome* did he escape the dramatic restraint of conversational speech. The result, at least in the reading, is the failure to which the temptation of the grand or the ornate style always brought him. The drama seems designed not to be represented on the stage. I should like, however, to see *Salome* acted, in order to discover if it be possible for any actress to hold the attention of an audience during the inordinate speech that preludes the fall of the curtain. Wilde had such a sense of the stage that one is inclined to give him the benefit of any doubt ; but it seems improbable that the monotony of effect at which the dialogue aims could retain in the delivery such attraction as can be felt, in the intention, when we read it. The sense of the stage, however, is displayed in the device that makes the arm of the executioner arise from the cistern bearing the head on the charger, with the man himself unseen. Had the executioner himself appeared, he would have dominated the stage, the head would have become a lump of meat, and the effect would have miscarried. The emergence of the arm, like the appearance of Jack Worthing in mourning during the second act of *The Importance of Being Earnest*, is truly dramatic because it appeals to the eye, and sight is the first sense that must be satisfied in acted drama.

Apart from their wit, the three comedies that preceded *The Importance of Being Earnest* seem to me no index of Wilde's originality. In them his

talent is employed to lend literary dignity to the scenarios of the fashionable commercial plays of his time ; but the utmost he achieved was to do more wittily than anyone else that which every West End dramatist was doing. In the first three comedies he did not depart from the conventional theatrical formula, and added nothing but his wit to the result. These sinning husbands, and idealistic wives, and intriguing adventuresses, and unacknowledged kindred, were no imaginative children of his. He did not believe in them, or their ardours or their repentance. He believed only in the witticisms that fell so lightly, and so improbably, from their lips. Therefore his problem, if he was to realize his imagination in the theatre, was to project characters in the spirit of his epigrams, to create, if you like, not other people's puppets but his own. For his original gift was a pervading levity, an intellectual trifling, of the most dainty and spontaneous order. The characters of Congreve, also the spoil of his predecessors in the Restoration drama, were no more than essays toward his original creation in the characters of Millamant and Mirabel. Similar lay figures were those which Wilde, too, had to refine, if he was to attain originality, nearly two centuries later. In his first three comedies the dialogue was an invention, the characters were taken on distrust ; but in *The Importance of Being Earnest*, the most " trivial " of the comedies, the characters, having less of the convention and more of artifice, are more worthy of the wit that they exist only to utter.

It is now becoming fashionable to accept Mr.
Bernard Shaw's verdict that *The Importance of
Being Earnest* was either the early draft of a modern
play retouched in the later manner (though Wilde
personally denied this), or a falling off, perhaps
the sign of a character coarsened by indulgence
and success. The comedy, we are reminded, is
" absolutely heartless." It is, but so was its author.
He could, we are assured, be touching and kindly,
but he was incapable, from the beginning, of deep
feeling, as every attempt to express it, in any of
his works, remains to show. It was well, then,
that he should abandon the attempt. Whenever
he made it, he became unreal and profane. The
grand style was his most insidious temptation, and
there are sentences concerning the death of his
mother which could have been written only by a
man, not only incapable of feeling, but deprived,
when simulating it, of any sense of humour. It
is useless to demand of a man qualities which he
does not possess, and also useless to assume that
the possession of one quality necessarily implies
the possession of another even if that other be
ordinarily associated with it. The surface of
feeling has also its charm : the foam can be as
lovely as the deep water, merriment no less beautiful
than tears. It was with the surface of intelligence,
with the delicate play of ideas, with the " cham-
pagne of comedy," that Wilde was most himself.
He had, Robert Ross tells us, a singularly sunny
nature, and *The Importance of Being Earnest* is so
playful, has such an abandoned frivolity, that it

remains, I think, the most sincere piece that its
author wrote. True, it touches at moments the
level of farce, and this might have ensnared him ;
but we cannot avoid asking if Wilde might not
have achieved, in favourable circumstances, that
rarest feat of our theatre, a series of plays that
should be the very froth of farcical comedy. His
genius lay in that direction, and so playful was his
intelligence that it is remarkable, after thirty years,
how little his best epigrams begin to date. It is
his serious moments now that seem outmoded.
This contrast proves that his levity has an imagina-
tive quality, for ideas very quickly grow old, while
wit survives ideas by presenting a playful imagina-
tion in their likeness. To point the contrast, Mr.
Shaw is a wit of a different order. It is no dis-
respect, I trust, to say that his already written
plays do not raise so many laughs to-day as they
did on their first appearance. We, ungratefully
enough, have assimilated some of his ideas, and
with our familiarity has gone our laughter. Wilde's
ideas were distilled to the quintessence of them-
selves, and cannot convert us to anything except
delight in comedy. More than most epigrams,
they rely on a perfection of phrasing to transform
a mustard-seed of thought. This phrasing is a
true imaginative gift, and the form it created
retains its fun in spite of familiarity. Had his
penetration been as keen as his phrasing was
polished, he would have been the Oberon of wits.
As it is, and with every allowance for criticism, he
remains the most amusing of English writers for

any reader with a suspicion of brains. Obvious
as this is, it has never been sufficiently admitted
by his critics. Yet his power to awaken mental
laughter is the quality by which his writings main-
tain their interest. In the technique of talking,
in verbal fitness, which was Wilde's idea of literary
beauty, the narrowest form is that provided by
the phrase, and there, the form being as narrow as
the substance, he could not betray himself.[1]

Thus, his prose is at its best when it is most
conversational. Outside the plays, he sometimes
won an equal lucidity. The best passages of this
kind are to be found in *The Soul of Man*, and in
certain pages of *De Profundis*. There imaginative
ideas, the description of the miracles, the interpre-
tation of the parables, or again, in *The Soul of Man*,
the sentences on property, the paragraph on the
complete personality of man, are limpid with light.
Sense and sound in this prose refuse to be separ-
ated, and they fit so delicately that the resulting
phrase is no more than their delighted laugh of
mutual welcome. *The Soul of Man* is an amusing
defence of individualism, though it has the fault
of being a little protracted. In *De Profundis*
Wilde tried to adopt a new appropriate attitude.
But he was incapable of change, because he could
accuse himself of nothing but idleness and indul-
gence, and of these he was incurable, as he knew.

[1] Sometimes the phrase contains excellent sense ; for example :
' Selfishness is not living as one wishes to live : it is asking others
to live as one wishes to live. And unselfishness is letting other
people's lives alone, not interfering with them."

He could not repent of them because both, indeed, encouraged him to make the utmost of very little, to develop his technical resources to the full ; and, since he had no depth in himself, they became indeed less a hindrance than a help. His talent, at its best, is so gay, so playful, so genial, that it inspires an indulgence in his readers that survives the severe strictures that criticism must make upon his works. It explains why William Morris, when he was dying, is recorded to have enjoyed a visit from Wilde more than from anybody, though Morris was the reality of so much that Wilde profaned. When meeting this airy intelligence on its proper level, in conversation with himself, when the voice, the fine eyes, the personality, the evident enjoyment of the talker, were at their most radiant sparkle, we can understand the spell of an individuality to which, at last, we forgive everything, for the sake of the intellectual liveliness that he dispersed. Fortunately his talk is not wholly a tradition. Its spirit has arisen from the grave in Mr. Laurence Housman's delightful *Echo de Paris*, where we listen to a reconstructed conversation that his memory preserved for twenty years.

The intelligence of Wilde radiated in flashes of summer lightning ; and he has reduced our conventions to absurdity, not only by laughing them out of existence, but by inviting their strictest censure and surviving their worst. It was the ironic intention of Providence, who owed Victorian earnestness a private grudge, that this summer lightning should illumine the darkest recesses of

the Victorian sky, and the very man who seemed, for a moment, to lie beneath the reach of sneers, is the man we have to thank for our consequent shame and enlightenment. For his disgrace was temporary and accidental, while ours endures so long as we remain obnoxious to his laughter.

His career was the epitome of the decade, as his fall was its climax. In its lights and shadows, its colour, all that it offers to appreciation and distaste, it is symbolic. He had little new to say, but he said it vividly ; and what seemed new was really the last flicker of an exhausted impulse, in which the Romantic movement, seeking throughout the century to escape the Victorian convention, rent at last its respectable robes, to release the human spirit for the building of some new synthesis on the ruins of forsaken formulæ. Disillusion had followed illusion to corruption, and the new dreams that were to take its place were already quickening to the birth. On the ebb of this exhausted tide we seemed, for a moment, almost back again in the melancholy dandyism of Byron and at the ideals of Carlton House, but repetition is not permitted to history ; the rue was worn with a difference ; and fresh motives had begun to trouble human brains.

CHAPTER VII

The Poetry of the Period

THE critical point of departure from which to consider the poetry of the decade, in so far as it illustrates the peculiar point of view now associated with it, is found in three essays by Walter Pater. One of them, entitled " Æsthetic Poetry," has never been reprinted with the later issues of *Appreciations* in the first edition of which it once appeared. Speaking of the *Defence of Guinevere and Other Poems*, by William Morris, Pater extends his view to include a special division of recent verse, and adds : " The secret of the enjoyment of it is that inversion of home-sickness known to some, that incurable thirst for the sense of escape, which no actual form of life satisfies, no poetry even, if it be merely simple and spontaneous. The writings of the ' romantic school,' of which æsthetic poetry is an afterthought, mark a transition not so much from the pagan to the mediæval ideal, as from a lower to a higher degree of passion in literature." There follows a characteristic description of the poem which gives its name to the volume ; and another sentence,

beginning " here under this strange complex of conditions," is such a revelation of its author's manner that the essay should be rescued from oblivion for the sake of these two passages alone.

Again, in the more familiar essay on " Rossetti," Pater says : " Poetry may reveal, it may unveil to every eye, the ideal aspects of common things, after Gray's way (though Gray too, it is well to remember, seemed in his own day, seemed even to Johnson, obscure), or it may actually add to the number of motives poetic or uncommon in themselves, by the imaginative creation of things that are ideal from their very birth. Rossetti did something, something excellent, of the former kind ; but his characteristic, his really revealing work, lay in adding to poetry of fresh poetic material, of a new order of phenomena, in the creation of a new ideal."

Finally, from the " Postscript " to the same volume, let us take this : " It is the addition of strangeness to beauty that constitutes the romantic character in art ; and the desire of beauty being a fixed element in every artistic organization, it is the addition of curiosity to this desire of beauty that constitutes the romantic temper. . . . If there is a great overbalance of curiosity, then, we have the grotesque in art : if the union of strange-ness and beauty, under very difficult and complex conditions, be a successful one, if the union be entire, then the resultant beauty is very exquisite, very attractive. With a passionate care for beauty the romantic spirit refuses to have it, unless the

condition of strangeness be first fulfilled. Its
desire is for a beauty born of unlikely elements, by
a profound alchemy, by a difficult initiation, by
the charm which brings it out even of terrible
things ; and a trace of distortion, of the grotesque,
may perhaps linger, as an additional element of
expression, about its ultimate grace. . . . It is
in French literature that its most characteristic
expression is to be found. . . . It may be said
to be the product of a special epoch. Outbreaks
of this spirit, that is, come naturally with particular
epochs—times, when, in men's approaches towards
art and poetry, curiosity may be noticed to take
the lead, when men come to art and poetry with
a deep thirst for intellectual excitement, after a
long ennui, or in reaction against the strain of
outward, practical things."

This analysis can hardly be studied too care-
fully in relation to the work of the period generally,
but as it was evoked by the poetry its proper place
is here, even though the prose and the drama of
the time also are illuminated by it. It provides,
too, a kind of test. In the mass of verse still sur-
viving from a decade in which some really new
motives and the more curious expression of the
old occurred side by side, these paragraphs by a
critic, who himself inspired some of the latter
search for intensity, provide us with the necessary
distinction. Since this essay in critical perspective
can do no more than illustrate by some references
a characteristic tendency of the time, it is impor-
tant that the references be apt, and that no incon-

gruous contemporary be included whatever his in-
trinsic claims. Even from the verse that is specially
characteristic of the Beardsley period, only a few
writers, a few examples, can be chosen, and we
need to define the distinction in virtue of which
the selection, and still more the principle of exclu-
sion, has been made. There will be a debatable
border certainly, but we shall neglect, whatever
its merits, any verse that does not show some
" inversion of home-sickness," some seeking for
" a higher degree of passion in literature," some
attempt to add to " the number of motives poetic
or uncommon in themselves," including the motive
of a learned corruption of language, some " over-
balance of curiosity " in subject or style, above all
some " thirst for intellectual excitement, after a
long ennui, or in reaction against the strain of
outward, practical things."

These will be our criteria, as they were by pre-
ference those of the critic most identified with
these qualities at the time, and most responsive to
them in other writers. For a general, though
necessarily incomplete, review of the poetry of the
period, Mr. William Archer's elaborate study of
twenty writers, *Poets of the Younger Generation*,
can still be recommended, but, less specially em-
ployed, he includes or omits writers that, without
regard to their merits, need not concern us here.
Writing in 1898, and eventually publishing from
the Bodley Head four years later, he was the most
comprehensive critic of the younger generation of
versifiers, and to his book I am as much indebted

as I am to Mr. Richard Le Gallienne's *Retrospective Reviews* for a survey of the contemporary prose.

The most characteristic poet of the period was Ernest Dowson, and in his best-known poem, " Non Sum Qualis Eram Bonæ Sub Regno Cynaræ," not only did he say all he had, but summed up in four stanzas the rebellious temper, the artistic ideal, of all the group. It is a poem of ennui, and of reaction, of the inconstant flesh at issue with the constant soul, paradoxically combining the fine and the sordid as if content with nothing less than both extremes. The immediate mouth that inspired his recollection must be " bought " to contrast with the recollection of an unpurchasable emotion that the flesh was too weak to sustain; but the bargain is not decried, nor the sweetness of the purchased kiss unadmitted, because, where degrees exist, the strangest, the least commonly accepted, has to this temper a peculiar artistic appeal. The lower and the higher motives, being equally real in Dowson's experience, demanded an equal place in his conscious and unprejudiced art. The whole is sung to a haunting and original music, and the rhythm which gives the line of beauty to the whole will not be forgotten by posterity. At a further remove from immediate reality, is the sonnet " To One in Bedlam," where the " inversion of home-sickness " breaks out, desiring " half a fool's kingdom " in exchange for the whole world of rational, practical things. Contrast this sonnet with the lines written by one in

Bedlam, John Clare, from the Northampton County Asylum, and the lucid moments of a man under restraint, feeling " the huge shipwreck of his own esteem," and longing " for scenes where man has never trod," and to " sleep as I in childhood sweetly slept," are not more poignant. There is the same " incurable thirst for the sense of escape " from familiar and repressive surroundings, the same isolation of the ego turning round and round in its narrow cage, the same ennui and disillusion. In the almost wordless lyric headed with the words " O Mors," the French poetry of Verlaine is wonderfully echoed into English. The disillusioned proem to the verses, the strain of ecclesiastical mysticism in its more immediate appeal to the senses, the Swinburnean measures, the graceful villanelles, the Latin titles and quotations, the feeling for the eighteenth century in the poetic fantasy of Pierrot, the regrets and disappointed love, the whispers of riot, and the literary point of honour cultivated to its author's utmost : these are almost as complete a tissue of the poetical motives of the time as the art of Beardsley was, on a larger plane, of their contributory influences. The lamenting lines, " You would have understood me had you waited," with their carefully stilled but breaking music, reveal the poet, for regret is the commonest theme to be chosen by a versifier, but its presentment in these and the like poems displays a poet to whom nothing was denied of true lyrical feeling, and the fit words that only that can find. Dowson's life, even in Mr.

Victor Plarr's discreet remembrance, and with Mr.
Symons' warning in mind, was a true comple-
ment of these poems, which reflect his less oblivious
moods, if with faint echoes yet with rare fidelity.
We may agree with Mr. Symons that " there are
men whom Dowson's experiences would have
made great men, or great writers ; for him they
did very little," and that he brought back from the
wilderness of London streets nothing to be com-
pared with what " Villon, Verlaine, Musset, Byron "
brought back. But he brought back something :
enough for the man and the poems to be insepar-
able in the smaller mould in which both were cast.
This identity, sufficient not complete, was part of
his sincerity, and it is this that wins our respect.
The poem to Cynara contains its most complete
expression, and will be as certain to attract the
reader of future anthologies containing it, as does,
for example, the " Vixi puellis nuper idoneus " of
Sir Thomas Wyatt.

 Perhaps because Dowson's poems and experi-
ences have become symbolic of the period, they
stand a little apart, for the representative is always
in some degree the exception, and to be true to
type is a distinction in proportion to its rarity.
We must therefore turn to others to see the dia-
thesis in proportion, and the same temperament
reflected in other ways. Mr. Arthur Symons is
the most convenient transition, and the two writers
are naturally linked because both have done admir-
able translations. Ernest Dowson's metrical trans-
lations are familiar in the poems, but not less

distinguished are his prose versions of French authors. It is hardly recognized enough how distinguished is the literary gift that achieves a good translation. It is the rarest blossom of literary craftsmanship, and the great translators take the rank of great authors. Though circumstances forced Dowson to this task, it could not have been very uncongenial, for he was asked to translate one of Balzac's short tales, and his preface to his version of the *Memoirs of the Cardinal Dubois* slyly refers to the " amiable characteristics " of their period. Dowson deserves a collected edition of his complete prose ; some of his stories have not been reprinted, and were we to have the translations as well we should do better justice to a small but exquisite literary talent. I commend this suggestion to the owners of our private presses, who do not do the work they should for the less-known corners of modern literature.

At the risk of seeming severe, I venture to assert that Mr. Symons' translations are the best of the verse that he has given to us. He is a fine critic, without whose work the movement would have lost one of its most distinguished members. By his metrical translations and his criticism he was the strongest link between English literature and French influences. But he was not a poet born ; he brought to poetry every gift that can be acquired without the specific poetical endowment. Consequently his verse is at its best when it seeks to render into English the quality of foreign thought and rhythm. When once the indispensable ele-

M

ment is supplied, all his gifts of scholarship, crafts-
manship and imaginative sympathy can accomplish
wonders. It therefore follows that he was designed
to be an artist in prose, and particularly in that
kind of interpretative prose, itself a form of trans-
lation, which we call criticism. The quality of
prose can be acquired : by diligent practice over
many years it is possible to write one's native
language beautifully. The Beardsley group is
interesting because all its members were distin-
guished by a scholarly respect for English, an
intense desire to write well. But Mr. Symons,
not being, except at one remove, a creative artist,
was at his best as a translator of verse, and most at
ease as a translator in criticism. Assuredly the
poet is made as well as born, but he must be born
first. The prose-writer, on the other hand, is
perfected in the making. Though Pater, who
influenced all of them, especially Mr. Symons,
pleaded for the cultivation of prose, verse remains
a temptation for all but the strongest literary
temperaments that are not poetical.

Mr. Arthur Symons is an example of this. His
verse shows all the qualities needed for good prose,
but these very qualities betray the absence of an
essence without which verse becomes no more
than prose made to measure. We hesitate to dis-
miss work that has so many honest claims to critical
attention, but these claims are to another form,
and it is really to his prose and away from his
verse that they invite us. Nevertheless, the critic
begotten by the movement, one of England's best

critics indeed, was among the characteristic verse-
writers of the period. This verse in substance,
temper, Latin sympathies, French influence, sensi-
tiveness to impressions, melancholy, craftsmanship,
was typical. The verse of Mr. Symons desired
the qualities that Ernest Dowson's poetry achieved.
It is in Dowson's poetry that we find the poetic
reality after which *London Nights* and *Amoris
Victima* were seeking. Can we read them with-
out recalling the verdict of Lionel Johnson : " a
London fog, the blurred tawny lamp-light, the red
omnibus, the dreary rain, the depressing mud, the
glaring gin-shop, the slatternly shivering women,
three dexterous stanzas telling you that and nothing
more " ? These verses, except the translations,
do not easily survive the decade in which they
were written, whereas Mr. Symons' critical prose
remains as distinguished as ever. On the other
hand, the symptomatic importance of these verses
on their appearance must be conceded. In this
return to the flesh and to Bohemia, an inland country
whose seaboard runs down every street, they had
their place, and perhaps the two concluding lines of
one verse from a lyric on this region contain the
verdict of experience on the eroticism that he and
his contemporaries sought :

> We smoke, to fancy that we dream,
> And drink, a moment's joy to prove,
> And fain would love, and only seem
> To love because we cannot love.

The egoism, the sensuality, the resulting disillusion

here record themselves wearily, and remind us
that egoism may signify an absence of personality,
and that bad resolutions are not enough to make
a sinner or a poet.

A more authentic poet speaks in the three poems
left by Aubrey Beardsley, whose ambition always
was to be a man of letters. Oddly enough, his
best verse is also a translation, and I do not think
that any competent critic will deny that the lines
beginning

> By ways remote and distant waters sped

are a beautiful poem. The manipulation of the
rhythm is exceedingly skilful, and the result is a
genuine poem, not an artificial piece of verse-
making, for the lines move us by a dirge-like
chant full of the Pagan wistfulness that provoked
them, and all experience proves that the genuine
poetic effect cannot be fabricated. The " Ballad
of a Barber " and " The Three Musicians " pick
up the eighteenth-century tradition at the point
where it was dropped by Pope, and the latter poem
especially recreates this tradition in the terms of
our own day to produce new and original verses.
They were, no doubt, experiments, but the literary
precocity that they show is so astonishing that we
would willingly exchange for them a whole library
of more pretentious verse. Their kind may be
small, but the quality of the gift displayed in them
is unmistakable. The two shorter pieces deserve
a place in any late Victorian anthology. There is
also an early drawing, very much in the manner

of Burne-Jones, which frames an as yet unpublished poem called " The Courts of Love " believed to be by Beardsley. As the drawing is in a high degree imitative, so the lines, a series of simple couplets, are probably an echo, of whom their very simplicity makes it difficult to say.

John Gray, the author of *Silverpoints* and *Spiritual Poems*, has several literary affiliations with the others. The most remote of these was a fiction, originally intended to be a joke, but it became practical when its mention in a newspaper was made the subject of an injunction. Gray was also the recipient of some of the last letters of Aubrey Beardsley, which he edited, and his own *Spiritual Poems* were printed by the Vale Press, founded by Mr. Charles Ricketts. The same artist, Mr. Holbrook Jackson reminds us, had previously designed the covers and supervised the type and pages of *Silverpoints*, published by Elkin Mathews and John Lane in 1893. This slim volume, which is almost the shape of a cheque-book standing on its end, has several points of interest. It is printed in a minute italic relieved by Roman capital initials, occasionally themselves set in a decoration. Most of the poems are inscribed, among others to Verlaine, Wilde, Ellen Terry, R. H. Sherard, Charles Shannon and Ernest Dowson. Altogether, in appearance, inspiration, intention, style and subject it is a very characteristic volume. The verse is that of an accomplished craftsman, very much in his own movement, who can write but cannot sing.

It is the curiosities of the pen, not the subtleties of the heart, that he reveals, seeking to intensify the convention then in fashion. Both Ernest Dowson and John Gray translated Verlaine's *Spleen*. Dowson's version sings itself charmingly into English, and becomes an English lyric on the way. Gray's rendering halts ; even his original verses seem to shun a smooth rhythm, as if, in this poem, to remind us that the vital objection to translations is that they usually rob us of our English. Indeed, the sense is apt to be at the mercy of Gray's interlaced little metres. He is often condensed or obscure, but always scholarly in manner. Domination is a word of five syllables to him, and when he rhymes heart and spikenard we know that the flaw seemed lovely to himself. He does not hesitate to distribute the word sun-beam between two lines, or to begin a line with the last word of a sentence, though he does not approach Gerard Manley Hopkins in these devices. Carelessness can never accomplish experiments like these, which are the careful licences of the craftsman. " The Barber," a poem not far in feeling from Beardsley's ballad, describes a dream that in any preceding decade would have been remembered differently. The two opening stanzas from the lines " To E.M.G." show John Gray at his best :

> Lean back, and press the pillows deep,
> Heart's dear demesne, dear Daintiness ;
> Close your tired eyes, but not to sleep . . .
> How very pale your pallor is !

You smile, your cheek's voluptuous line
 Melts in your dimple's saucy cave.
Your hairbraids seem a wilful vine,
 Scorning to imitate a wave.

The skill is undeniable, but does it touch anything
deeper than critical interest and curiosity ? Per-
haps it was because Gray was doubtful of this that
he left poetry for the priesthood.

We now come to a writer, who must be included
here because he developed as a genuine modern
poet one of the themes out of which the artistic
sympathies of the period was woven. He was
alone, I think, in the fullness and sincerity of his
apprehension of it, and this places him outside
the circle of men who were mainly abortive seekers
in all but the technics of writing; but this solitary
eminence emphasizes the vitality of the Pagan
ideal for which he stood, an ideal that absorbed
his soul while it attracted the senses of men who
were not scholars. I refer, of course, to Mr. A. E.
Housman. It is significant of the reverence with
which he regarded the Pagan ideal, that though
cradled, as it were, in London, he discerned it
where it still survives, not in the appetites that
haunt our city streets, but in the English country-
side where the old life has been least altered. He
studies it there, because the life there reminds him
most of the humanity that he admires in Pagan
times and classic authors. Like them, he is wistful
before death, which he will not seek to explain
away by entertaining any hope of immortality.
Like them, he admires excellence of body and brain,

especially the noblest of the virtues, courage. Like
them, to him life is tragic, and most moving for
the opportunity it gives to display the heroic quali-
ties in man. Again like them, he believes that
suicide may be a noble act ; and his heroes are
not famous or eccentric people, but local athletes
at some moving moment of their lives, country-
folk, indeed humanity itself as it lives under ancient
rural traditions :

The lads in their hundreds to Ludlow come in for the fair,
 There's men from the barn and the forge and the mill and the fold,
The lads for the girls and the lads for the liquor are there,
 And there with the rest are the lads that will never be old.

We are fated to lose our battle, he seems to say,
but that does not matter so long as we live and
die bravely, remembering that where we stand the
Greeks and Romans stood, and could do no less
and succeed no more.

Unlike other writers who have found their most
congenial influence in classic literature, Mr. Hous-
man revives the substance rather than the acci-
dents of Paganism. He is grave, noble, austere,
and writes of the body with a dignified simplicity
as if it had always been to him the foundation,
and not the disturbance, of human life. There is
a simple strength, a grave sweetness in his utter-
ance, which is very moving. Such lines as

> Lovers lying two and two
> Ask not whom they sleep beside,
> And the bridegroom all night through
> Never turns him to the bride

fall on the ear with an antique beauty, a sense of
vanished splendour, such as is given by the sight
of a piece of Greek sculpture unexpectedly found
in some uncrowded corner of a country house.
There is a rebuke in this poetry, as there is in
Greek sculpture, for all that is not simple, restrained,
and strong. Only in its reverence for what has
perished from the world is there anything romantic
in its wistfulness. No writer is more original.
He has no modern models or imitators, and did
all other modern verse perish, Mr. Housman's
poems would be like the Greek Anthology of our
tongue. Life, to him, has much good but more
ill for humanity, and it is this note of disillusion,
in a scholarly sense very unlike that characteristic
of the decade, which, with his classic sympathies,
binds him to, but places him above, it. His work
is small in quantity, but he is perhaps the only
poet, technically a minor, who seems too great for
such a term. The most manful sight in the world
to him is that of a Greek statue, and we feel that
he has assimilated the living secret of its nobility
as few connoisseurs or æsthetic admirers have ever
done. Every true author is the writer of some
one book, but Mr. A. E. Housman is the author
of none other. He reached his aim at a single,
deliberate stride, for the *Last Poems* admittedly
date, for the most part, from the period of *A
Shropshire Lad*, and contain nothing, even the
War poems, that are not akin to it. The earlier
patriotic poems would have seemed an excrescence
if patriotism were not a Hellenic virtue, and I

mention them here to make one criticism on the
" Epitaph on an Army of Mercenaries," which
has been called the best poem produced by the
War. It certainly shows Mr. Housman's tech-
nical resources at their most splendid ; the rhythm
is so superb that people seem to overlook the
meaning, which is outrageous in its patronage
of God. But the display of metrical mastery re-
minds us how much skill was spent on the apparent
simplicity of the earlier volume, which has earned
for him the reputation of a dozen of its size.
Compared with his, the Paganism of Swinburne,
Symonds, Pater, seems a literary and scholastic
affectation. Indeed his " home-sickness " was not
inverted, but real. The result was a book that
was original and enduring, and by comparison
with it the other work of the decade is seen to be
not the new creation that it believed, but the final
exhaustion of an impulse.

A Shropshire Lad was written in the spring of
1895 when, the author tells us, he was visited by
a " continuous excitement." It is to *Poems and
Ballads* somewhat as Lucretius is to Catullus, for
it gives us rather the roots than the flowers of
Pagan Rome. The most subtle of its metres haunt
us strangely, because they seem to accompany
themselves with a strain of independent, but half
audible, music. As we read, we surrender our-
selves, now to the accompaniment and now to the
measure, in an alternating and hardly expressible
joy. When we try too intently to overhear the
accompaniment, the measure draws us back to

itself as the dominant partner. This poetry, at
its best, is the marriage of physical content and
spiritual desire. It dissolves the listener in an
ecstasy, as a man lying on the earth in summer is
dissolved in the light and scent and sound about
him. When the page has fallen on our knees,
we wonder if any composer could capture the
musical notation of this mysterious accompaniment
which fills while it eludes our mortal ears. The
question makes us understand why Lovat Fraser
and other artists have desired to illustrate *A Shrop-
shire Lad*, and why too Mr. A. E. Housman
answered even Lovat Fraser in the negative, though
his designs have now been given separately to the
world. We should however have thought that
the rhythm of such poems as

" Be still, my soul, be still ; the arms you bear
are brittle,"

The no less superb movement of

> We'll to the woods no more,
> The laurels all are cut,
> The bowers are bare of bay
> That once the Muses wore;

or

> He stood, and heard the steeple
> Sprinkle the quarters on the morning town.
> One, two, three, four, to market-place and people
> It tossed them down,

would have proved irresistible to musicians, and
if this be their effect upon the most humble of
concert-goers, who must be to the composer as
the deaf-adder to the charmer's voice, how much

more then these poems should awaken in an inconceivably more responsive ear !

The antithetical strand to Paganism in the skein of the time was that of Christian mysticism. Hints of it were everywhere found, especially in Francis Thompson and Mr. Laurence Housman, but since the latter was more akin to the Pre-Raphaelites than any of the group, he deserves to be mentioned first. Like Rossetti and William Morris, Mr. Laurence Housman was not content with one art. He wrote not only poems and fairy-tales, but made charming drawings for them, and designed bookplates and covers and title-pages, so that his volumes are delightful possessions, which link the nineties to the sixties by carrying on the same tradition. In the poems a casuistry of feeling, devotion and disillusion are found together, so that we are forced, despite the art displayed, to see in the devotion mainly an æsthetic motive. An interesting collection could be made of the devotional poetry that has been written by sceptics, and were it undertaken, I think that Mr. Housman's volumes would be laid under heavy contribution. It is only because the current is now setting in another direction that *Spikenard* and *Green Arras* do not attract more readers, for the devotional poems in these books convey, sometimes exquisitely, the emotion of belief, and the pages, like the decorations, overflow with an intricate and learned fancy. *Spikenard* begins by quoting two lovely verses from George Herbert, and if Mr. Housman's poems miss his forerunner's simplicity, it may be because no one

except an unsophisticated peasant can believe now as simple-minded folk believed three and four hundred years ago. There was a haunting pathos about most of the literature written by the Pre-Raphaelites, and it lingers like a faint perfume in Mr. Housman's poems. It evokes memories of youth and undefined desires, and the will to believe and unencumbered horizons, always with the sense that the service of the altar was being attended for its mystery and not for the accidents by which the ritual makes to the senses its immediate appeal. Poems like "The Cornkeeper" haunted one's imagination with the feeling of that fatality that Rossetti and Morris knew how to render so well, and it was only in the rhythms that betrayed the influence of Swinburne that Mr. Housman seemed to be echoing anyone but himself. In any review of the devotional poems produced by the group to which I think he ought to be related, Mr. Housman's verses seem the most longing, for it was not discipleship but sympathy that bound him to the Pre-Raphaelites, from whom he was separated only by the accident of time. I return now most often to his drawings, to the illustrations to "The End of Elfin Town" and to those in his own books. These reveal a talent as unmistakable as is the school to which they belong by natural right.

The ecclesiastical mysticism, so called because several of the writers who employed it were sceptics, was approached from within by Francis Thompson. It was but right, therefore, that he and none other should have been the author of "The Hound of

Heaven," the one great religious ode that the period produced. This was as it should be, for he was a devout Catholic who found more in common with his friend, Coventry Patmore, than with any contemporary poet. Thompson does not use mystical language for the sake of its effect. It was his natural idiom, particularly when expressed in the Latinized English of his favourite seventeenth-century writers. But he has many affiliations to the group in connection with which perhaps his more sectional admirers will be reluctant to place him. He, too, was a Romantic born out of due time, whose life enacted the legend peculiar to the period except that, by the goodness of two friends, it was happily reversed. He fell from poverty to beggary, relieved by opium, but his sordid experiences were not sought for their own sake and left him unsoiled. But as free as you like from decadence in his life, he was, critically considered, the most decadent of writers. The term is thus used to describe "the learned corruption of language" which was sought first in France and then here, perhaps by Thompson because it had been employed by the old authors with whom he was most in sympathy. His style is almost as heavy with the coinage of Latinisms as that of Sir Thomas Browne or De Quincey, in the latter of whom poetic prose began again in the early days of the Romantic movement. Thompson also played a scholar's tricks with words, but his gorgeous sonorities, if not always happy, have only to be compared with, say, *The Sphinx*,

or the rhetoric of Stephen Phillips, to convince us, for example in the extravagant "Judgment in Heaven," that Thompson was the spendthrift of a talent in this kind that was far beyond the reach of Phillips or Wilde. He was also a critic of convention, a defender of the body, in an unexpected and curious way. He composed an interesting tract against mortification, in which he reminds the reader that the body has terrible revenges for those who abuse it, however pious their motives may be. " It grows a vain thing to mortify the appetite," he exclaims, " would we had the appetite to mortify ! " " We cannot merely ignore the body : it will not be ignored, and has ungovernable avenues of retaliation. . . . He that sins strongly has the stuff of sanctity rather than the languid sinner." Therefore, runs the conclusion, " to foster the energies of the body : yes, and to foster the energies of the will ; that is the crying need of our uncourageous day. The most potent ally of the Church and ultimate stickler for an ascetic religion—Nature. Holiness energizes . . . one might almost say it prolongs life."

He was like the group also in this that he cultivated his prose with the same ardour as his verse, perhaps with more, since verse was his natural language needing rather to be curbed. He coloured all his language with the scientific idiom that he learned during his days as a medical student. Two characteristic instances are : " Poetry is a thermometer : by taking its average height you can estimate the normal temperature of its writer's

mind " ; and the passage where he speaks of
Shelley's " power of apprehending everything in
figure " : " The dimmest-sparked chip of a con-
ception blazes and scintillates in the oxygen of
his mind," a simile that recalls the experiment
that every medical student is invited to observe
at his first lesson in chemistry. A poet's love of
words can gratify itself in many ways ; but, whether
he turn, like Petronius, to the racy idiom of the
Suburra, or like Shakespeare, in Dr. Johnson's
words, " sometimes to the sports of the field, and
sometimes to the manufactures of the shop," it is
the technical vocabulary that lures him, and the
Beardsley group exploited its resources to the full.
Though he remained all his life in the religion in
which he was born, Francis Thompson was of his
age also, and the incompleteness that resulted
justified the final criticism of Lionel Johnson that
the poetry of Thompson was " never noble, only
sublime." His story is not unlike that of Dowson's
happily reversed, or Lionel Johnson's happily pre-
vented, for Thompson descended into hell in the
early part of his life. With every allowance, he
belongs to the group, perhaps because the visible
movement was no more than the eddy on a wider cur-
rent in which the Romantic impulse sighed itself out.

 This current must, I think, include Lionel
Johnson also, despite many characteristic differ-
ences. Unlike the rest, Johnson was more intel-
lectual than imaginative, and his home-sickness
was for the dogma and stern thinking of scholastic
philosophy. He was indeed almost a lay theolo-

gian, who referred to the " unspeakable vulgarity
of those who do not believe in eternal punishment."
He was austere and restrained in mind, a noble
reactionary, seeking in the intellect that return to
unity which the others sought in the senses or in
mysticism or in art. Of all the converts to Rome
whom the pursuit of individualism left otherwise
exhausted, Johnson was intellectually the most
logical ; but his return, which failed to unify his
life no less than theirs, must seem the confession
of an exhausted impulse even to those who accept
his religion as the ultimate truth. He had, more-
over, definite affiliations with the others. He was
the most just, if the most severe, critic of their
verse, as all will admit who remember the pithy
sentences in which he defined them to Katharine
Tynan Hinkson, sentences since included by Mr.
Ezra Pound in his edition of the *Poems*. Mr.
Yeats tells us that the favourite phrase of Lionel
Johnson was " life is ritual," and this, if variously
interpreted, expressed their prevailing attitude to
life. The others thought that life ought to be
ritual ; their sympathies were with usages and
decoration, but Lionel Johnson, the theologian,
believed that it was. He was a sterner thinker
than they, and carried a tendency, emotional in
themselves, to a logical conclusion beyond their
scholarship. They believed that English should
be written as if it were a learned language, and
loved Latinisms and the happy subtilties of speech.
He wrote poems in Latin, and in English as if it
were Latin, with a learned punctuation of his own.

N

He did not write English as if it were inflected,
but with a marmorean dignity and severity of grace.
His most characteristic poem was " suggested by
a statue of King Charles at Charing Cross." In-
deed, all his poems seem incised on stone with the
quality in the written word that fine lettering gives
to inscriptions. Dr. Johnson's hope that the walls
of the Abbey would never be disgraced by an inscrip-
tion in English, must have been sympathetic to his
namesake, who succeeded in redeeming English
from disgrace, if anyone could ! On the whole his
criticism is finer than his verse. The latter contains
two poems that belong to the history of the period.

Tradition associates the sonnet beginning

> I hate you with a necessary hate

with Wilde or, as one hopes, with one of Wilde's
disastrous acquaintances. There is also the re-
markable Latin poem in which Lionel Johnson
acknowledges enthusiastically the receipt of *Dorian
Gray*. The latter, which is not included in the
Poems, is to be found in Stuart Mason's *Art and
Morality*, and from this text I quote the first and
the most eloquent of its subsequent verses :

> In Honorem Doriani Creatorisque Ejus.

> Benedictus sis, Oscare !
> Qui me libro hoc dignare
> Propter amicitias :
> Modo modulans Romano
> Laudes dignas Doriano,
> Ago tibi gratias.

> * * * *

Amat avidus amores
Miros, miros carpit flores
 Sævus pulchritudine :
Quanto anima nigrescit,
Tanto facies splendescit,
 Mendax, sed quam splendide !

This poem, when read in its entirety, and that other
upon the Dark Angel

who still dost
My soul such subtile violence.

Through thee the gracious muses turn
 To furies, O mine enemy !
And all the things of beauty burn
 With flames of evil ecstasy,

proclaim a strain in Johnson that the severity of his
writings generally might tempt us to overlook, did
not the craving for drink that conquered him prove
that his serenity was intellectual only. It sufficed,
perhaps, for him to know good and to know evil,
and each kind of knowledge fed an intellectual pride
that doubtless heightened the fascination of either.
The shadows and the stern intellectual morality
seem to show that he too was caught at the deba-
table moment of a tide at its extreme ebb, and
was unable to discern more than the contradictory
current of its directions. Religion, sincerely held,
could not save him, for intellectual apprehension
is not enough. His moments of perception were
followed by their moments of eclipse. He suffered

from a malady of the will, and was deprived of
unity because he mistook the tree of Knowledge
for the tree of Life. In this confusion his virtues
became dangerous to him, and he too is typical of
the characteristic antithesis that divided the energies
of the time.[1]

[1] A friend, who knew him, writes: "He had four literary
passions, Æschylus, Cardinal Newman, Victor Hugo, Lucretius.
. . . Newman and Victor Hugo were inconsistent authorities;
and indeed I can never read Johnson without asking myself whether
good theology would not debar a believer from such satisfaction
with the writings of infidels and heretics. In his undergraduate
days he had not yet accepted the Roman creed. He met, it is true,
some words of mine with ' Perhaps I am too Christian to agree
with you '; but this might have been due to his noticeable wish
to differ from his hearer. His points of opposition were well
taken, but they were taken for the sake of opposition. . . . When
he had made, or was about to make, his submission to the Latin
Church, he informed me that this action was ' wholly for purposes
of controversy.' There was the same lightness in his advocacy
of Home Rule: ' Don't you think that it would be the most
picturesque thing that could happen ? ' His criticism of style
was solid. All extraneous considerations were laid aside; he
showed free appreciation and discrimination so that you felt a
pervasive justice and almost that he did not care what the admirable
author maintained. . . . In the New College Essay Society, of
which he was President, he was a delight, and himself delighted
to offend plain Britishers, disposing of their contentions with
chilly urbanity, in which there would sometimes lurk the suggestions
of a contrary meaning, as when he told us with pontifical gravity
that there was ' quite as good proof of the existence of devils as,
let us say, of angels.' . . . I was not surprised that Lionel's
taste for phrases and his want of conviction, at least while at Oxford,
should dispose him to invention. His eye was on an effect achieved

There was no unity for these men, because they desired a lost synthesis that they could neither recover nor replace with something else. The constituents of the old, for them at least, had dispersed ; the constituents of the new had not been, are not yet, assembled ; and the ego was left shivering with the choice of one or more fragments of a disrupted tradition that refused to cohere.

All the members of the ninety group were derivative, all in revolt against the age in which they lived. But alone of them all John Davidson was incoherent ; in this he was, in a way, sincere, for he mistook incoherence for poetic frenzy. It was, indeed, his personal experience and substitute for it. The matter was complicated further because he definitely desired a new gospel to preach, and, failing to enunciate it, in the words of one of his characters he " called his least caprice the law of God." He was a Nietzsche without his genius, but has the interest of one who pondered over the world and dreamed of things to come. To have his due, John Davidson needs, more than any recent poet, a volume of selections. He tried, a little rhetori-

with good taste . . . His damnations were of phrases . . . I liked Johnson. I thought him a good critic and a discriminating controversialist. I could not find that he revered truth."

It is noteworthy how this criticism, by a contemporary and sympathetic observer, touches upon points that were common to the group. There is hardly any typical figure to which it could not apply, and I am therefore grateful for permission to print it. To all of them, as to Gautier, the perfection of form was virtue.

cally, to " think God's thought before Him," and,
in overleaping the mood of the decade without
achieving an affirmation, he falls between the dying
century and the new, or is, if you prefer it, a plank
of the temporary bridge between them. The chaos
of his verse reflects the confusion of his mind ; there
was generally, as Mr. Archer well says, " more fire
than finish " about it. His favourite writers were
the Elizabethans, who probably did him more harm
than good, for he possessed all their vices with little
of the real power that made them bearable. At his
best, he is apt to shine like the moon with a reflected
glory. He was intoxicated with the idea of fame,
and when this was denied to him he committed
suicide. His dramas and his Testaments are diffi-
cult to read without impatience, so inordinate is
their language, so imperfectly sifted is their thought.
On the whole, his best writings are the *Fleet Street
Eclogues*, but even in these the flashes for which we
wait while we are reading them often seem on turn-
ing back to be rhetorical. Like the others, David-
son was out of sympathy with his time and dis-
satisfied with himself, but he was not content to
celebrate these wants in verse that should seek
something tangible in every mood that waylaid him.
He was hungry for the idea, and for the reputation
that the discovery and the statement of a new and
moving idea brings with it. This made him a
poet of the transition rather than a poet of the
decadence, and indeed he was inspired more than
once to sing the view of the world which the theory
of evolution has brought with it :

He works but as He can ;
God is an artist, not an artisan . . .
And soon the great idea came.
" If I could give my work a mind ;
If I could make it comprehend
How wondrously it is designed." . . .
Trembling with ecstasy He then made man,
To be the world's atonement and its prince.
And in the world God has done nothing since :
He keeps not tinkering at a finished plan ;
He is an artist, not an artisan.

That is a fair specimen. It invites an attention that it is unable to sustain, whether as verse or thought. The line about the artist, that evidently pleased its author, does not well bear repetition ; and when we come to examine the substance, we discover a most unscientific assertion. The theory of evolution implies no " finished plan." It implies a continual endeavour to discover a plan that shall prove worth pursuing, and this involves a continual tinkering for the sake of those immediate slight improvements that in the aggregate constitute a difference of kind. None of Davidson's poetry, except here and there a vivid, if rhetorical, bit of description, will bear careful examination either by the mind or by the ear, and we are forced to regard him as a rhetorical writer whose works seem to say more than they really say, and whose effects lack a subtlety of rhythm. He too was a member of the Rhymers' Club, and, like the majority, he failed to achieve unity. There was something logical in his end. He drowned himself, and this

final impulsive act of his has the pathos of the outburst of a weak man who retaliates savagely upon a foe that he is unable to master. His language was violent because his will was weak, and his verse expresses the qualities that he desired but did not possess. The boisterous individuality of the Elizabethans captivated him, and he was shut in upon himself with the dreadful loneliness of a man who cannot escape from the sense of his own shortcomings. The reckless desire of the moth for the star can have no other end than suicide in a lighted candle.

Another seeker for affirmations, and more nearly an affirmative poet, was Francis Money-Coutts, afterwards Lord Latymer. I include him here for an act of courage which led him to support and stand by those concerned with the movement when the crash of 1895 led so many to desert their friends and deny their acquaintances. He was not a poet of moods or impressions, but a thinker. In *St. Love the Divine* he says that, æons hence, soul and senses are destined to be reconciled, thus differentiating him from the characteristic attitude, which was to accept the duality and to seek the satisfaction only of one or the other. He needed, and usually found, a substance for his style, and his point of departure from the group is that they preferred on the whole style to substance, and passing moods to the enduring simplicities of feeling. It is a surprise to read him. When we are tired of the familiar masters and resort to the smaller names, we often come to an honourable company and find

ourselves astonished at the lovely extent of the
underwood. In this company Lord Latymer's
verses have an eloquent and dignified place, and
we leave his work with the thrifty sense that we
are carrying away something to remember, that
leaves us thinking.

The name of Sir William Watson may, at this
point, occur to some readers. But surely his
Vergilian dignity of phrase is not a characteristic
product of the period? It is true that his early
poems show some influence of the Pre-Raphaelites,
but this we should expect from the date of his birth.
Beyond this I discover no affinity with the point
of view of the *Yellow Book* writers. Sir William
Watson, on the contrary, is rather in the Tennyson-
ian tradition, in its later phase when the laureate
had deserted the Lady of Shalott to celebrate, in
his auguster mood, Roman Vergil, Tithonus or
Lucretius, and, in his less profound moments, the
reigning family. Sir William, indeed, contributed
to the *Yellow Book*, as Mr. Shaw did once to the
Savoy, but one yellow feather makes a goldfinch,
not a canary.

Rhetoric is more popular than eloquence or
poetry, and it was upon the public's incapacity
to distinguish between them that Stephen Phillips
won contemporary renown. The best critics did
not accept the popular verdict, but he still has
believers who prophesy his eventual return to
favour. His main successes were with his dramas,
which happened to suit the policy of pomp that Sir
Herbert Tree was conducting at His Majesty's

Theatre. The verse of *Paolo and Francesca, Herod, Ulysses, Nero*, was the metrical equivalent of the scenery in which Tree, and one or two other managers, delighted. They failed to see that such verse made such scenery unnecessary, and that a spectacle should not be interrupted by a play. The verse was a popular version of Francis Thompson's jewelled eloquence, but the utmost that can be said for it is that rhetoric is a form of its own, that his is no further from poetry than some Elizabethan writing, and that Phillips had some sense of the melodramatic opportunities of the stage. He could " bombast out a blank verse " with anyone, but his best differs only in degree from his general tumidity. Probably *Paolo and Francesca* would best endure the test of revival ; and though anyone who wrote a new *Marpessa* or *Christ in Hades* would reap a large reward, the kind requires the excitement of a new author to impose on the public. Its fate is to gain the immediate and passing success at which each individual line aims. This mode endeavours to silence our judgment by a magnificent sweep, and, in truth, it passes over our ears, like a wave whose impulse is exhausted in the effort, leaving no impression, when once it has surged by. It is not that Stephen Phillips had no gift, but that he has been praised for the wrong one, and the excesses of his first admirers are now laid with corresponding severity upon himself.

The figure-head among the poets of the time, who embodied the public idea of the poetic personality, was Mr. Richard Le Gallienne. To the

writers of the nineties he was what Rupert Brooke
became afterwards to the Georgians. But, unlike
Brooke, he failed to achieve the poetic act of dying
young. His name, his appearance, his sympathies
seemed, like Brooke's, designed for the part he had
to fill. But beside possessing the pretty virtues of
his successor in the public imagination, Mr. Le
Gallienne did yeoman service. He was a pub-
lisher's reader, and is still gratefully remembered
as one of the best of his tribe. He was also a
practised reviewer who did much to secure a public
welcome for the works of young writers that might
have missed due attention save for him. He was
never afraid to praise. Thus his two volumes of
Retrospective Reviews have the interest which he
claimed for them, that of " a literary diary of the
time." These reviews are also interesting because
they indicate the extent, only known to those behind
the scenes, of the services rendered by Mr. Le
Gallienne in securing public attention to a school
of mostly young writers who in many respects were
antipathetic to the surviving current of taste, and
had to make their way by creating the response
without which they could not be enjoyed. He
contributed none the less definitely to the tendency
because his most important gift was neither his
verse nor his prose, but the focus of his name and
personality, his reports to his publisher, and his
critical encouragement in a score of widely read
newspapers. His verse is often dainty and grace-
ful, but it is not strong, original, or free from the
minor lapses of taste that make certain aspects of

things intolerable if they are not touched with direct simplicity. His poems suffer at times from a curious mixture of sensuousness and sentiment. Either by itself can be charming, but the two cannot be mixed without disaster. Sensuality and passion may be well, either severally or in conjunction, but sensuousness and sentiment, being fragile flowers, perish if they be not kept apart in the carefully guarded seclusion necessary for their existence. Apart from this, the general defect of Mr. Le Gallienne's writing is that it leaves us with the question whether any of his verse would have been written if he had not had a taste for reading. His inspiration seems to derive more from the printed volumes on his shelves than from inner necessity. He has evidently been from early years unusually susceptible to literature, and if this susceptibility were enough he would have made a great reputation. But by itself this quality becomes in the writing an echo of the printed word rather than of the active imagination. Publishers have been responsible for more books than the instinct of authorship itself engenders, and Mr. Le Gallienne's verses do not wholly rise above this derivative class. In the *English Poems* of 1892 the best perhaps is one called " Beauty Accurst," from which we may take the following verses :

> I am so fair that wheresoe'er I wend
> 　Men yearn with strange desire to kiss my face,
> Stretch out their hands to touch me as I pass,
> 　And women follow me from place to place. . . .

Two lovers kissing in a secret place,
 Should I draw nigh—will never kiss again ;
I come between the king and his desire,
 And where I am all loving else is vain.

Lo ! when I walk along the woodland way
 Strange creatures leer at me with uncouth love,
And from the grass reach upward to my breast,
 And to my mouth lean from the boughs above.

The sleepy kine move round me in desire
 And press their oozy lips upon my hair,
Toads kiss my feet and creatures of the mire,
 The snails will leave their shells to watch me there.

This combination of beauty and fatality is charac-
teristic, but the final verses, not quoted here, just
fail of the expected climax, and are typical of the
absence of a salt without which the grace and dex-
terity are unsatisfying. In a poem, " To a Dead
Friend," he writes truly :

Poor selfish tears ! we weep them not for him,
 'Tis our own sorrow that we pity so,
 'Tis our own loss that leaves our eyes so dim,

but where love can no longer help the loved one, a
selfish sense of loss is all that remains for it to feel,
and the implied criticism is unconvincing. There
is a curious satirical piece, " The Decadent to His
Soul," in which the decadent amusingly confesses
that he

Eat strange dishes to Gregorian chants,

but the poem leaves us pleasantly in doubt of its
author's personal attitude.

Writing of John Gray, the author of *Silverpoints*
and the recipient of a few last letters from Aubrey
Beardsley, Mr. Le Gallienne discusses the meaning
of the term decadence, and finds its real core to
consist " in its isolated interests," without regard to
the particular theme chosen in its relations to " pity,
morality, humour, pathos." We may infer, per-
haps, that Mr. Le Gallienne was in sympathy with
some of the achievements of the school, but endea-
voured to avoid its excesses, and to relate its point
of view to larger things. This would explain the
mixture to be found in his verses, for only an excep-
tional vitality could unite successfully the parts to
the whole in the movement of his time. The
obvious risk of this endeavour was to fall between
the two tendencies that he was attempting to unite.
In failing to accomplish that which we set out to do,
we sometimes succeed in an unsought direction,
and if Mr. Le Gallienne is scarcely a poet within
nor beyond the decadents, his double sympathies
made him an invaluable interpreter of the writers
of his time, and this service can hardly be empha-
sized too strongly since the evidence for it is neces-
sarily the cherished recollection of those who do
not tell all they know to the general public.

" Poetry," says Mr. William Archer in his
general survey of *The Younger Generation*, " has
the religion of the future in its hands," and " in the
like manner must the religion of the future spring
from some body of poetry potent enough to give
the spirit of man a new elevation and a larger out-
look upon nature and destiny." By this test, of

course, the peculiar poetry of the nineties fails. It was rather, as Pater discerned when thinking of the Pre-Raphaelites from whom it derives, the product of a special epoch. Artistically, it is seen to be the expression of a finally exhausting impulse. It became, therefore, the poetry of an age which, having lost its convictions, was asserting the rights of the only entity left, the ego, to develop itself in any direction without heed to existing conventions. Its only affirmative motive was that of a personal, isolated individualism, except where it confessed its exhaustion either by suicide or relapsing into the arms of the most paternal church. The centrifugal tendency, which was started at the Reformation, became complete, but only in the last decade of the nineteenth century did men become fully aware that they were living in the Age of Hamlet, the symbol and prophecy of the succeeding three hundred years. Some, like Lionel Johnson, attempted an intellectual return ; others, like Dowson, beat against the bars of their prison, but both were foiled, for the synthesis, once abandoned, cannot be recovered, and for all not born out of their time into an earlier state of unsophistication, it has to be recreated from the foundation in terms of everything that has happened or been imagined since. The poetry written under these conditions achieved little that was new, but at least it accepted the ruins, and was sincere in this that it declined to confuse morality with religion. The instincts were reasserted again, and the legacy to us is some beautiful verse and a surviving memory of a state

of soul from which we have not yet escaped, though the present generation prefers to ignore the confusion, and to make verses about a variety of things without confessing its absence of conviction upon many of them.

CHAPTER VIII

The Prose Writers

QUALITIES similar to those that Pater discerned in æsthetic poetry are to be found in the prose of the time, which tends to divide itself into the decorative or the realistic manner. Among the earlier characteristic examples of the former was the *Ten o'Clock* lecture by Whistler, so much admired by Max Beerbohm. This and its complement at the other extreme, the *Confessions of a Young Man*, by George Moore, were discussed in an earlier chapter, and of Wilde's prose nothing more need be said. It is more convenient here to start with *Under the Hill*, that astonishing fragment in which Beardsley, as was his wont, carried a particular convention to its extreme conclusion. Unlike many extravagancies, *Under the Hill* remains an interesting book, and, like its author's verses, displays a precocity of talent which seems to make all things possible to him. The dedication, with its elaborate compliment and ornate grace, would have pleased Congreve and delighted Pope. It is a piece of pastiche that rivals its originals, a mince-pie of prose garnished with aromatic sauces. It perfects a

manner of writing in which the parts are more
important than the whole, the details than the sub-
ject, the sentence than the paragraph, the epithet
than the phrase. Only the punctuation is ordinary,
and if the proof-sheets could have been passed by
Lionel Johnson this convention also would have
been reversed. The language is carefully cor-
rupted by the smuggling of foreign words, and
trifles become important from the gravity with
which they are mentioned. Thus we read of pan-
toufles for shoes, of fardeuse (not to be translated),
of taper-time for twilight, of chevelure for hair, of
the little mutinies of cravat and ruffle, of every
depravity of phrase that a vivid imagination and
indiscriminate reading can pack into the opening
paragraphs. The catalogue is ransacked for elabor-
ate and, if possible, incongruous details, and the
whole is allusive with references to obscure books,
technical minutiæ, and fantastic knowledge. The
literary skill is displayed in the use of common, no
less than recondite, words not ordinarily found in
literature, such as spellicans or vallance. There are
wayside flashes of wit, as in the description of the
banquet when, we are told, " mere hunger quickly
gave place to those finer instincts of the pure gour-
met," or again in the footnote that explains why it
was remarkable for St. Rose of Lima, at the age
of four, to vow herself to perpetual virginity. The
footnotes seek to be more pungent than the text ;
a fictitious learning is invented ; imaginary books
are mentioned, such as *A Plea for the Domestica-
tion of the Unicorn*. Only a potential master of

words could contrive so artificial a texture of language, in which the extremes of refinement and colloquialism jostle side by side, and the subject, the treatment, the very words, become separate inventions. It is the kind of fragment that we can almost imagine the author of *The Rape of the Lock* to have invented, if it had occurred to him to employ his fancy on a prose burlesque. Though the trick, once accomplished, becomes obvious, the result has defied imitation, and the one attempt that has been made, *The Nuptials of Count Fanny*, by Simon Arrow, is little more than an ingenious tribute of admiration. As a decorative prose fragment, *Under the Hill* remains unique, and reveals the characteristic of the time : to value technical accomplishment above every other quality. Elizabethan euphuism makes dull reading to-day. Will the style of the *Ten o'Clock* come to seem finical, and this fragment of Beardsley also assume in time the air of an obsolete absurdity ? It does not follow, for euphuism was an ornate manner of saying ordinary things, whereas in the later invention the subject and the ideas were also provoking and strange. Everything is directed to produce an appeal to the more imaginative senses, to gratify microscopic curiosity. *Under the Hill* is our one example of the grotesque in modern prose, and attained its aim in the extreme of possible contrast to the conventional standards of Victorian writing. If Dickens is an instance of an author who was all humanity and no technique, Beardsley is an instance of an author who is all technique and no humanity.

But, to be just to this reaction, we must not judge the conventional standard of Victorian literature from the works of Victorian men of genius. No genius is typical ; and, with the comparison of Tennyson in mind, insistence on the tediousness of the contemporary ideal becomes itself tedious and misleading. We must forget works by a few exceptional men of genius to recall the staple of the age, those books now forgotten that lay on every table and filled every Victorian shelf. It is still possible to enter a Victorian house that has survived unchanged from the middle of the nineteenth century. This experience recently happened to the present writer, and it made the Beardsley reaction seem inevitable. It was like entering the home of the Dombeys without the humour of Dickens to make the facts bearable to the eyes. The ornate overmantel, bristling with mirrors and vases standing upon obtrusive shelves, was a conspicuous altar in honour of ugliness. It was extraordinary that such things should have been made, and it now seems far more perverse than anything of Beardsley's that they should have been collected in one spot together. It is difficult now to realize that there were virtually none others to be had. Every object ministered to a mind diseased, to an artificial corruption of taste that is without parallel. In the centre of the mantelpiece was an (ugly) ormolu clock ticking beneath its glass cover, and flanked on either side by a pair of hideous bronze horses. Against the ornate brass of the fender, twisted into fantastic coils, was a white hearthrug, and beyond,

a floriated carpet that mimicked the contorted paper on the walls. Enormous dahlias in bright colours peeped between the framed engravings of Doré, and the floor was studded with occasional tables and crowded whatnots, sprinkled with gilt albums and framed photographs. Bright cushions reposed in the chairs, which seemed to overflow into white lace antimacassars. Everything looked as if it was meant to be seen but not used, and the windows were draped so heavily with double curtains that the blanket of stale air was the only neutral presence in the room. Against two recesses in the walls was a couple of lacquered bookcases. There reposed many volumes the names of which I had no leisure to record, but hardly one in any way connected with imaginative literature. There were sets of the *Leisure Hour*, of the *Sunday at Home*, the only ones whose titles were familiar. I turned the pages of one unrecognized volume, when there came back, as in a dream, the sense of the nameless tedium of this literature, and the explanation of the revolt of the children from all that it taught, recommended, or desired. It is so much forgotten now that it would scarcely seem credible if it were resurrected, yet this was the atmosphere in which Victorian childhood was brought up. The formidable mass of dullness and hypocrisy was, however, carried to such lengths that the product of the nineteenth century must be unique in the history of printing. My hand chanced on a volume of anecdotes intended for children. Among them was one of a small boy who was asked by his father

if he was ready to die. "Not yet," replied the
child. " Not yet ?" said the father sternly. The
child, perceiving that his reply had been the wrong
one, and anxious to avoid a whipping, then ex-
plained : " Not till I have a new heart." The
smile of satisfaction that must then have overspread
the father's face is too horrible to dwell upon. Was
not the revised answer a sign that the child of an
old, perhaps unconscious, hypocrite was growing
into the likeness of his father ? What a gulf
separates the Victorian genius from such writing ;
yet, having escaped from its clutches ourselves,
we see ungratefully the infusion that remained in
the great authors. If any reader will spend a day
over such books, the only books then accessible to
children, he will come to believe that the picture in
Dickens' novels is no caricature, and is only thought
to be so because the descriptions are made by one
who was a humorist as well. The Victorian home
is not misrepresented in, say, the first chapter of
Dombey and Son. The average was similar and
often worse. It is natural that we should shrink
from such a conclusion, for it is the nature of evil
to seem incredible so soon as it is recognized to be
itself. The facts refuse to be explained away, and
this room, this ugliness, these books, inevitably led
to *Under the Hill*, which was their exact opposite
in every particular. Place the two ideals fairly
side by side, and it becomes extraordinary that the
Beardsley period should have been attacked more
vehemently than the period against which it was
reacting. The perversity and the corruption are

upon the earlier side, and, compared with them, the Beardsley period is natural and healthy. The centrifugal tendency that led first to a repudiation of traditional religion and then to a mask that disguised its decay, resulted in an anarchic individualism of conduct, in a gathering sense of disillusion in regard to life, and finally came to be reflected also in a style which sacrificed everything to decorative detail, and reduced art itself to a matter of technique, and the aim of literature to fanciful experiment. From seriousness, formality, dullness and hypocrisy, the printed word came to substitute frivolity, impudence and candour. In nature's way, the remedy was begotten of the disease, and was therefore thought to be itself an infection by those who were in no danger of recovery.

If the movement had been genuinely creative and new, if it had fully escaped from its prison, it would have given to us the fine art of disillusion, an age of great comedy. But the transition was not over, nor the escape complete. The two artists who did come near to this achievement were Beardsley and Wilde, who recovered the grotesque and farcical comedy. But in the main we had no more than the mood of disillusion, sensuously and decoratively expressed, for comedy is only possible to those who have left this mood behind them. It cannot be practised by Hamlets, since Hamlets themselves are the very cream of comic figures.

A sense of perspective and proportion is given to the prose of the time when we turn to the criticism that it produced. The judgment of its

artists on the work of others contributes to our knowledge of their own standard and desires, and fortunately they produced an unusually fine critic in Mr. Arthur Symons. When we consider the range, the sensitiveness, the extent, and the thoroughness of his work, he stands alone in our critical literature. None has had the various qualities that produce good criticism so evenly balanced as he. Compared with Mr. Symons' body of work, all the rest seems to resolve itself into the occasional exercises of writers generally concerned with other things, with poetry, or the essay, or preaching, or professorships. But Mr. Symons is a man of imaginative insight, and of catholic knowledge, not only of the arts but of artists, who has devoted himself without wavering to criticism almost alone. We go to his writings, therefore, not in search of independent essays on the subject of their titles, in which the treatment may seem more important than the text, but for an imaginatively precise definition of the particular quality of the work of art in question. There are aspects of criticism with which Mr. Symons does not deal, but since the artistic quality and character must survive, in the long run, all the other qualities by which a work of art interests us, there is a sense in which Mr. Symons' work will remain unaffected by time. The aspect with which he deals is the simplest and enduring aspect, and wherever he has been able to discern it rightly and to make it clear, he has achieved a piece of criticism that will always be revealing. His work, indeed, is the most solid

contribution in prose that the Beardsley period produced. It has supplied something curiously lacking in English literature, a body of criticism that artists will study with pleasure, the harvest of a life devoted to the work of criticism alone. Wonderful contributions have been made to English criticism from the time of Dryden to the best work, say, of Mr. Edmund Gosse, but who is there, except Mr. Symons, who has devoted himself exclusively to criticism without the licence that makes so much would-be criticism either compilations of fact or general essays in disguise ? He has an extraordinary power of giving definition to elusive qualities, which Pater, being less intellectually minded, was content to suggest emotionally. It is natural to make a comparison between Mr. Symons and the writer whom he has most gratefully admired. The manner of Pater seemed, sometimes unfairly, to be of more importance than his matter, which becomes elusive in the recollection. In the writings of Mr. Symons the matter always comes first, and the manner consists in avoiding all surplusage in its definition. The style, indeed, where it invites us to notice it, is extraordinarily tired, and becomes thin when the matter is scanty, for example in the essay on " Fact in Literature." It bears the unmistakable sign of a man who has read too much, and whose hand holds anything that is not a book, even a pen, a little stiffly.

Mr. Symons has defined his intentions with repeated care. He has studied all the arts in an endeavour " to master the universal science of

beauty " ; and of criticism he has said : " it is a valuation of forces, and it is indifferent to their direction." In the same context he has said also : " I am interested only in first principles, and it seems to me that to study first principles we must wait for them till they are made flesh and dwell among us." He goes on : " I have a few principles of criticism and I apply these few principles to every writer and on every occasion," therefore the unity to be found in his work " must come wholly from the uniformity of the tests " which he has applied.

He does not further define what these principles of criticism are, the truth of course being that his real test has been, not a series of verbally capturable definitions, but the degree of intuition and of good taste in the critic himself. To say that such a test cannot be defined is very far from denying its existence. Neither life nor beauty can be caught in the gin of logical terms : they are primary simplicities to be reasoned from, and not about. A man recognizes or fails to recognize their quality. This has virtually to be admitted by Mr. Symons himself in the artful declaration that he waits for first principles to be made flesh in individual authors before he deals with them. This is a very pretty way of begging the issue, since a principle is a generalization, while no artist is more than a variation, whose mysterious affiliation to his fellows leads us to infer the obscure existence of some general principle or rule. No artist therefore embodies or displays first principles. On the con-

trary, his interest precisely lies in his inflection on a common principle or theme, for the style of a good writer is no more than the quality which distinguishes his work from that of all others. There is no such visible thing on earth as good style : there are only styles, and Mr. Symons properly prefers to deal with the reality and to ignore the hypothetical abstraction. This explains why there are no rules in art, but precedents only, and so every new artist arises by breaking their letter in order to display his individual intuition of them in a manner never employed before. The letter of the three unities of drama was broken by the Shakespearean play, which then revealed that there was no real departure from them, since the experiment proved that, so long as cumulative interest, the third, was maintained, the spirit of the other two was preserved also.

In the criticism of Mr. Symons, therefore, we must not look for any generalization of critical principles. We find instead an exposition of the quality of beauty peculiar to the work of each author or artist whom he treats. In so far as this satisfies us, we carry away not a rule of thumb but a continually growing confidence in Mr. Symons' sensitiveness of taste and acuteness of judgment. By following the excellence of this trained intuition we foster our own, and to that extent are better able to welcome new manifestations without being too much puzzled by their necessary strangeness. This is as near as we shall come to mastering that " universal science of beauty," which, after all, did

it exist, could never take the place of individual works of art that are seen finally to be not our starting-point only but our conclusion. As in art beautiful things are the only beauty, so the definition of the quality of beauty in each of them is the only satisfying criticism. It was the merit of this group of writers to aim at beauty first in their writings, and at the recognition of beauty only in their criticism, and they followed this aim more disinterestedly than has been customary in England.

Apart from sculptors, painters, and musicians, perhaps an hundred and fifty authors have been criticized in Mr. Symons' books, and these mostly English and French, and mainly modern. No English critic has done more to introduce French men of genius to our country, or to remove the reproach of provinciality from our knowledge and taste. Thus his works contain the most useful library of criticism from a single pen that we possess, for no other critic has written more that is worth reading on eight arts or on a greater number of authors. Mr. Symons, I think, is the only English critic who has brought to criticism the same concentration that has been spent on poetry or narrative. He does not write round his subjects, he penetrates to the core of the beauty that is present in their work. Mr. Gosse is an inspired talker with the pen who will give you the background, the forerunners, the influence, and the surroundings of innumerable books. But on the whole he is more interested in tendencies of taste than in qualities of beauty, and tells you more about the frame

than the picture. If his portraits of human faces
were equalled by his critical definitions, he would
be the English Sainte-Beuve, but he remains the
inspired librarian who has all the world's literature
on his shelves and is always full of interesting
'gossip' on any volume you may bring to his notice.
Gossip in a library, to use his own phrase, is his
peculiar gift, but this is not, though it may happen
to become, criticism. Mr. Symons is a judge, not
in terms of praise or blame, but in kinds and degrees
of beauty, and his merit is that he neglects every-
thing else as far as possible in order to tell you at
once what the kind and what the degree is. A
convenient example, because of the pleasure that
it gives in a dull place, is the sentence which con-
cludes in a work of reference the chronological
facts concerning Mr. Thomas Hardy. The facts
given, Mr. Symons immediately proceeds : " In
all his work Mr. Hardy is concerned with one thing,
seen under two aspects ; not civilization, nor man-
ners, but the principle of life itself, invisibly realized
in humanity as sex, seen visibly in the world as
what we call nature." How terse and admirably
disciplined that is ! He sometimes opens essays
or paragraphs in the same delightful way. " The
five senses made Gautier for themselves, that they
might become articulate." Criticism could hardly
be more concise or more revealing. Again, " the
poems of Edgar Allan Poe are the work of a poet
. . . who would have reduced inspiration to a
method." Such sentences make us feel that,
whatever else may be said, they themselves are

indispensable, and the habit of writing them has made Mr. Symons an indispensable critic. The same intellectual precision becomes almost witty at times, as the definitions of Euclid are witty from the perfectness of their economy : " Like most fighters, Buchanan fought because he could not think, and his changing sides after the fight was neither loss nor gain to either party." Examples might be multiplied, but is there not more matter in these detached sentences than we often find in whole essays ? If Mr. Symons were a great writer as well, all this matter would have been fused into a state of dilution, and it was because he found it fused in a prose from which the tissue of thought is hardly detachable that Pater has seemed to him to be impeccable.

To Mr. Symons criticism has been a vocation complete in itself, a primary end. He has spent his life " distinguishing the precise qualities of the eyes and minds which make the world into imaginative literature." He discerns the intention of each writer justly, nowhere more scrupulously so than in the essay on Wilde, which is less reserved than it seems at the first reading. All this criticism, final so far as it goes, suffers from compression. Mr. Symons is more interested in the prevailing quality of a work than in its composition. He discusses nothing in detail. He betrays no narrative sense, and tells us nothing, for example, of the narrative form in the novels of Hawthorne and Hardy, though the construction is purely artificial in the one and rigidly mechanical in the other. He

does not distinguish between the carpentry of plot and the humanity with which this scaffolding is covered. There are, of course, exceptions to this. The essay on Beardsley is not likely to be surpassed, and says everything. No other English critic has been so wise in so many directions as Mr. Symons, or interpreted so many arts with so much intuition as he. This would be even more apparent than it is if his essays were regrouped under the different literatures and arts that he has criticized. As I write, a collected edition is announced, but there is no hint at present that this plan is being adopted. It would give us a volume of essays on French writers, beside that valuable work on *The Symbolist Movement*; two volumes on English literature in addition to the early study on Browning, one on painting, music and sculpture, another on the drama and the arts of the theatre, and so on. Surely such a library of criticism could not be rivalled by any other single English critic, and yet, I think, an ungrateful generation has not yet devoted a critical study to the work of that critic who could teach it most, despite his own reminder that " the final test of a critic is his reception of contemporary work." It has been the distinction of this criticism that we do not question its judgments but wish that it had passed beyond its central definitions to deal with the qualities that remain in ampler detail. The future is likely to reverse few of his verdicts because he has limited himself to the artistic core. His work will survive changes of taste, and be supplemented rather than superseded. No criticism

is so like that which artists themselves pass on one another, and the final impression that remains is that the love of perfection, the respect for personality, those doctrines immediately derived from Baudelaire, which distinguished the creative efforts of the period, created also a criticism even more artistically disinterested than its own poetry and prose. In this regard, Mr. Symons' work becomes the touchstone of the period, the definition of the point of view, expressed by him contemporaneously and imperfectly in verse, but finding its proper form in the critical volumes published when the decade was over. From the mannerisms of the period his prose generally is free, and thus it does not date as do his verses.

There are other volumes of his deliberately unmentioned here in order not to disturb the balance of judgment which, I feel, should place the emphasis where we have now left it. That on *The Romantic Movement in English Literature* shall have a final word, however, because it is the epitome of the others. It leaves us characteristically asking where else can we find, in a single volume, an equally revealing collection of criticism on a greater number of authors ?

Henry Harland, the literary editor of the *Yellow Book*, who began by writing sensational novels under a pseudonym that he hoped would prevent their resuscitation, made his reputation late in his short life. His most popular acknowledged novel, *The Cardinal's Snuff Box*, is not without charm or grace, but it has the decorative sentiment of a

drawing, say, by Arthur Hughes, transposed into
the aristocratic key of an Italian villa, with the
inevitable figure of a tantalizing duchessa hovering
on the nether bank of a dividing stream. With
the aid of a cardinal, whose ring is eventually kissed
by the young Englishman, the thread of the flirta-
tion is unwound. The grace of so simple a story
depends upon the telling, which is humanized by
the character of an old Italian peasant, exalted by
the innocent machinations of a romantic cardinal,
and set against an almost cloudless sky. Harland
had a light touch, a dainty manner, and the peculiar
emotion for the older parts of Europe that is aroused
in sensitive Americans. *The Cardinal's Snuff Box*
is a book for an afternoon in a country house, and
if the house be placed within the sound of an
angelus-bell, the reader will probably slip through
the trees to be present surreptitiously at Benedic-
tion. Of his short stories, for instance *Grey Roses*
and *Comedies and Errors*, the one called " Castles
in Spain " in the former collection is like a sketch
in miniature of the later *Cardinal's Snuff Box*. It
also shows that incident, the strokes of action and
surprise, were not Harland's readiest gifts. The
climax had to be postulated, and the tales mostly
confine themselves to the events that produced or
followed from it. He escaped the anecdote to
risk a series of reflections, and thus fell short of
pure narrative which combines both of them. Per-
haps the effort to depict human beings at moments
of crisis had been made in the early sensational
novels, and he wrote them under a pseudonym

P

because he felt that his gifts were prostituted at this task. " A Responsibility " is a meditation out of proportion to its cause ; " A Reincarnation " is a not very happy essay in the humour of egoism. " The Bohemian Girl " has zest and comes nearest to narrative of any in *Grey Roses*. " Castles in Spain " is one of his typical flirtations in dialogue ; the rest are romances of the Latin Quarter where Harland had spent some early years. Henry James admired both Crackanthorpe and Harland, especially the latter's *Comedies and Errors*. These include a study of awkward youth, a king and queen's flirtation, two more shapely tales, " The Invisible Prince " and " P'tit Bleu." In the best of the short stories the form is carefully composed from many short sections, like a house that has been planned room by room and afterwards gathered under a single roof. This was also the manner of Crackanthorpe's *Sentimental Studies*. The dialogue in which Harland's tales delight is a polite persiflage, not as witty as it would like to be, but redeemed from cleverness by occasional strokes of character. This dialogue is an invention not a revelation, and the best part of the stories is the design to which they owe their shape.

Less completely typical, and easier of comprehension to the world at large, was the prose of Mr. Le Gallienne. He generously made it his business to descend into the market-place where his sympathetic reviews informed the public and other journalists of the more artistic work then coming, amid the annual harvest of chaff, from the

more discerning publishers. Almost a new, certainly a newly defined, department of letters was arising under the heading of Belles Lettres, and publishers were cultivating its appreciation, in much the same way that editors to-day have created the new department of literary journalism. Mr. Le Gallienne was the prince of belletrists of his time, and an invaluable link between its writers and readers. The term survives, but not in the plenitude or the grace of the nineties. There was then a happy conspiracy of taste to produce charming literary trifles in a form perfectly adapted to themselves, and the collector who is interested in the individuality of books, and not merely biased in favour of their contents or their covers, can still delight in these products of the printing press. A handful of them evokes the period in the less recondite aspect of its taste, and shows us a common impulse at work, seeking to give to the form of every book a quality as distinct as that which had sought to express itself in the writing. The general standard of printing, binding, and pagination was quickened by Morris' example, with the valuable difference that the taste shown was contemporary, and designed to accomplish no more than the best that contemporary conditions of publishing in the ordinary way would allow. The result was a real achievement, which shows a pervading spirit at work binding artists, publishers, and authors to do their united best in a common endeavour. The honours, on the whole, remain with the publishers, for it was they who invited the willing service of

such artists as Mr. Charles Ricketts, Mr. Charles
Shannon, and Mr. Laurence Housman, and encour-
aged the printers to make charming experiments
in the setting of title-pages, tables of contents,
and chapter headings. The heroes undoubtedly
were Mr. John Lane and Mr. Elkin Mathews,
but their example luckily was not alone. Delightful
work was done by the firm of Lawrence and Bullen,
the publishers of the Muses' Library in its first
form, and an object lesson in the grace which the
mere spacing of words can give to a title-page is
found, for instance, in the first edition of *Life's
Little Ironies* as it came from the publishers, Osgood
McIlvaine, in 1894. Even the grave firm of Mac-
millan would unbend under this influence, and the
End of Elfintown by Jane Barlow has delightful
covers, title-page and illustrations, though, save
for the work for which Mr. Housman was respon-
sible, no particular pains were taken with the type.
These are only indications of a leaven generally
astir, and its effect was a display of good taste in
any book that seemed to deserve it, so that the
general standard was higher than it had been in
previous years. Save by a few publishers, it was
allowed to languish before the war, and we have
hardly yet recovered it. Its interest lies in this,
that it was not confined to the private presses, but
that their example raised the standard of ordinary
work. The form and contents of these volumes
were the reflection of the taste of the period, into
which Mr. Le Gallienne descended like the spirit
of the hour.

It was a timely and gallant descent, for he was the first critic to devote a study to George Meredith, and his book was exactly the bridge required between public hesitation and awakening curiosity. It can be read usefully to-day when the long-delayed recognition has once more been succeeded by aversion. The critics of the hour once again can see nothing in George Meredith but his mannerisms. They miss the fact that he was a poet in every line that he wrote, and that the consciousness of this gives to all his work, crabbed and wayward as it is, a power over the imagination which makes the faults seem characteristic of the genius underlying them. " If criticism," Mr. Le Gallienne remarked, " must be dubbed a science at all, its place is rather among the occult sciences, and the divining rod an appropriate symbol of its method." His literary instinct placed that rod in Mr. Le Gallienne's hand, and its possession enabled him to do for George Meredith, and for the younger school of writers, exactly the service that they then required: the creation of a public willing to acknowledge them. His curious blend of sentiment and sensuousness, which is not to everybody's taste, and occurs in his verse and prose like soft patches in an otherwise fresh apple, appears in a sentence in this book upon Meredith that I quote as the shortest example. He says that Meredith touches his women with " an exquisitely tender reverence . . . like some gentle physician with his stethoscope at the bosom of a blushing girl." Sentences like these are apt to transfer their blushes to the

reader, who would prefer a more direct simplicity of touch. Imagine, then, the mixed feelings aroused by a romantic narrative which was to make the search for a series of blushing girls its deliberate theme.

The Quest of the Golden Girl, now in its eighteenth edition, is the most popular and characteristic book that its author wrote. All the influences that went to his making are to be found in it, and it confirms our opinion of him as the point of contact between the more recondite and the more popular literary aspirations of his time in the declining phase of the Romantic Movement. The book has been called, aptly enough, a new sentimental journey. It springs from an ancient literary lineage, and the parts played by the author's favourite writers and by his own faculty of invention are not easy to apportion at first. Boccaccio, and Sterne, and George Borrow, and Gautier, and the picaresque novel, have all contributed to this romance, which is bookish, and adventurous, and surprising by turns. The adventures seem to threaten the conventions that they end by respecting, and the reader feels like one of the seven heroines, in doubt whether to be grateful or disappointed at the happy issue of her fears. It might have shocked Queen Victoria. It might have seemed tame to Marie Bashkitseff. To the wider public of the nineties, which was mostly far from either of these extremes, it was tantalizingly perfect. The incident, familiar in Gautier, of the girl who wears the clothes of a youth in order to accompany a charming stranger

on his walking tour, exactly hit the taste of the age when the New Woman upon the horizon had become the girl with a bicycle in the street. The temperamental blend of the author, that was noted briefly above, colours the romance throughout, and certainly romance, as it is known to those who prefer it in the distillation of literature, has never been more romantic. There is a sense in which adventures are to the unadventurous, for the real plunge is too serious a matter at the moment to be enjoyed imaginatively. The titillation is enjoyed by those whose toes are tingling on the bank. This tingle is conveyed to perfection in these pages which, while giving to the reader the sensation of adventure, also persuade him that they can be made his own to-morrow morning if he will but show a fraction more of resolution than he had dared hitherto. What more can be asked of any author ? Borrow is charming to read, but the Flaming Tinman would be a desperate encounter, for not one in a thousand of Borrow's readers has the capacity (or desire) to use his fists. The description ties us contentedly to our chairs, and even the comparatively safe experiences of the supertramp tempt few of us to accompany Mr. W. H. Davies to the dosshouse for a lodging. Mr. Le Gallienne, however, tempers the wind of romance exactly to the tenderness of our sophisticated shoulders, and entices us from the humdrum without ever threatening us with the ditch. To have the sensation without the danger is exactly what conventional people desire, and in between are pages of playful descrip-

tion. Of many that might be taken, there is the well-known rhapsody on Spring :

" A mad piper, indeed, this spring, with all his lying music,—ever lying, yet ever convincing, for when was Spring known to keep his word ? Yet year after year we give eager belief to his promises. He may have consistently broken them for fifty years, yet this year he will keep them. This year the dream will come true, the ship come home. This year the very dead we have loved shall come back to us again : for Spring can even lie like that. There is nothing he will not promise the poor hungry human heart, with his innocent-looking daisies and those practised liars the birds. Why, one branch of hawthorn against the sky promises more than all the summers of time can pay, and a pond ablaze with yellow lilies awakens such answering splendours and enchantments in mortal bosoms, —blazons, it would seem, so august a message from the hidden heart of the world,—that ever afterwards, for one who has looked upon it, the most fortunate human existence must seem a disappointment."

This is a characteristic passage, and, like others that could be quoted from such writers as George Egerton, the author of *Keynotes*, shows the desire for a heightened form of expression, for a deliberate artifice of language, that made a sense of style the principal pleasure of literature.

It is well to recur to this, for what seemed then the first condition of taste is now no longer fashionable, or much sought by the succeeding generation,

Good authors necessarily write well, and every author, no doubt, as well as he is able. But if we contrast the writings of the Beardsley period with those, for example, of the Georgians, a difference of intention is felt. It may be that the latter, with good precedents behind them, believe that good style is a personal gift, and that signs of polish lead to an affectation that destroys the very quality of which it is in search. It may be that the growth of literary journalism, which has become a new profession for young writers, has imported a cheerful haste into the manner of composition, and that while it is now more than ever possible to live by the pen, the amount of criticism, reviewing, and essay-writing, for several different papers, encourages competence rather than distinction. I do not profess to judge. For better or worse, however, the writings of to-day are more conversational, and depend for their interest rather on the matter than the manner of their presentation. In the nineties it was otherwise, and the distinction is worth notice : unless each period be judged by its own standard, it will receive less than justice to-day when the emphasis has become reversed. The result has been to make belles-lettres a term of less precision. Indeed, all the old terms are wider than they were. Mr. Le Gallienne was the type and leader of a form of writing in which the manner was the first consideration, and prepared the way for a freedom in which to be readable seems the only rule.

We still find, however, a peculiar intimacy of welcome for writers whose personal manner is the

most immediate quality that makes itself felt, who
have a style that cannot be mistaken, and the charm
becomes irresistible when it is cultivated to the last
degree of which it is capable. Mr. Max Beerbohm
is the modern instance of this. While his writings
unmistakably derive from the Beardsley period, of
which he constituted himself the historian in little,
they have overflowed the decade to delight its so
different successors. Is this because he possesses a
sense of humour, which, being more human than wit,
may be independent of the taste of a moment for
its enjoyment ? It enabled him to see all humanity
as a spectacle, and to indicate the foibles of the
Victorians and of the nineties with equal impar-
tiality. At the same time, it left no doubt where
his own preferences lay, and he has contrived like
Puck, or was it Lincoln, to belong to two worlds.
It is as if he had chosen to present the Victorian
point of view in an ironical spirit, so that between
the point of view and the irony there might be
something to flatter both sides. He has confessed
to a Tory temperament ; the subject of Royalty
maintains an irresistible fascination for him, and
yet we may conjecture that his essays on the subject
might not be more agreeable to Court circles than
some of his cartoons.

Indeed no books seem to be written specially for
kings and queens, but Mr. Max Beerbohm, were
it not for a twist in his humour, might have written
a kind of regal prose, and accomplished in that
field a feat similar to the one that Tennyson attained
in certain of his verses. If an illustration were

wanted of our earlier contention that the Beardsley period was a revulsion from the long reaction that followed the Regency, it would be found in Mr. Beerbohm's writings. The Regency, nay the Regent himself, is his favourite subject, and the essay that he has devoted to the defence of George IV gives, as it were, the historical pedigree of the sympathies of the time.

We see these sympathies, coloured by the intervening Victorian discretion, in the story of *The Happy Hypocrite*. In the very title the adjective and the noun unite the periods in a mystic marriage. It is, I think, the only example of the fairy tale with a modern historical setting. Like all fairy tales, it has an unexpectedly happy ending, and the surprise is doubled because the conclusion is achieved by a technique in which a happy ending seemed impossible, or at least outmoded. In the average Victorian novel a happy ending was attained by the sacrifice of art and truth. The consequence was that truth and art seemed to involve a tragic or embittered close. Mr. Beerbohm therefore invented a refinement of technique by which the happy ending should be brought about through a final stroke of imagination, and, as his story therefore took the form of a fairy tale, the conclusion was not only true to art, but true to fairyland. He may not have approached the story consciously from this point of view, but no neater example could be given of the grace that rewards a finished piece of technical virtuosity.

All his essays are " little creatures of fancy "

that have been subjected to careful " scrutiny and titivation." The style is as fastidious as Whistler's own, and the effects depend more on the manner than the subject. My own favourite is the essay on " Going Back to School," but preferences are impertinent when we should see in this author a rainbow spanning the nineteenth century, with one point of his arc resting on Carlton House and the other on the Café Royal of the nineties.[1]

On Mr. Beerbohm's cartoons I do not propose to linger. They do not seem to me to discover his affiliations with the period, but rather to display a side of his temperament that might have produced the same result at any time. There is more humour than irony in them, and perhaps the cartoon is a medium from which the nicer forms of fancy must be excluded. Indeed, there is generally a contrast between the broad strokes of the drawing and the serpentine inscription underneath. The cartoon possesses the humour, the inscription the irony. The malice is suggested rather by the words. How like a cartoon, by the

[1] " A Peep into the Past," the essay intended but not used for the first number of *The Yellow Book*, has now been printed privately in America. It shows the delicate irony of Mr. Beerbohm at its finest distillation, and his style at its pink of innuendo. A malice, often subtle yet without cruelty, feathers his quill. Even the subject, Mr. Wilde, treated (in 1894) as the genial ghost of a past age, a retired old gentleman already forgotten, might not have quarrelled with it. As we know, " A Peep into the Past " was replaced by " A Defence of Cosmetics " in the opening number; yet, for the connoisseur of style and also for the collector, " A Peep into the Past " is a rarity to be treasured.

way, are the sentences in which he conveys his
recoil from Pater's style. We see the widower
laying his sentences in their sepulchre, while the
sprightly Max hops eagerly away. Such a passage
needs no drawing. The very sound of the words
evokes the sight. It is not by his cartoons that
Mr. Beerbohm belongs to the Beardsley period,
of which he wrote as a past epoch so promptly as
1895. While his colleagues of that time were
reacting from the Victorian ideal, he was beguiled
by the interest of something that had begun to
date, was discovering in it the charm of its period,
and, like a connoisseur examining a rarity that the
world decries or passes, he picked up this uncon-
sidered trifle, set his glass in his eye, and examined
it with an attention half ironic and half affectionate.
He is still content to be a master in miniature, well
aware that a small talent remains exquisite so long
as it respects its limitations, and that mediocrity is
the fate of those who, designed to strain exquisitely
at gnats, allow themselves to be tempted by camels.

In so far as an affiliation with the nineties has
ever been used as a term of the faintest reproach,
a caution is needed before we include, as we must,
among the prose-writers of the period, the irre-
proachable, the distinguished, Mr. A. B. Walkley.
His is the real reputation that needs no herald :
his prose a sun that sheds its radiance every Wednes-
day on the *Times* without the cock-a-diddle-dow of
noisy acclamation. How then had Mr. Walkley
any business in the neighbourhood of Vigo Street ?
We can conceive him in the adjoining Albany ; we

can picture him in the Burlington Arcade ; but *qu'allait-il faire dans cette maudite galère* ? round the corner. Whence this amused glance over the way, of course from the other side of the street ? For Mr. Walkley is the unexceptionable. Is he not deservedly adored as the most Gallic of English critics : the impeccable in taste, the fastidious, the incorruptible, in judgment ? The obvious answer is that Paris, a place of pilgrimage to the others, was no more than his second address in humanity's metropolitan city of pleasure : that celestial city wherein London, Rome, Paris and Brussels are but the names of different squares. He could be frivolous in any, because he was equally at home in them all. He crossed the Channel as nonchalantly as the rest of us cross Westminster Bridge. His contemporaries went to Paris in order to leave their native element, but he was amphibian from the first. Walter Pater even could not converse, we are told, in French at all. Mr. Walkley finds it difficult to write continuously in homely English idiom. When he is in France, does he utter such words as *redingote*, *ticket*, *le sport*, with the same delicious unction that he will use when writing of " a *je ne sais quoi* " in the course of an essay in English ? Would that Anatole France were still alive to tell ! No, compared with the members of the ninety pilgrimage to Paris, not far from whose bias we venture to set one among the inclinations of his mind, Mr. Walkley had been over the *gazon* before (as he, almost, might say). With a great sum they had purchased their freedom,

but he, having been classically educated as well as classically minded, from the first was free of the sacred city on the Seine. The distinction is more subtle than it seems, but it is a distinction worth making.

An illustration may help to clear it. Once only, when the Irish dramatist succeeded, for a moment, in changing rapiers with the English critic, in the perpetual fencing match between original genius and (its rarer brother) original connoisseurship, did Mr. Bernard Shaw succeed in passing Mr. Walkley's guard in classic style. This was in the induction to *Fanny's First Play*, the ' potboiler ' that contains its author's purest page of comedy. The reason is an open secret. The critic himself was introduced. This was an inspiration, worthy of Mr. Walkley. As we listened enchanted to the echo of Mr. Walkley's celebrated style, did we not feel the critic's foil to have passed miraculously into his opposing partner's hand when Mr. Trotter was said to be " thoroughly English : never happy except when he is in Paris." Such wit as this is beyond the utmost ripple of interior laughter : it is the, momentarily visible, flicker of the smile on Comedy's own face. When interpreted to mean the happiness of a second spiritual home, and not excitement aroused by a foreign contrast, this is true. The great Lord Chesterfield, as we have already seen, was such another amateur of life and letters, a fine Englishman and a good European withal : for to be *thoroughly* English, as all the world knows, is to make the best of both worlds,

and of a third (if there is one). That is why a
thorough English man of letters is as rare as any-
thing else which is perfectly true to type, for
example the thoroughbred race-horse ; and why
too he is wonderful when he appears. Dr. Johnson
was the root, as Lord Chesterfield and Mr. Walkley
are the intellectual flowers, of English humanity,
in their respective centuries.

Thus it comes perhaps that the finer justice has
been done to the three by foreigners. Who has
surpassed Hawthorne, the American, in his criticism
of Dr. Johnson : who has appreciated Mr. Walkley
more keenly than his Irish subject, Mr. Bernard
Shaw ? Is it not one of the finest revenges that
Criticism has ever extorted from dramatic Author-
ship to have inspired the passage of purest comedy
in Mr. Shaw's writings through the playwright's
imaginative surrender to the quality of his critic's
mind ? In years to come (horrible thought !) Mr.
Walkley may be destined to be cast for the part
of Bacon to Mr. Shaw's Shakespeare in the author-
ship of this particular play. Some time ago, when
I read that some French critic had called Mr.
Shaw the English Molière, involuntarily I shuddered.
It seemed a stealthy premonition of the thing. Nor
is it much consolation to remember that Mr.
Walkley will have no Bacon to disturb his own
rights of authorship. Even in a world of fools,
where the fate of Cassandra is even more prophetic
than historic, it seems absolutely safe to predict
that *Playhouse Impressions* will never be attributed
to the pen of Bernard Shaw. The Irishman, with

his second home in London, and the pluperfect Englishman, with his second home in Paris, understand one another very well. To the complementary and contrasted action of their minds— " each rejecting its similar and desiring its likeness in a living and alluring opposition "—there is no impediment. Their apparent differences and impatiences are no more than those other eternal misunderstandings of attraction which mark the harvest of the ripest and longest years of married life. They have found each other out, and the inexhaustible joy of this discovery is the final bond of friendship to such men, whose Gargantuan appetite for comedy is inextinguishable.

As we think upon the pair, vista upon vista opens, but we must turn aside to note once more how the French phrase insinuates itself into the classic prose of Mr. Walkley. In this he is far more excessive than Chesterfield, who was equally fond of French and Latin. Yet Chesterfield has many paragraphs in pure English : Mr. Walkley few. One suspects him, in the old days (at Voisin's, was it ?), to have asked the *waiter* for the *bill of fare* ; and, on his return to London, at the end of dinner we can almost hear him cry *l'addition* to the *garçon* at the Café Royal. Why is he not content, in English, with bill of fare and bill ? This pretty patch on the cheek of his style is the speck of an Oxford superiority. Max Beerbohm and Arthur Bingham Walkley are both Oxonienses, but both, the latter especially, are examples of those Oxford men who have never quite " come down." Perhaps more

Q

than any other writer of his rank, the second should
write only of that which he loves in literature, for
when the duty of criticism gives to him " a banyan
night " at the theatre, he does not invariably display
what Francis Thompson would have called " a
rebukeless mind." Before inferior work, or good
work that happens not to interest him, his writing
will stifle, now and then, a yawn in the Oxford
manner. This condescension, one may fear, has
been liable to be misunderstood by some newspaper
readers, who may have supposed it, outrageously
of course, to flatter their own inferiority. Im-
peccable himself, Mr. Walkley would be over-
generous to this public if he allowed it, even for a
moment, to presume an equality with himself.
Most at home in the best company all down the
centuries, from Aristotle to Jules Lemaître, the
limitations of the rest of us must be painfully clear
to him. It is impossible, however, to read the
master without asking one pertinent question of
ourselves : can we ever hope to reach the standard
of good manners that he has set in the happiest of
his styles ? Meredith on comedy : Walkley on
good taste : we can never be sufficiently grateful
to either. They have given to English literature
the attar of its criticism.

It was the largeness of his learning that stood
between Lionel Johnson and the criticism for which
his prose seemed to be designed. But he too
studied technique, in a point which all the others
neglected. He is the only modern writer who can
be read for his punctuation alone. He is under-

stood to have followed the practice of the seven-
teenth century, but punctuation, I think, has never
been uniform, since there are always two prin-
ciples at work, and most punctuation oscillates
between the two. We may punctuate mainly to
mark the pauses that the voice will make in the
reading, or according to the grammatical clauses
by which sentences are formed. On the whole,
Lionel Johnson inclined to the latter principle ;
otherwise many instances in the mode of his pro-
cedure would be obscure. It is obvious from his
Art of Thomas Hardy that he uses the semicolon
where many people would use the comma, and the
colon where they would use the semicolon, but the
reason for the third comma in the following sen-
tence is not the ear :

" I dwell upon Mr. Hardy's unity of design,
because it is an excellence rarely desired now, and
an excellence, which atones for a multitude of
faults."

The voice would not pause at this comma, but
it illustrates the grammatical "rule" that a comma
should always precede a relative clause, and perhaps
the array of Lionel Johnson's punctuation was the
result of an attempt to punctuate invariably, not
by ear, but according to grammar. His greatest
feat perhaps is a sentence fifty lines long. This
is to be found on pages 49–50 of the 1923 edition
of his book on Thomas Hardy. It is true that
the sentence is largely a long list of things on which
Mr. Hardy delights to dwell, and that a capital
letter follows a colon in the middle of it. The

capital letter introduces the word " And," for
Lionel Johnson would not favour the modern prac-
tice of beginning a new sentence with this con-
junction after a full stop. The complementary
half of this majestic sentence is a series of infinitive
verbs, showing what Mr. Hardy loves to contem-
plate, to show, to note, to exhibit, to build up. It
is therefore perfectly easy to read, and the cumu-
lative effect is to evoke the landscape of Mr. Hardy's
mind as an ancient Roman road will evoke the
landscape of the Wessex Novels. The sentence,
therefore, must be regarded as a work of art achieved
by means of a learned punctuation, and as this
punctuation is lavish, the grammatical method is
probably its rule, for the voice does not pause at
the end of every clause in a sentence.

The learning of the book is not confined to its
punctuation. The opening chapter is thick with
allusions, and throughout every thought evokes so
many authorities that the author is inclined to
write in a series of quotations. He values authori-
ties for their own sake, and is tempted to forget
that learning should be a prop and not a burden.
The result is an admiration for Mr. Hardy's art,
especially for the design and construction of the
novels, with a repudiation of the philosophy of life
that is brought to bear on them. Like other
critics, save one novelist who is also prejudiced,
Lionel Johnson, however, does not distinguish
between the artificial scaffolding of the stories and
an organic form. In the last, event grows from
event and is not controlled from without by the

requirements of a complicated plot or a mechanically made pattern. The art of Thomas Hardy is not free from this defect, but spends itself to clothe with living flesh a skeleton of artificial manufacture. The artifice that has been detected in the play with a well-made plot has taken longer to be recognized in the novel. Lionel Johnson was not endowed with the narrative sense, but on style, character, dialogue, scenic description, morals, he was always interesting. He was best of all, I think, on poetry, and could put his finger infallibly on the peculiar quality of each writer. This gift is seen unimpeded by his learning in the brief notes on his contemporaries to which we referred in the previous chapter. It would not be seemly to quote more than the two there mentioned ; but the little series included in Mr. Pound's preface to the *Poems* is a string of judgments of which any critic might be proud. There are also the two volumes, *Post Liminium* and the more recent *Reviews and Critical Papers*, which are also rich in their good sense. To adopt an invention of his own, he regarded " men of letters as a third order of the priesthood," and his criticism sprang from convictions as definite in the sphere of art as they were in that of dogma. In this year of Byron's centenary had we anything better than his : " Byron could shout magnificently, laugh splendidly, thunder tumultuously ; but he could not sing ? " This criticism has a way of passing from the writing to the mind and the soul behind it, so that we seem to be reading the verdict not only of a literary

critic but also of an Inquisitor of the Church. He
makes every writer show cause why he should not
be placed upon the Index.

There is a similar objective quality in the writings
of Hubert Crackanthorpe, where, however, it is
displayed in observation rather than in reflection.
His stories are written in a terse, dry style, as cold
as the depressing facts on which he generally chose
to concentrate. The situations that encourage
other writers to be emotional were to him sufficient
in themselves. He wished to leave on the mind
of a reader an impression that had been etched in
acid, the acid, not of the manner of presentation,
but of the experience, the fact itself. A scrupulous
loyalty to his material, the truth, guided him, and
he thought that a narrative should be followed
with the disinterested eyes of science. In *Wreckage*
the marriage of Oswald Nowell happens as sud-
denly, as unaccountably, as such things happen in
life, and the six brief pages of " The Struggle for
Life " have the vividness of an occurrence that
the reader has witnessed and remembered. His
eyes could see a limited distance only : the fatigue
of watching the course of events is great, and,
where he invents a conclusion, the tales are less
satisfying than where, having seen so far, he is
content to stop. Things happen so, we feel of
the best of these stories ; and the art of this realism
is to convey the sense of this happening. Like
Oswald's, each of his stories might be called " A
Conflict of Egoisms," and Crackanthorpe, at his
best, was content to record the tragedies that

result from the conflict of egoisms that people are unable to control. Such beauty as there is in this writing consists in the artist's loyalty to his material, which he will not embroider in any way, and the restraint imposed by this method, when at the end we become aware of it, wins our admiration. *Anthony Garstin's Courtship* is an admirable tale, and the fine scene with which it culminates has the directness of drama. His dialogue, as this scene shows, can be splendid ; and if he had not died so young, he should have written plays. By giving us the truth, as he perceived it, he gave to us also an austere beauty. This beauty had not been an end in itself : it was the proof that the truth had been attained. The truth that Lionel Johnson sought in criticism Hubert Crackanthorpe sought in narrative, and our respect for both resides in watching the same process of intelligence judging art and judging life respectively. Both found relief in the satisfaction of an intellectual curiosity. It was the form that conscience took in each of them.[1]

Miss Ella D'Arcy, to whom every one is grateful for her recent translation of *Ariel* by André Maurois, was a distinguished writer of short stories at a time when writers and readers were taking exceptional delight in this form. Indeed, a whole chapter could be written on what might be called *The Yellow Book* tales, and a book would be required to do justice to the many kinds of talent that happened simultaneously in the nineties to be spent

[1] Cf. note on page 180, *ante.*

on the short story. The preface to Mr. Wells's own collection, *The Country of the Blind*, throws an interesting light on this wealth of activity. Writing in 1911, he says : " I do not think the present decade can produce any parallel to this list, or what is more remarkable, that the later achievements in this field of any of the survivors from that time, with the sole exception of Joseph Conrad, can compare with the work they did before 1900. It seems to me this outburst of short stories came not only as a phase in literary development, but also as a phase in the development of the individual writers concerned. It is now quite unusual to see any adequate criticism of short stories in English. I do not know how far the decline in short-story writing may not be due to that. . . . It was primarily for [attention] that the short stories of the nineties were written. People talked about them tremendously, compared them, and ranked them. That was the thing that mattered." Certainly it will be found that the few we have the space to mention here are as interesting as when they were written. There is a quality about the short story itself that guarantees this, and it is difficult to conceive any short story that should be incomprehensible to its own age and the delight of its successor. In profundity or levity the form involves a mysterious kind of immediate appeal, with the associated consequence that, whatever its merits, it tends to fall into oblivion. This is not because short stories are closer echoes of the hour than other kinds of narrative but rather, I think, that

the author works under the spell of his medium, is himself foreshortened to the limits imposed, and that readers demand ever new writers of short stories, and will only look at reprinted collections because of some independent interest. Had Mr. Wells ceased to write in 1900 would *The Country of the Blind* have reached a popular edition, and is not the appreciation of his collection as independent of its merit as is the comparative neglect of other stories of the same date that were equally admired at the time ? Mr. Wells's short stories live because he deserted the form for other things, and his contemporaries in it are now neglected because they were content with their original laurels. Few writers who survive their youth remain constant to the short story. Either they write something different or they write no more. Thus one returns richly rewarded from an exploration of this neglected field, and it is amusing to record that the most popular form that the Beardsley period touched is the one of its achievements that posterity overlooks undeservedly.

This fate, which seems inseparable from the form, might be prevented, but it would require an act of courage. Selections of short stories do very small justice to their separate authors. The need is rather for a series or " library," in which every short-story writer should have his own volume, and the collection, which should be of standard pretensions, should aim at fostering a taste and knowledge of the form in the same way that people have been taught to cultivate a less profitable taste

for minor poetry. In their lifetimes short-story
writers gain from appearing in company, and I
think that they would similarly gain after their
death ; but when they reach the stage of posthumous
publication in books, the anthology-form inevitable
in a periodical should be replaced by a collection
of single complete volumes if their respective merits
are to continue to enhance one another. The attrac-
tion would lie in the whole series of authors. This is
one of those enterprises when a timid policy would be
fatal, but a bold one, beginning with the nineteenth
century authors, would be unexpectedly impressive,
and readers would be astonished at the quantity of
good work that they had not known hitherto.

Miss D'Arcy has several slim volumes to her
credit. *Modern Instances* contains the admirable
" Death Mask," the only less good " Villa Lu-
cienne," both oblique descriptions that suggest
cunningly much that is not told, so that they haunt
the reader's imagination afterwards. " The Web
of Maya," in the same volume, is less elusive in
its form. It is an excellent tale, though the reader
is deliberately misled whereas a finer art would
have conveyed, without imposing, the illusion of
the hero. *The Bishop's Dilemma* is a long short-
story, complete in itself, perhaps a sketch for
a novel, or the kernel of a novel abandoned.
It has not the originality of the rest, for the char-
acters, though individual, had become types long
before Miss D'Arcy touched them, and have the
fatal disadvantage of being the favourites of impos-
sible authors. It is impossible to read these stories

without admiring the skilful arrangement of the strokes whereby each impression is created. The analysis of any two reveals by comparison how artfully the beginning has been chosen, sometimes afterwards, sometimes in the middle, always in the pregnant place. One notices a few idiosyncrasies. The author shows less sympathy for her women than for her men, and in both goodness and weakness tend to go together. The especially foolish marriage is a subject that attracts her, and her lovers are sent to the altar as if not a blessing but their blood was to be shed. She can render horror and the surprise that afterward seems inevitable, and her best work is extremely good. Were I not limited to few examples, I could discuss at least a score of other names, but those mentioned are an indication of the high level to which the art of the short story was carried during the decade, and Miss D'Arcy herself became assistant literary editor of *The Yellow Book*.

The stories by Ernest Dowson, which he called *Dilemmas*, are akin to those of Crackanthorpe ; indeed, their sub-title " Stories and Studies in Sentiment " recalls the *Sentimental Studies* of the latter. Both were realists, and this desire to depict life as it occurs, without romantic disguises, became, in truth, the sentiment through which life was viewed in this Darwinian age of disillusion. Realism exacted unhappy endings almost as rigorously as romance had insisted upon happy ones, with the excellent excuse, of course, that such endings predominate and are therefore more true.

We are born to struggle : not to succeed ; and, provided that we remain at our posts, our victory or failure is as much a matter of indifference as a soldier's. Dowson, however, had not Crackanthorpe's dramatic power. He preferred to shoot a little beside the mark rather than at it, for the gift of narrative was less strong in him. He stood therefore at one remove from the material that Crackanthorpe unflinchingly faced. His tales, "A Case of Conscience" in particular, are apt to break off abruptly, and to read like one chapter from a longer story, a scene that happens to be complete in itself. The subsequent unwritten scenes that the conclusion of "A Case of Conscience" suggests might have made a novel ; and there is a question whether they were omitted because Dowson preferred to leave his reader thinking, or because he felt that the short story was the longest flight within the capacity of his wings. At all events, in the two novels that bear his name he appears as a collaborator, in both books with Arthur Moore. To be conscious of one's limitations is a virtue in literature, and the only criticism to be made of these stories is that the first one turns upon an extraordinary mistake : the heroine slips two letters, vitally distinct, into the wrong envelopes. " The Souvenirs of an Egoist " (Dowson, by the way, always, like Lionel Johnson, wrote subtile, not subtle, and an before an aspirate) is interesting for a paragraph which explains frankly the intentions of its author and his school.

The egoist is a street urchin of genius who

became a famous musician. In childhood he ran away from his parents, and found in the streets of Paris a girl organ-grinder who befriended him. She generously spent a louis, which had been given to her in mistake for a franc, upon a violin, and thus replaced the instrument that the boy had broken in his flight. Then, instead of promenading together, they went separately, in order to earn more money. A rich amateur of music heard the boy improvising beneath her window, and had him trained. To console him for the loss of his little playmate, whom she did not want to introduce also into her house, the lady gave him a Stradivarius. Years after, when he has become rich and famous, an organ outside his house sets him dreaming. He wonders what the future of this girl, his first and truest friend, has been. As he sends out a servant with some money to the organ-grinder, he says to himself :

" Now if I was writing a romance, what a chance I have got. I should tell you how my organ-grinder turned out to be no other than Ninette. Of course she would not be spoilt or changed by the years—just the same Ninette. Then what scope for a pathetic scene of reconciliation and forgiveness—the whole to conclude with a peal of marriage bells, two people living together happy ever after. But I am not writing a romance, and I am a musician, not a poet. . . . I owe that unmusical old organ a charming evening, tinged with the faint soupçon of melancholy which is necessary to and enhances the highest pleasure.

Over the memories it has excited I have smoked
a pleasant cigar—peace to its ashes ! "

There we have, side by side, the artistic con-
vention of romance that the nineties overthrew,
and the realism that they substituted for it. When
we compare the two conventions by such a simple
instance as the above, we see that romance is the
victory of imagination over intelligence, and the
result in art of imagination uncontrolled by con-
science. The Corellian recipe is here, and the
secret of all immediately popular successes. On
the other hand, it is also clear how much greater
imagination is required to make the romantic con-
vention artistically satisfying. If you abandon
truth in your stories, you cannot abandon it too
thoroughly. Such a stroke is needed as that which
brought the Happy Hypocrite to his reward, when
we are transported, willingly but unexpectedly, to
fairyland, that imaginary place where dreams come
true of themselves.

Dowson's prose is scholarly and scrupulous, but
I do not think that anyone would guess from his
prose that its author was a poet, as, for example,
any one would know Rossetti to be a poet from
his prose fragments. In " A Case of Conscience "
Dowson describes the London of his time as " a
world without definitions, where everything is an
open question." From that world beauty (which
only those who do not see it wish to define, and
which is not an open question to those who do)
offers an escape. That is why beauty was pur-
sued almost fanatically by these writers, and not

with the natural appetite of men who are not
deprived of every other certainty.

A more powerful writer, of curious originality,
was Francis Adams, the author of *A Child of the
Age*, and himself deserving of that title. This
book, which still lives in a popular edition, is odd,
well written, and original. Begun at eighteen,
revised later, and at first called *Leicester : An
Autobiographical Novel*, it was the opening of a
projected "comedy of humanity" that consumption
did not allow the author to complete. It is a study
of egoism in a self-conscious, morbid, passionate
youth, who suffered from the contemporary " con-
flict between religion and science," and was inclined
to vivisect every one, including himself, especially
women. The work, perhaps through the revisions,
remains uneven, but the crudity of the earlier part
may be intended to reflect the awkwardness of the
hero in his school days. The book has powerful
pages, and must have been very real to its author.
It carries us back to the intellectual atmosphere of
the eighties, and there are little ninety touches as
well. We seem to drop back fifty years to the
appearance of the realistic novel when one of the
characters exclaims :

" Can't you read the signs of the times ? Can't
you see an Art that becomes day by day more of
a drug, less and less of a food for men's souls. A
misty dream floating around it, a faint reek of the
east and strange unnatural scents breathing from
it ; but underneath mud, filth, the abomination
of desolation, the horror of sin and death ! "

Elsewhere we light upon the characteristic comparison : " Corisande is her name. It sounds like a cleft pomegranate." There are more cunning verbal translations, the elaborate but not over-strained description of Miss Cholmondeley's rendering of the lullaby music. At the end of it all, the book falls upon our knees, and we are left interested and puzzled. The sensation that remains is that of an uneasy dream, a troubled sleep, and it is hardly a surprise to learn that the author hastened the slow progress of his painful disease by suicide. There is a brutality about the hero of this novel, which he cannot escape even when he is in love, and one feels this to have dimly weighed on him so that he is never quite real to himself but changed his part when he changed his mood and, like Legion, found himself the prey not of one but of many personalities. The book is a mirror of disillusion and self-consciousness, and Rosie, the heroine, though she lives, is shown through Leicester's eyes, a limitation for which excuse is easy since we hear of her through some one else's autobiography. Adams understood hate better than the love he wished to understand, and is an adept at invective and at quarrels.

This opinion is confirmed by the character and speeches of Julia in his blank verse drama of *Tiberius*, an original study of the emperor, whom Adams believed to be a great man corrupted by power. The drama is introduced by W. M. Rossetti, and it is pleasant to learn that William Michael, on whom the worst writings of his dis-

tinguished relatives have been jokingly fathered at one time or another, received from Adams the manuscript of this play and some poems, with a spontaneous tribute of the younger writer's admiration. To W. M. Rossetti, the hodman to his family, the Muse allowed one talented disciple of his own.

Tiberius, though not more than the apprentice effort of a talented young man cut off before his time, is worth reading. The verse is rough but has always a solid core, and a tinge of that bleakness which Swinburne used with such tremendous effect in the *Duke of Gandia*. An instance of its force, especially in invective, is Julia's sneer at the emperor :

> Has he the palsy that he shakes so. This
> Augustus ? He will slobber presently.

Not only is this capital abuse, but it cries to be spoken, and we cannot fail to hear our favourite tragic actress sling the words. In the same scene Julia goads Augustus to frenzy, but when, ill and exhausted, he at length recovers his self-control, the old man wins our respect by these few telling words :

> That will suffice. . . . Thanks, thanks. . . . I am better.
> . . . Thanks
> I can stand up. I am myself. . . . My friends.
> Forget what late has passed. . . .
> I have my death, Tiberius, yea, my death.
> This only brings it closer. A mad rage
> Possessed me. I forget my moderation.
> Then it is time I went.

R

The passage, clipped as it is here, gives unmistakable evidence of talent not only for writing but for writing for the stage. There is a grip, an economy, about all the work of Adams that makes such a quotation impressive, for the force behind seems always greater than that which appears. The writing of John Davidson creates the opposite impression, and this is the important difference between certain surface resemblances of manner. The love that Adams understands, but did not desire, is of the flesh, and his writing aches with his bitter yearning for the kind denied to him. If he was unhappy, it is because he was not self-deceived, and the spirit turned to ashes in his hand because he was allowed no more than an intellectual apprehension of it. This apprehension is enough to ennoble, though it cannot transform, the writer's complex temperament, as Caliban is ennobled by the glimmer that made him condemn himself for having supposed a god in Trinculo. Caliban has yet to learn that knowledge of such mistakes may not prevent their repetition, and that " to seek for grace " is not enough to find.

It is not their secret faults that trouble people, but those apparent to the world, especially to themselves. Torment begins with the discovery that knowledge and hatred of our faults is no guarantee against their repetition. No one has shamed us, even at home, as we often shame ourselves, and yet the word is spoken, the action flies, before we are aware that it is coming. What is it that usurps command, what the intuitive impulse that betrays

us ? If it were without, we might be able to resist it. Because it is within, knowledge of its existence only increases our trouble, and poisons half the lives of many people. There is only one satisfactory explanation, and this makes the doctrine of original sin the most comforting in the church's treasury. It cannot be defined so as to be understood without being believed, but Francis Adams was one of those to whom only the contradiction and not the explanation had been granted. In this he was a child of his age, and his confusion shows an observation blindly groping toward one of the very principles the abandonment of which had become his vital point of honour. It is hardly too much to say that the mood of all his work results from the tireless accumulation of evidence for a proposition that would probably have seemed to him an intellectual insult. There is nothing like the truth for putting clever thinkers off the scent. Obscure facts are often much less puzzling than their simple explanation, for facts we can discover for ourselves while explanations have to discover people, and by a mode so peculiar to themselves that we have no other word for it than revelation. Where this is denied, the more evidence we possess the more puzzled do we grow, and Adams was like a man threatened by a fire, whose supplies of water add to its horror as he suddenly realizes that he is on a ship at sea.

Though he wrote very little, and his talents really lay in other directions, it is among the writers that Robert Ross can most conveniently be placed.

His best book is the little volume on Beardsley, where he says so well :

"If the history of grotesque remains to be written, it is already illustrated by his art. A subject little understood, it belongs to the dim ways of criticism. There is no canon or school, and the artist is allowed to be wilful, untrammelled by rule or precedent. True grotesque is not the art either of primitives or decadents, but that of skilled and accomplished workmen who have reached the zenith of a peculiar convention, however confined and limited that convention may be." The nineties too had a convention, in life as well as art, an ideal of society and of manners. Robert Ross himself, with his genius for friendship, his delightful manners, his wit, his carefully disguised learning, his singularly happy nature, which no trouble could more than cloud, was the personification of this ideal. With almost every one he was irresistible. He delighted to espouse unpopular causes, but, though he rarely wandered far from Mayfair, he professed radical opinions. These were met by saying : we must not judge your opinions from your friends, a remark that became a joke at his expense in his own manner. He used to call himself an early Victorian, but he really belonged to the Beardsley period ; only, as he survived its vogue, his humour took the form of reacting from a revolt that had itself become respectable. In matters of opinion he was always on the side of the opposition, and the success of any cause was enough to make him criticize it. If the

Bolshevists had triumphed in his time, he would
have professed himself to be a Tory. If he ever
visited Bayswater, he might have been mistaken
there for a communist. One friend explained
these contradictions by saying that conversation
was Ross's only form of exercise and therefore
meant to him a game of intellectual fence ; another
that " Ross had seen so much of the divagations
of cleverer men that he himself recoiled to common
sense." His humanity was suspicious of theories.
When a man of erudition lamented the " waste "
of a scholar who had lost his life in the attempted
rescue of a child, Ross was horrified. It seemed
to him inhuman to value scholarship above the
life of any child. To a young enthusiast who pro-
posed to act upon one of Blake's most challenging
precepts, Ross turned in solicitude and begged him
gravely " not to be like Blake." The heart, he
seemed to think, was a surer guide to conduct
than any theory. Theories were matters for dis-
cussion, his favourite recreation. Conduct was the
province of good sense. To the last he thought
that people should live entirely for pleasure, but
his own principal pleasure was to serve the inter-
ests of others, without weighing the cost to himself.
Time and again he became the victim of his abound-
ing good nature. No one has been missed more
sincerely by a wider or more diverse circle of
friends. No one embodied more completely the
good qualities of his own ideal. It is sad to think
that so delightful a personality has left so inadequate
a record of itself ; and yet inadequate is hardly

the word for the multitude of cherished memories that his innumerable friends retain of him.

Among these memories is the vision of a personality which, as he said of Beardsley's art, " sums up all the delightful manias, all that is best " in the ninety point of view. In life, as in literature, it desired a personal perfection, the attainment of what is, fundamentally, the aristocratic ideal. It sought distinction, grace, beauty ; and the element of strangeness in it was a protest against the uniform, the commercial, and the dull. It aimed at creating a prose whose fine shades could be appreciated only by cultivated people, by those to whom excellence is never so delightful as when it is a thing apart and different from the rest. Curiosity, strangeness, scholarship was to rescue this prose from the printed word that is content merely to assert its meaning. Language was heightened and refined, seeking deliberately the subtler effects, and giving to words a new colour, a finer precision : Mr. Charles Ricketts, who has given distinction to painting, printing, and the arts of the theatre, has also produced a Corinthian prose in those delightful books *Pages on Art* and *The Art of the Prado*.

The authors mentioned here are no more than examples of this, but these, and others who could be named, aimed at a perfection which gives a character to all that the period produced, a character that is distinctly felt though elusive of definition. Only the accident of genius in one or two of these writers could carry their work to popular

success, but their distinction lies in having sacrificed nothing to this end, with a disinterested devotion that is rare in England. Their work in kind is not great, but in degree it is as perfect as they could make it, and they have their reward, for contrast respects them. Just as London is a city which is often beautiful by accident, and hardly ever by design, a city in which nothing is sacrificed to beauty, so English literature is full of accidental, wayward beauties, with little tradition of excellence, and abounding in surprising extremes. Our great authors, from Shakespeare to Browning, have delighted to be the spendthrifts of their own genius, to be utterly reckless in their use of words. This turbulent stream is periodically checked by the influence of foreign literatures and the desire of a more formal grace. The latest instance of this was provided by *The Yellow Book* school. Its members tried never to write below a certain level of excellence, and preferred, not only in theory, to the successes of an intermittent inspiration the more restrained virtues of scholarly conscientiousness and scrupulous care. It was also a point of honour with them to write nothing merely for money. They put their ideal of literature before their livelihood, and this has given a dignity to their work, the lack of which can be felt in writers who have made concessions. The choice is a matter of taste, and the taste is reflected in the style.

CHAPTER IX

The Yellow Book and *The Savoy*

MR. JOHN LANE has recorded how, one day in 1894, Aubrey Beardsley, Henry Harland, and himself met at the Hogarth Club, and how the result of this meeting was the foundation of *The Yellow Book*. It appeared, as perhaps artistic experiments best appear, without any statement of its aims. The contents showed it to be a quarterly devoted exclusively to art and letters. It gave no literary news, and published no reviews of books. It produced its own writers and artists, and was not about art and letters. Among the artists was Charles Conder, a delightful colourist, whose work is so full of graciousness and decorative charm that his colour retains the ghost of itself even in the wannest reproduction. His landscapes and his fans are delicious, with a wistfulness that reminds us that, as much of his inspiration came from France, so his temperament and his sympathies were unsatisfied in England. Regret for a vanished grace breathes upon his designs, and his favourite form, the fan, is symbolic of the spell cast over him by the eighteenth century.

Watteau drew Conder as Pope attracted Beardsley, the one by an emotional, the other by an intellectual magnet. The influence of the Japanese is common to both, the invisible bond that unites two temperaments, the surface differences of which cannot disguise a mutual sympathy for much that their own age and country could not give. Mr. Walter Sickert, another member of the International, is named among the contemporary English painters who influenced Beardsley, but to exhaust the list of those from whom his inspirations drew would be to ransack the history of painting from the Greek vase painters to his own time. By the opportunities given to original work from artists as well as authors *The Yellow Book* did a double service to both. It was not a chronicle but a creation, and in its pages good artists and writers presented their own work side by side without introduction or apology. Such a periodical is very unusual in England, because we instinctively feel that there is no public demand for it, and therefore that no magazine deserves to exist which does not make news, politics or some practical purpose its main interest. To omit such a section thirty years ago was to air an eccentricity, excusable in undergraduates but not in men and women of the world. This canon does not run in other countries, but it exists with ourselves, and *The Yellow Book*, so far as I am aware, was the first quarterly exclusively intended for men and women of letters to be printed in England. " This class," Mr. George Moore has remarked in reference to the private publica-

tion of *A Storyteller's Holiday*, " is not recognized
by the libraries as readers of books ; strange that
it should be so, but so it is ; for whilst there are
books for astronomers, for scientists, for doctors,
for lawyers, for golfers, for cricketers, for chess-
players, for yachtsmen, and as for young girls in
their teens voluminous literature awaits them every
year, there are no books written for men and
women of letters exclusively." In regard to books,
this is an exaggeration ; but it is no exaggeration in
respect of periodicals, and the oddity of its aim
helps to explain the extraordinary outcry with
which *The Yellow Book* was greeted.

The designs by Beardsley, who was then little
known, for the cover and title-page were the prime
excuse for this, and coloured for the public eye
everything else within the volume. Indeed, none
of the literary contents compares in originality
with the Beardsley decorations, and if the former
had appeared by themselves, or Beardsley's hand
had been excluded, the sensation would have been
less. Essays, poems, stories, many of which have
since been incorporated in the books of their re-
spective authors, fill the volume, but their only
common character is their disinterested artistic
appeal. There is nothing in *The Yellow Book* by
Wilde, the one writer of the time who made a
speciality of shocking. It would be unjust to the
other contributors, however, to make Beardsley
the sole cause of offence. A contributory reason
was the exclusively artistic character of the periodi-
cal. *The Yellow Book* becomes in our periodical

literature the surprising realization of the seed that
was sown by *The Germ* in 1851. Besides intro-
ducing Anatole France to England, *The Yellow
Book* showed a catholic taste, for it printed a paper
by Mr. Arthur Waugh on " Reticence in Litera-
ture," which criticized Swinburne and challenged
one of the very principles for which the paper was
supposed to stand. It also invented the idea, Mr.
Lane reminds us, of having a new cover and title-
page design for every number.

The assistant literary editor of *The Yellow Book*,
after the first volume, was Ella D'Arcy, the author
of *Monochromes*. She contributed three stories to
the quarterly, " Irredeemable," " White Magic,"
and " The Pleasure Pilgrim." All bear an affinity
to the genre in which Crackanthorpe, Dowson and
George Egerton specialized. Her first story is a
realistic study of a foolish, but possible, marriage,
less feverish in style than the tales in *Keynotes*, but
less dramatic and restrained than those in *Wreckage*.
The second is a trifle of no special merit on sur-
viving superstitions in the Channel Isles. The
third is a study of the new American girl, and its
merit is to project without pretending to solve the
heroine's character. Lulie Thayer leaves us won-
dering, as real people do, whether she was a vulgar
minx, a typical cosmopolitan flirt with the instincts
of a rich hotel promenader, or an actress off the
boards to whom every man she met in life sug-
gested a stage situation. The suicide, told a little
baldly, with which the story ends, may have been
an accident or a theatrical climax, but the type to

which we are introduced was probably new to fiction then, and is still plausible enough to enrage people who dislike it. Miss D'Arcy, who saw all her women through masculine eyes, had that degree of talent which seems capable of more than it attained. It is difficult to be just to any such gift, but she has a gift, and her stories were of the tone that *The Yellow Book* wanted, and justified her position on its staff. Against the background set by Henry James, who sent the " Death of the Liar " to the first number, and of Lord Leighton, who also contributed designs to it, the work of the younger writers and artists, like Ella D'Arcy, Harland, Kenneth Grahame, Walter Sickert, Wilson Steer, made a catholic collection. The new school and the seniors were skilfully placed side by side in a living relation to each other.

After the fourth issue, when Beardsley ceased to be the art-editor, the magazine began to lose its character and appeal. It will be remembered that the fifth volume of *The Yellow Book* is dated April, 1895, the month when the Wilde trials were proceeding. It is also on record that the four designs made by Beardsley for this number were cancelled, and the original issue withdrawn. The volume was made-up afresh in consequence of a particular protest. No doubt the condition of public feeling at the moment helps to explain this, but the immediate reason for the alteration was a protest from Sir William Watson. As a contributor to *The Yellow Book* he could command a hearing, and his words had weight from another

cause. The poet, like many others, was at the moment in violent reaction from the gospel that *The Yellow Book* was supposed to preach. It was natural that he should believe the ideal maintained in his own works to be preferable, and many of his admirers urged him to combat the malign influence of the quarterly to which he contributed by raising his own standard within its very doors. Among these admirers was Mrs. Humphry Ward. Shortly before Volume V appeared, she remarked that William Watson was determined to make a protest, one too that the editor could not disregard. Mr. Watson, she affirmed, was determined to make the last sacrifice. The nature of this sacrifice was left for the moment obscure, but this made the warning more impressive. Mrs. Ward regarded the poet as the appointed guardian of English morality, destined to uphold it at a critical time. Her prophecy was fulfilled when he wrote a letter to Henry Harland saying, among other things, that unless Beardsley's work was withdrawn his own poem should be. With this number Beardsley ceased to be the art-editor. Henry Harland, a charming companion at ordinary times, was subject to strange fits of excitement, and this letter made an alarming impression on him. He bowed to the storm, and the original issue was cancelled. The designs intended for this issue have all, I think, been printed since, and, contrary to a general impression, they do not differ from Beardsley's other published work. But the incident revives a time of tension, and shows indeed that *The Yellow*

Book did not regard itself to be the peculiar property of any school, for it welcomed the work of such unimpeachable writers as Henry James, Edmund Gosse, and Sir William Watson, and of such artists as Lord Leighton, from the first.

The Yellow Book ran, despite Beardsley's resignation, for thirteen volumes, however, but its original banner passed to *The Savoy*, which Mr. Arthur Symons founded in 1896 to carry on the original tradition. *The Savoy* also began as a quarterly, but it became a monthly almost at once, to die, very undeservedly, at the end of the year. Beardsley contributed to *The Savoy* not designs only ; *Under the Hill* and his three poems also appeared in it. " Even apart from Beardsley," Mr. W. B. Yeats has written, " we were a sufficiently distinguished body . . . but nothing counted but the one hated name." Personally, I find the literary contents of *The Savoy* more interesting than most of those in *The Yellow Book*. Many read to-day as freshly as ever, a fact which is often forgotten, for most of us know them only through the pages of subsequently printed books. It is the distinction of both periodicals to have contained much that has survived the process of reprinting. Collectors, I understand, are not more eager for *The Yellow Book*, although it was the first.

The preface written by Mr. Symons to the first number of *The Savoy* contains a definition of the aims of both. Though the phrasing afterwards seemed to him " pettish," it is strange to learn

that the expressed intention to publish any work that seemed good, and nothing that did not, should " have made so many enemies for the first number." This fact suggests, however, that Beardsley was not entirely to blame. Experience shows it to be a very difficult thing to draft a statement of intentions for a new periodical in art and letters, and I know none that is better or more to the point than that which introduced *The Savoy*. All such statements are apt to seem conceited, and the wisest rule is to allow the contents to speak for themselves. *The Savoy* was published by Leonard Smithers, who commissioned Ernest Dowson's delightful translations from the French. His full-dress version of *Beauty and the Beast*, illustrated by Conder, deserves to become a classic.

The Savoy, whose title ingeniously suggests the combination of Mayfair and Bohemia to be found in the ninety point of view, was planned at Dieppe in 1895, the year of the exodus to France. Consequently it appeared on the ebb of the tide that had carried *The Yellow Book* to notoriety. Its failure seems to prove, however, that there is no permanent public for such magazines in England, where the national individualism produces isolated talents but hardly ever groups of writers and readers with common sympathies or aims. When such groups happen to be possible, they are exceptional and short-lived, and, like the Rhymers' Club, seem to be attempts to copy foreign graces in a climate hostile to their survival. Despite the passing of *The Yellow Book* and *The Savoy*, how-

ever, a mysterious impulse was at work, and begot a series of more or less kindred publications : *The Hobby Horse, Pageant, Quarto, Parade, Evergreen, Dome, Venture, Butterfly,* and several others. The impulse was strong enough to create many abortive attempts, but not strong enough to maintain any of them very long or successfully. Periodicals devoted to the art and literature of the past can generally endure in England, but we never seem able to maintain a periodical devoted exclusively to the imaginative work of our own contemporaries. The reason perhaps is that suggested by Mr. T. S. Eliot, who has finely said that a cultivated taste is traditional and fond of novelty, while the uncultivated dreads novelty in proportion as it fails to understand the tradition. Each magazine of this class tends to become the exclusive expression of a point of view that disappears with its inventors, but as *The Savoy* succeeded *The Yellow Book,* and published work of very diverse excellence, we might expect, but we do not find, the perpetual existence of one familiar magazine into whose pages the most disinterested artistic product of the day would naturally be attracted. *The Yellow Book* and *The Savoy* are famous because they did, for a time, accomplish what nothing else had accomplished before. The last number of *The Savoy* contains a remarkable feat of editing, for the entire contents, poetry, narrative, essay, and translations were from the pen of Mr. Symons.

Without these two quarterlies, the artistic movement of the time would lack definition to posterity.

The periodicals were less than the forces which created them, but these wilful centrifugal tendencies were momentarily induced to coalesce, and thereby seemed impressive, and even formidable, to contemporaries. A common front was presented, and by its means a series of individual tendencies assumed the dignity of an artistic movement. It was precisely this that was original and startling, for we are a combative race, and there is a shocking absence of solidarity among men of letters in England.

The book is older than the newspaper, and the newspaper, the periodical, has always been commercial in England. It was therefore felt to be inconvenient for the commercial field to be invaded by an uncommercial publication. If there were really a public for such a periodical, existing journals might be threatened by a competition that they would not know how to meet, and demands would be made upon them that commercial enterprise would be at a loss to satisfy. The commercialization of something previously disinterested is always welcome and reassuring, but the reverse process challenges our established order of things ; it is revolutionary, against all experience, and beyond calculation. The success of a book is an isolated event, and it justifies the commercial test because it is presumed to enrich the author. Nobody is threatened by it ; but that a number of uncommercial talents should unite to produce an uncommercial publication, and find a sufficient number of disinterested supporters to maintain itself, is a

very different matter. It argues a widespread change in the public taste, that may produce all sorts of vaguely apprehended consequences. Its success involves the existence of a number of persons, not merely with interests that commerce cannot satisfy, but with sufficient cohesion to supply their wants themselves, instead of, as hitherto, accepting whatever commerce may find it convenient to give to them. If they spread their ideas, and all commercial experience teaches that one success opens the path to another, the industrial market may be upset in all directions. Once these people enter the commercial field, and prove to be capable of doing what hitherto commerce alone has been able to do, who can tell where the process will stop? An industrial society can endure only so long as people believe in its assumptions, and they will continue to believe, or remain negligible, so long as their wants cannot be supplied without its aid. While commerce remains the sole effective agent, it can control the disaffected minority, for their criticisms will accomplish nothing. But the day when the disinterested leave idle criticism for intelligent activity, and begin to supply their own wants themselves, then commerce begins to lose its monopoly. It was the uneasy sense that this moment might be arriving, that disinterested work might be able to enter the commercial field and appropriate a corner of it, that contributed to the excitement that *The Yellow Book* aroused.

For many years there had been much talk about art, but the shop of William Morris was the only

sign that talk was ever likely to be changed into activity. After all, his furniture, hangings, and chintzes, were more costly than the commercial product, and a limited licence is allowed to the shopping of the rich. But *The Yellow Book* was a quarterly published in the ordinary way at a commercial price, and if there were enough subscribers to maintain it, then the public taste which it represented was much wider than had been supposed. *The Yellow Book* represented the mentality which commerce was unable to understand ; it contained the kind of product with which commerce was unable to compete ; and it was really with a cry of despair that the *Westminster Gazette* appealed for " a short Act of Parliament to make this kind of thing illegal." A short Act ! It could hardly be too short ; a single clause was all it wailed for. " We do not know that anything else would meet the case," it exclaimed impotently; " this kind of thing " was beyond the reach of competition, therefore it should be made illegal. It is a revealing line of argument, for if this kind of thing was allowed to establish itself, the obvious inference was that it would make illegal the *Westminster Gazette* and all its tribe !

Indeed, it would be startling if imagination became an active force in the world, and ceased to be the private indulgence of a few eccentric people. A hint that this revolution may somewhere be taking place is enough to excuse the sense of shock in an unimaginative, and therefore timid, people. Now that we know *The Yellow Book* to

have been the precursor of nothing alarming, but the final eddy of an ebbing tide, we are in danger of underrating the peculiarity of its first appearance. With *The Savoy* it marks one of those " hours that might have been and might not be "; and they are so rare in England that these quarterlies have won a repute, as it were in excess of their contents, which has come to need a word of explanation. With hardly an exception, the contributors to both believed with Gautier that the perfection of form was virtue, and the lesson that they have bequeathed to us to-day is that the desire for perfection is an end to aim at because this desire gives to work, however limited in scope, a worth beyond its own nature that survives the mode in which it is done. This quality, like the desire that went to its making, is rare in our periodical literature, and it is the rareness of a body of men intent upon it that has given to *The Yellow Book* and *The Savoy* their historical place among literary reviews.

CHAPTER X

The Æsthetic Type

THE nineties, then, saw the end and not the beginning of a movement, as perhaps Robert Ross alone fully realized at the time. He used to lament that no one who fell under the influence of Oscar Wilde ever accomplished anything, that Wilde seemed to waste everything around him, and that the renaissance that he claimed to lead was a culmination, not a birth. But the end was an end historically only, for in art the expression of an end fixes it for posterity ; when realized by men of talent, it becomes an achieved thing to crystallize an attitude of mind that still endures, and is indeed to be found, here and there, in every generation. The point of view is eternal, and will last at least as long as the universities survive the advancing corrosion of industrialism. The life of leisure involves the possibility of its abuses, and its protection must protect these along with its proper fruits. To unfit men for earning an industrial livelihood is one of them, and of those so unfitted many will necessarily be unable to pursue any liberal or scholastic profession. The attitude

to life of such persons retains something of the dreamy undergraduate, [a hatred of commerce and money-making, and consequently, in an industrial society, an exaggerated regard for the little world of Mayfair in which alone leisure is normal and men are industrially free. There people may indulge commercially useless tastes without sacrifice or interference, and, spared the intolerable nuisance of earning a living by a commerce that they loathe, may give to the practice or enjoyment of the arts whatever grace is in themselves. Such people, being aliens in their surroundings, desire to escape not to reform society.] The nonsense knocked out of our young men at school, says Mr. Max Beerbohm, is gently replaced in our ancient universities, and to have escaped from school is the chief pleasure of these studious, gay, and leisurely retreats. For the æsthetic type, to leave Oxford or Cambridge in order to enter commercial life is to be sent back again to school, and such people miss, more acutely than others, the architecture, the disinterested and leisurely pursuits, of college life.

The æsthetic temper itself is mainly one which enjoys without creating anything more permanent than conversation, which is content with all that has been already done in art, and dreads the conditions out of which all new art, except pure poetry, is produced, however much it may be capable of appreciating the results attained by it. Unfitted for commercial pursuits, which it is their point of honour to despise, and imperfectly endowed with creative imagination, these men fall between the

two worlds of art and industry. They may write
a few charming short stories. They may become
exquisite critical amateurs. They may produce a
slender volume of poetry. They may even be
beautiful calligraphists ; but the probability is that
they will talk life away and leave no memories,
except those of a few hours of companionship among
friends who were content that they should merely
be, because, for their friends, they had a charm
that was enhanced by their commercial ineffec-
tiveness. Their limitations prevent them alike
from dominating society or escaping it. They
survive mysteriously like blades of grass in the more
neglected corners of the city, and pass in and out
of the lives of their friends in the same irrelevant
way. They suffer from the want of a patron, since
the private patron has almost faded out of life.
The public has vaguely ventured on this duty, for
which it is constitutionally unfitted, and makes
even more muddles of its endeavours than the
private patrons often made of theirs. The æsthetic
type will not accept the public in this capacity.
It is by nature and by choice impossible, though
with all the compensations that this quality often
gives to impossible and half-delightful things. The
arts of public cajolement are beyond the attainment
or effort of these beings, and they will not sue for
patronage at the public door. They would prefer
the approaches of Lord Chesterfield, for however
long he kept them waiting, an eighteenth-century
drawing-room in Grosvenor Square has more con-
solations for their eyes than the bleak stairs and

frosted doors of an editor's office with a typewriter ticking at alarming speed over the way. They are obscurely conscious that the spirit of such places is beyond them, that they need the patron who has disappeared, and for want of him they perish like a flower for want of earth.

Consequently they revenge themselves by mocking at a world in which they find no corner, except that one to which private property conceals the key. In art and literature they seek vicarious satisfactions in those forms in which the imagination escapes most completely from actual surroundings, for the only convictions that they retain are the satisfaction of grace and beauty and the worth of cultivated ease. In the coarser type the allurements of Mayfair, in the finer the allurements of art, exercise the dominating influence. But we have them always with us, and the product of the Beardsley period has given a revealing picture of their mentality. Its satire confirms their own distaste for the conditions of our industrial society. Its realism flatters their perception of the disparity between the facts of this society and its pretensions. Its romance and decoration carry their imagination beyond the taint of its grasp. Its paganism or mysticism encourages their faith in the existence of a different order. Its extravagance pleases them by the protest of its fancy, and the assertion of an individual escape from the oppression of commercial standards and ideas.

Therefore, though the period is over, it presents an eternal attitude of the human mind, and from

time to time books are still produced that convey
one or another aspect of its mentality. The tales
of Lord Dunsany, whose style, though better, was
perhaps inspired by *The House of Pomegranates*,
would have been welcomed by *The Yellow Book*
or *The Savoy*. Mr. Forrest Reid would have
found appreciators among their readers. The
Trivia of Mr. Logan Pearsall Smith would have
been called prose poems in the decade, and the
best of them, the " Vicar of Lynch," which is a
charming imaginary portrait and has little con-
nection with the rest, would have given pleasure
to Walter Pater. James Elroy Flecker they would
have admitted to be a poet, and Mr. W. H. Davies,
and Mr. Walter de la Mare. The irony of Mr.
Lytton Strachey would not have offended their
taste, and *J'expose*, the motto that he chose for his
historical portraits, would have gained in their
regard from the language of its origin, and because
the emphasis falls upon the pronoun which his
authorities had uncritically sundered from the verb.
It seems, too, hardly more than an accident of time
that *Ulysses* was not published in the nineties. Its
vast experiment would have interested them. They
would have recognized the learning, and been
beguiled by the effects, of its immense vocabulary.
Even the absence of punctuation in the last chapter
would have seemed to Beardsley, if not to Johnson,
a legitimate experiment in the attempt to convey
the flux of thought and feeling that passes through
the mind of one who, after a day crowded with
impressions, is slowly falling asleep. They would

have said that the experiment was worth making
even though it may seem the occupation of a life-
time to vanquish the obstacles of a book that took
eleven years to write. They would have compared
Mr. Joyce with Sterne, and not fallen into the easy
error of asserting that a sciolist could have accom-
plished such a feat. Confronted by its frequent
obscurity, they would have asked how far this
might be a reflection of some obtuseness in them-
selves, and compared its microscopic picture of
the minds of its characters with Apuleius' crowded
gallery of the streets.

Return once more to Pater's analysis of the
components of æsthetic poetry, given in the Post-
script to *Appreciations* already quoted, and we dis-
cern the inevitable cultivation of these in a world
that had less for the eyes and imagination than
any period recorded in history. We still accept
this ugliness, struggle, squalor, because we are
forced to do so and have lost the memory of better
things. But it is well to ask ourselves how far
this acquiescence may be due to a blunting of our
normal faculties, to an infection from that world
itself. It is too readily assumed that this accep-
tance is natural and healthy, and that all protest
is eccentric or perverse. Observation shows, how-
ever, that our great men accept in a determination
to alter, and, of the rest, it is more human to evade
than dumbly to conform. Such conformity all
the world is in a conspiracy to enforce, since the
handful that thrives upon it depends on the degree
of service, disguised as voluntary, that it imposes

on the rest. These have been drilled so thoroughly
that they dread the critics who would revive them,
and, unconsciously, still more, since inactivity has
come to seem abnormal, the few who stand aside,
for nothing can equal the force of independent
personal example. Less than ever can we afford
to lose the stimulus of exceptions and of contrast.
Men, at least, are better not machine-made : until
serfdom is explicitly re-established.

The qualities that the æsthetic type does not
possess are obvious, but let us not confuse with
these the virtue of disinterested loyalties, which
they will pursue at a cost to themselves that no
commercial pressure can subvert. Let us forgive
them for not seeking prizes, for not making con-
cessions to a society that they detest, nor measure
their lives by the ridiculous tests of conformity,
success, or similarity. Live with dreams and you
will gain something of their charm is the admission
of one who has derided dreaming, and the type of
thirty years ago was recruited by young dreamers,
including men from Oxford, who regarded beauty
as the latest of lost causes, and put something of
this charm and of that faith into their best work.

They were disillusioned people, without sym-
pathy or understanding for the world in which they
lived, who found hardly any living activities in that
world to correspond with their susceptibilities to
beauty. The curse from which all minorities suffer
fell upon them. They experienced that extremity
of solitude that can be felt most acutely in uncon-
genial company, or in a crowd, or in family life.

They suffered from the egoism that has to be cherished because, in the circumstances, it can be escaped only at the price of self-treachery or surrender, since there is no healthy fellowship in which it can be merged or active tradition on which it can be grafted. The centrifugal tendency has been carried so far as to become a conflict of egoisms. An industrial society in this condition severs each of its victims from his roots in religion, in tradition, in such fundamental instincts as those for property, for personal relations, for beauty in life. The modern European of the Christian era, with that heritage in his very bones, is not yet, whatever he was in Aristotle's time, a slave by right of birth. But he is now bred into a slave-society that he cannot understand, define, or even recognize, for industrialism establishes a state of slavery more corrupting than any previously known in the world because the master is not a man but a system, and the whip an invisible machine. With this it is impossible to enter into any but inhuman relations, and in such an inversion of humanity all the instincts become perverted at their source. The institutions that have nominally survived this revolution in human affairs are allowed to survive but on condition of subservience and impotency. Religion becomes hated because it may never be practised, only preached, and is approved most when preached in such a way as to fill alert listeners with contempt or indifference. On the stage the comic figure, who was once the village idiot, had become the cleric, and during the War some at home wondered

what the chaplains found to do since cake-stands
were not handed in the trenches. A solution was
provided by the cigarette, which was distributed
in enormous numbers. It gave to an unfortunate
body of men a popular work to do. These symp-
toms cannot be neglected : the many honourable
exceptions that they do not touch only emphasize
how a religion and a society that contradict each
other in every fundamental reduce the first to
absurdity and the second to chaos. Every instinct
of man is similarly divided from its exercise. Art
and use may be pursued so long as they are mutually
exclusive. Marriages are permitted to men who
are not permitted to maintain even themselves ;
the necessity of work and the necessity of a per-
manent body of unemployed are inculcated in the
same breath.

In these circumstances the only beliefs that are
supported by practice are selfishness and cynicism,
and the stifled instincts, which will not be utterly
denied, express themselves in the sterile pursuit of
unrelated and subversive satisfactions. Each can
be indulged only by a refusal of the rest, and in
the general conflict that ensues the successful are
as much crippled as the failures. Disinterested
talents flourish, if at all, by the incalculable caprice
that happens to add an irrelevant market-value, or
through the possession of property that, in a society
that dispossesses nine out of every ten of the popula-
tion, is the oddest freak of all. In this world noth-
ing, except commercial keenness, is that which it
professes to be, and such order as is necessary to its

exercise debases rather than benefits the astute. There is little wonder, then, that the effect of all this upon the temperaments that we have been studying was to confirm their weaknesses and to warp their gifts. The apparently invincible machine of society made every imaginative desire or uncommercial aim seem eccentric, and tempted especially the weaker men into the paths of perverse idiosyncrasy. The period still suffers from this, for the fate of some of its figures has lent a scandalous glamour to the arts which, *The Loom of Youth* seems to suggest, continues to capture the more imaginative schoolboys in succeeding generations.

At all events, if the reader will ask himself what kind of literature and art was to be expected from the mentality just described, he will find its diminishing reflections in the work of that company of forgotten writers which revolved round the still remembered names, including Charles Conder's, that have been mentioned here. With all, it was neither possible nor desirable to deal personally, and their work has the finer justice done to it if the temperament be sketched of which it was the fitful outcome.

Now that we can see it in perspective, the product of the period is a suggestive revelation of the condition to which the human mind had come after industrialism had completed the phase that the disruption of Europe had opened. In the last decade of the nineteenth century this condition found an artistic form which interests us, in addition to itself, by virtue of the historical process that may

be discerned at its core. Apart from Beardsley, the period is important for us still, perhaps more for the attitude that it reveals than for its individual products, since this attitude is a permanent phase of consciousness in our society and will last its term. It is normally isolated and personal, but a discernible movement revealed the extent of its ramifications, and these remain, though no longer above-ground. Their extent at the time might not have been measured but for a school whose fate it was to mark the last decade of the grave Victorian age with the evidence of the appetites that it was starving.

CHAPTER XI

Toward the Latest Compromise

ACCORDING to Mr. Max Beerbohm, a contemporary authority, the Beardsley period was over by the year 1895, and after the climax of the Wilde trials the expression of its point of view became suspect and distasteful, publicly. The eclipse of its fashion gave added sanction to other writers who, with whatever modifications, were maintaining the Victorian attitude to literature and art. There was a momentary reaction, and those who profited by it, and yet had fallen under some of the influences that had moulded the Beardsley school, betrayed themselves by a tendency to preciosity. They retained the desire to be the exquisites of literature, but wished to show that the exquisiteness could adorn substantially Victorian views, and had no native connection with paganism, æstheticism, or eccentricity. The prose of Alice Meynell, despite obvious reservations, is the most convenient example of this type. It is self-conscious to the last possible point, but the self-consciousness is entirely on the side of the limits of Victorian conventions. It is only fair, however, to

recall that a long residence abroad had made the
French form of certain words more habitual to her
than the English, which flowered upon her page
in a landscape of French memories. A greater of
these Victorians is the present Poet Laureate. To
him, as he has explained in one of his introductions,
poetry is a learned language which can be acquired
by consummate scholarship and a sensitive ear, if
the student has the indispensable nucleus of imagi-
nation. His lyrical dramas on the Greek model
are essays in form, not Hellenic in feeling, and his
beautiful verse is at all times subdued to a medi-
tative ecstasy that the Pre-Raphaelites would have
admired. In the novel and the drama Sir James
Barrie wrote from the first regardless of the inter-
ruption of the early nineties, and his famous freaks
of sentiment and humour are refinements upon
ideals that the Victorians held dear. Like his own
Peter Pan, he has refused to leave the nursery.

With the end of the decade, Mr. W. B. Yeats,
soon followed by Mr. George Moore, departed to
Ireland, there to carry the leaven derived from
France with the intention, happily realized, of
creating an Irish Literary Theatre. The Dublin
group, though affiliated to the Beardsley school by
sympathy with the French symbolists and desire
for perfection, yet differed from all, except Beards-
ley, because they created something new, and did
much more than carry to its last development
the Romantic convention. Without his sojourn in
Paris, Synge would hardly have been himself. The
Dublin writers discovered a new material. They

T

created a new style in prose and verse ; they
founded a school of drama where none had pre-
viously existed. The word renaissance, often
vaguely applied to the writers whom we have been
considering, has meaning when applied to the
Irish movement. Ireland, indeed, has survived on
a succession of waves of patriotism, now revivifying
politics, now agriculture, now literature and art.
Patriotism is not an impulse, but an instinct, always
disproportionately active under alien rule, and the
mysticism of Mr. Yeats, with its infusion of patrio-
tism, has evoked the symbolic figures of Celtic
legends that are older than Christianity. The
revival of the Irish language may have proved a
literary dream, but the quest for it created a new
language, some of whose most beautiful effects
have been gathered from the Anglo-Irish idiom of
the people. This literary form has been enriched
from living springs, and, far from being a learned
corruption, has been fed on peasant speech, the
naturally poetic idiom of unsophisticated country
people. The typical ninety figures would have
appreciated the result, but their urban and scho-
lastic habit of mind would have prevented them
from discovering or collecting it. Mr. Yeats
turned from London to Dublin, and from Dublin
to the cabins of the peasants as hungrily as Beards-
ley turned to watch the crowd around *petits chevaux*
in the casino, Dowson to cabmen's shelters, Johnson
to a library, or Wilde to Mayfair. Therefore it
would only confuse the perspective in which the
Beardsley period should be seen to do more than

recall its affiliations with this new impulse, so foreign to its own sophistications, cosmopolitan habits, and the taste of the town.

The realistic school lived on, chiefly under the influence of Ibsen, who provided a point of departure unconnected with France or Zola, and in the main on less unpleasant lines. It is not upon unmentionable details that Ibsen delights to linger. *Ghosts* now gives no offence to people who would still recoil before *La Terre*. Ibsen is content to examine the structure of society, and to show how people are entangled between its institutions and ideals. His marvellous dialogue has, like none other, the verisimilitude of ordinary converse ; it gains its effect, never from the words used, but always from the situations of which this saplessness is the vehicle. The conversations are so like ordinary parlance that they hardly appear to be art at all, and this marvellous economy has seemed to all poets to sacrifice too much to actuality. People indignantly point out that art and life are different, and ask to what the drama of the past would be reduced if we expunged the soliloquies and asides. Ibsen's famous theory of the stage, a room with the fourth wall wanting, pursued an opposite intention. The prose dramas of Ibsen brought the world into the theatre. Poetic drama raises us above the world. Ibsen holds us by the interest of his situations and his stories. It is the excitement, not the beauty, of his plays that has moved the world. With few exceptions, such as Pastor Manders in *Ghosts*, the people in these plays are

T*

so real and familiar that the audience is inclined
to take sides, and is soon busy discussing whether
they were right or wrong in what they did, and
whether the institutions with which they came into
conflict should be altered or defended. The stories
are told with immense theatrical skill. Their effect
is to set people thinking. They stir curiosity
rather than imagination. They encourage activity.
They do all the things which we value poetry for
not doing, and they have never been loved by poets.
It is true that the latest plays are more remote
from immediate experience. The characters are
the ghosts of themselves, but Duse's revival of *The
Lady from the Sea* a year ago revived doubts. The
appearance on the stage of the elderly fisherman
reduced the symbol for which his absence stood to
ruins, a stroke of reality probably not intended by
the play. This example shall suffice to illustrate
the " stale poetry " that Mr. Yeats has found in
these last plays, and the people whom they have
impressed most are those whose main concern is
with applied literature.

This is an offshoot of naturalism, and replaced
a literary theory with a solemn moral ideal. Its
practitioners were advocates of this and that, and
however they enlivened their advocacy with didac-
tics, dialectic, or impartiality, they created what
was called, in contrast with the variety turns in
the halls, the monotonous theatre. The canons,
the aspirations, of this literature are almost the
opposite of those out of which the Beardsley and
the Dublin groups had been created. The example

of Ibsen concentrated attention on the stage, which in England, but for his followers, had been practically sterile. It had been by his plays, however, that Wilde had made the better part of his reputation, and these had shown that the life of our drama need not depend upon translations from abroad. But his peculiar talent was inimitable, and, as we have seen, he brought nothing new to dramatic art except a degree of wit which lent to the dusty conventions of the theatre an air of originality. Nevertheless, in his hands the drama showed renewed signs of life. The problem play, being serious in intention, was fatally easy to imitate, and this was the direction that the theatre pursued in subsequent years.

The disinterested and sometimes fantastic pursuit of art from the time of the Pre-Raphaelites had been intensified by a hatred of industrial society, but as this last phase of the Romantic movement, after a brief and brilliant display, passed into the shadow of eclipse, the individual protest lessened, or returned to constitutional forms. The prevailing energies were poured into one or other channel of applied literature. Despite its insecurity, industrial society seemed, as it seems still, secure, and all except an occasional poet tend to resent writing that is entirely the product of imagination. The characteristic talents that succeeded the æsthetic school welcomed this limitation, and many were bewitched when Mr. Shaw declared that " in all my plays economic studies have played as important a part as a knowledge of anatomy

does in the works of Michael Angelo." Mr.
Wells, too, has stated that he cares less for art than
for journalism. Both, indeed, have done magnifi-
cently in the theatre, the novel, the short story
and romance, all that journalism ought to do ; but
this is now not a profession but an industry which
drives into literary forms the men of genius that
it will not tolerate in its own field. The news-
paper has been found out, and the book, the play,
is taking its place to minister to our curiosity for
fact and controversy. From the good works of
the intellect the book is less than ever free, and
the seriousness of Mr. Shaw and Mr. Wells is
due to their desire to replace a blind acceptance
of industrialism with a self-conscious criticism of
it, and to create a new mentality, a new religion
even, in terms of the evolutionary hypothesis round
which circles all that is typically modern in our
confusion and our thinking. The men of the
nineties, who were alive only to the destructive
implications of this hypothesis, like Hedda Gabler
had nothing to replace the dogmas that they had
discarded. Consequently the energies of their
successors, desiring something more than a now
familiar protest, either returned to these dogmas or
followed the promise of the new. Either attitude
was welcomed, and its contrasted representatives
agreed in this, that sufficient taboos had been
destroyed for the moment, and that within the
limits of respectability art could satisfy all that
the imagination required. The scientific spirit
replaced the romantic in the affections of the young,

and the Victorian atmosphere, against which the
last romantics had rebelled so fiercely, seemed
forgotten until the publication of *The Way of All
Flesh* in 1903 reminded the younger generation
of its character, and to that extent identified the
outmoded revolt with the scientific essay toward
reconstruction.

This was accompanied by a tendency to recap-
ture tradition in other directions. Mr. Arnold
Dolmetsch revived the Tudor instruments and the
Tudor composers. Bach was preferred to Beetho-
ven, because if Beethoven pointed the way to
heaven, Bach was heaven itself ; and to anyone
who is familiar with the clavichord the piano seems
a domesticated orchestra, and after the pure joy
of the early pattern music the compositions of
Beethoven and Wagner become a fever of regret
for a state of artistic innocence that has been lost.

Despite every effort, however, we are still living
in an age without convictions, where everything is
an open question as it was thirty years ago, except
that the attack on respectability is less and that
we have grown so used to this confusion that we
take it for a matter of course. With this acquies-
cence, what is called sanity of expression is the
prevailing fashion of the day. Outside the coteries
faith, even in paradoxes, has been lost. Two
events, moreover, marked the first decade of the
twentieth century : the rise of literary journalism,
and the appearance of the Georgians, the first of
which preceded, and the latter almost coincided
with, the War. Presumably the former resulted

from the more literate generation that had grown since the Education Acts were passed. The *Manchester Guardian* had made an honourable beginning, and the independent publication of *The Times* Literary Supplement began in 1901. The experiment of *The Yellow Book* was now suggesting commercial possibilities, and a literary public was now recognized to have some journalistic needs of its own. Though the Supplement remains the only comprehensive weekly newspaper devoted to educated readers of books, every year larger space has been given to them in all but the most illiterate papers. Thus a new department of journalism has arisen, which offers to young talents a nearer approach to the profession of letters than ever before. Like everything else, it has survived the War, which had no effect on literature and art because the only creative imagination to which it could appeal was the exceptional imagination of the historian.

The historian is one who sees the present through his living consciousness of the past from which it has grown, and to him the present is habitually dwarfed as much as a remote century is to ordinary people ; it must be dwarfed to be intelligible and vivified. So far as I have observed, the War saturated the imagination of only one man in England, Mr. Hilaire Belloc, who became in enormous demand because he had a sense of perspective, and therefore could make it intelligible and interesting. That he was alone in this proves how exceptional is the historic sense. Nothing

else can give proportion, and consequently meaning, to current catastrophes. The mood that it aroused in him produced the immortal prose on the " spirits in conflict " that concluded the first volume of his general history of the War. Nor is Mr. Belloc's isolation in this matter surprising. The Napoleonic wars might never have happened for all their effect on the work of Shelley or Keats. The events had to wait a hundred years before the reflective imagination, in the person of Mr. Thomas Hardy, could compose the *Dynasts* out of them. Wordsworth and Byron, despite the former's sonnets, were not moved to much of their best work by the military events through which they lived, and Byron, after all, was the journalist of poetry. The typical attitude of the Muse on these occasions is that represented by Jane Austen, Shelley, Keats. Horace has endeared himself to the imagination of mankind because he confessed that, hardly had he been persuaded to enter the battlefield of Philippi, when 'swift Mercury bore him out of the fight'; and however fast the bodies of the poets may stand on these occasions, that is what the Muse does with their imaginations to this day. War of itself occasions worse verse than peace, but in the general need for economically unproductive energy, it creates a demand for sonnets as well as shells, and on this the young Georgian poets, whose work began before it started, rose into momentary esteem. The ingenious editor of their first anthology chose an admirable title, and the collection gave more dignity to the work of

most of its contributors than separate publication
had, or would have, done. There was the exciting
suggestion of a movement. A common point of
view, with a characteristic colour, cannot perhaps
be readily discerned in these writers. Among
their generation, though strictly senior, Mr. W. H.
Davies and Mr. Walter de la Mare stand apart.
Mr. Davies would be himself in any century, and
Mr. de la Mare is after Poe and Coleridge, that
is all. It is the discreet absence of peculiar thought
or music that unites the rest, and perhaps in this
they typify their time which, outside the coteries,
is without strong desires or prepossessions. But
they have not confined themselves to verse, and
have penetrated in all directions the field of literary
journalism. They do not *quote* Gautier or Poe
or Baudelaire, and the doctrine that art is an end
in itself ; but they are as disinterested as their
scrupulous care never to offend anyone will allow.
In part, then, they are akin to the ninety poets,
without the latter's eccentricity or courage ; for
courage was one of the virtues that the ninety
poets sought.
 The generation to which most of them belong
began to arrive at Oxford and Cambridge in 1900,
and was very different from the generation that
had come down ten years before. So far as the
Cambridge men are concerned, we have the record
of two types between which they oscillated : the
romantic type of Rupert Brooke, who had some
affinity with the æsthetic school and something of
the over-ripe pear in his mentality, and the raw

and rationalistic type of Frederick Keeling. On the former it is unnecessary to linger. The latter has left a less known but extremely vivid record of himself, and through him of his generation, though the confused experiment of his life is appalling to read. It depicts, by an extreme example, the effect on youthful minds of the wave of socialistic and Shavian ideas that swept over the middle classes in the brief years when the Court Theatre was at its height, to create, before it sank, the *New Statesman*, of which Keeling was once assistant editor.

We must here pause to note that this paper was begotten of the need to counteract from the Fabian side the vigorous criticism of socialism and Shavian ideas that Mr. Belloc and the two Chestertons were leading. Mr. Belloc supplied the faith, the history, and active personal criticism in Parliament. Mr. Gilbert Chesterton supplied the fun. Cecil Chesterton was the most brilliant and courageous journalist of his generation in London. It was, and the surviving pair remains, a formidable combination, though the loss of Cecil Chesterton at the very moment when he had written his admirable *Short History of the United States* is felt to this day. The traditionalists thus appropriated the literary weapons of their enemies, and, apart from personal adherents on one side or the other, the majority, between two equally lively displays, is confirmed in the conviction that all convictions are fallacious. To the literary aspirations of this majority it is now convenient to turn.

The greatest common measure of the imaginative

temperament of which these various individualists were the extremes appeared in Mr. J. C. Squire, who was to give a new direction to literary journalism. In the autumn of 1919 the *London Mercury* was founded, and the paper, whose orange cover gave to the yellow symbol of its so different precursor a more sober and discreeter tinge, showed the courage of its editor's beliefs. It was the first monthly review in this country to be devoted exclusively to letters, for it was a newspaper of current literature and art endeavouring to exhaust the whole range of interests provided by letters, the drama, printing, architecture and music. Original verse, criticism, stories, essays, balance the news, and the result has proved more comprehensive than anything previously attempted or dreamed of. Such a journal seemed impossible in England before it appeared, and its merit consists in that, having appeared, it seems natural and inevitable. It appeared, it said, because " we have had an orgy of undirected abnormality." The paper, therefore, was careful to disclaim at the outset the criterion of any coterie, and such work, if not Georgian, has been excluded. Its contents never go far beyond or fall below the average of intelligent appreciation. This policy, though it excludes one or two experimental writers, has enabled the paper to endure, and its permanence is worth more to the causes that it serves than any more adventurous experiment. Its defects are those incidental to all enterprises intended to survive their founders. It stands for " sanity and information," and is impor-

tant for its attempt to make all educated opinion
a conscious, and no longer ineffective, force in
national life upon the matters in which such opinion
is interested. It has hardly touched the art of
sculpture. It has not reviewed the statues of
London, to which a good guide would be very
welcome. It has left the War memorials alone ;
but on such matters, apart from letters, its readers
look to it for constructive criticism from those who
know for those who care.

The suggestive fact is this. While most culti-
vated people preserve uncommercial tastes as a
private possession, to be indulged, as it were, on
the sly, Mr. Squire has not been so timid. His
appetites are social. It is as if he had said to
himself : I have many uncommercial tastes for
which I care as much as for anything that necessity
allows me. All my friends have kindred ones,
and beyond that private circle there must be thou-
sands similarly inclined but at present isolated and
ineffectual. Suppose, however, all of us were
shepherded, suppose we had clubs and journals
and some organization, then our common point
of view would be expressed, our dissipated energies
combined, and a force might appear in modern
life to which, in time, the rest would begin to
listen. Why should we continue to spill ourselves
in air for want of a common mode of action ? It
is said that in commercial England such a scheme
is bound to fail ; so it will, if undertaken by a
man whose primary motive is money, and whose
real desire is to exploit the views that he pretends

to represent. Clearly, then, the attempt must be made by an uncommercial man, a man wide awake to the necessities indeed, but not subdued by them, and thoroughly representative of the educated public. The opportunity is waiting, but no one attempts to use it. Why not ?——

The first result has been that a hitherto unco-ordinated type of mind has its journal, and the beginning is being gradually followed up. The Architecture Club, of which Mr. Squire is president, is too much akin in principle to the *London Mercury* not to have sprung from the same representative mind, with the help of the same type of people. The Three Hundred Club, for the benefit of young dramatists and suggestible managers, seems to show the same principle at work. Of both architecture and playwriting it may be said that about one-twentieth of modern work is good, and that a similar proportion of persons is ready to recognize it ; but, till lately, neither had a convenient way of making itself known to the other, or of focussing intelligent interest upon itself.

The movement of which these activities are the signs is the compromise resulting from the protest and experiment that led to the creation of *The Yellow Book* thirty years ago. Idiosyncrasy and extravagance have been discarded in an attempt to bridge the gulf that divides the intellectual from the active life of the nation. The want of such a bridge was a contributory cause of the disillusion that flourished fantastically in the period. The world of ideas and the world of activity went their

separate ways to their mutual impoverishment. Cynicism, commercial and artistic, flourished side by side with no more effect than glances of mutual hatred at each other. For want of contact, art and use became perversely opposed, but now the possibility is held out of some composition of their quarrel. This movement, I think, is an index of the disinterested aspirations and policy to-day no less characteristic than *The Yellow Book* was of the Beardsley period. It deserves definition because it is yet neither disappointed nor triumphant. We are watching the endeavour of the disinterested to play its own policy upon the world. The attempt denotes a less wayward mood of the imagination, because the energies that used to waste themselves in protest have begun to combine for common ends, and, as the years pass, we shall have the opportunity of judging how far a disinterested body of opinion, acting in concert, can influence for the better the practice of the nation where this touches the things of the imagination and the mind. Is any force conceivable to-day that could have prevented the demolition of Regent Street ? Because the answer seems to be in the negative, the fate of Regent Street becomes a test case ; for its preservation would have meant that a limit had been set at last to the forces of commercialism, and until there shall be some such a limit it is idle to pretend that the smallest progress has been made.[1]

[1] For a full statement of the facts about Regent Street, the reader is referred to the second chapter of Mr. A. Trystan Edwards' learned and witty volume, *Good and Bad Manners in Architecture*.

At least, if the perspective in which I have tried
to set the Beardsley period before the reader is to
be just to the different tempers that went before
and have ensued, it may pause upon the vista that
Mr. Squire has determinedly opened. The Vic-
torian, the æsthetic and the rationalistic ideals
having been tried and found imperfect, such
qualities as are common to the three have com-
promised to evolve another policy. The primrose
path remains for the individualist who will always
tread it. The coteries succeed each other for
experiment and adventure. In addition, we have
now this middle path. Will it win a richer spoil
than the others, and this attempt in due time appeal
to the imagination that has found something to
remember and to boast in their defeats ?

In a wider view of the movement of the human
spirit before and after the Beardsley period was
reached, we find that the want of conviction, the
loss of self-confidence, the cult of egoism in the
absence of any common bond, continues, and that
we are still in the late Victorian confusion except
that, as some taboos have been broken, so the more
assertive protest has lapsed because the confusion
has come to be accepted as a matter of habit, and
any protest has the air of an extravagance now
out of date. The appearance of a new genius might
revive it again, but faith in the power of individuals
against the machine that controls our society and
dictates our moral pretensions has grown weaker.
We are at home in our scepticism, we are accus-
tomed to commercialism, we are subdued by our

routine, and the attempt to return to the conditions preceding the War has been only too successful. It is more difficult than it used to be to conceive a realizable improvement. Protest seems vainer than it once did, because we have grown a little weary of denunciation and losing causes; and the new evolutionary philosophy, visibly struggling to appear, will not emerge within the lifetime of the youngest. The War was not a conclusion but a warning that the industrial epoch will destroy itself, and the forces that men serve but are unable to control will carry them to a climax that they neither will nor have the intelligence to prevent. We are at the mercy of the machinery that we have created, and only when that machinery itself breaks down will the epoch, and the centrifugal tendency that accompanied its start, work out their inevitable consummation. As has been said, "it is a race between education and catastrophe."

Thus this essay cannot be brought to a conclusion. The historical process in the course of which the Beardsley period arose is not yet over, and the period provides the evidence of forces that protest against but are unable to control it. This protest is less shrill than it was when Beardsley led it, but we still refuse to acquiesce in the system that we obey. In the outward conformity that is forced upon us a calmer note is heard, but this means no more than that the prevailing opinion is that the epoch will work itself out, and that Time needs no effort of ours for the breakdown that is preparing. Disillusion is a little out of date, for

this implies a conscience that is still sensitive. Disillusion has been replaced by indifference, and the change congratulates itself on the return of good taste, the recovery of sanity.

INDEX

INDEX

Index

301